ISBN: 1-933197-02-1

Copyright © 2005 by Mark M. Stang and Phil Wood

Orange Frazer Press, Inc.
Box 214
37½ West Main Street
Wilmington, Ohio 45177

Telephone 1.800.852.9332 for price and shipping information
Web Site: www.orangefrazer.com

Library of Congress Cataloging-in-Publication Data
Stang, Mark (Mark Michael)
Nationals on parade : 70 years of Washington nationals photos / by Mark
Stang and Phil Wood.
        p. cm.
Includes index.
ISBN 1-933197-02-1
1. Washington Senators (Baseball team : 1886-1960)--Biography--Portraits. 2.
Baseball players--United States--Biography. 3. Baseball players--United
States--Biography--Portraits. I. Wood, Phil, 1951- II. Title.
GV875.W3S72 2005
796.357'64'09753--dc22

                                                    2005050869

Printed in Canada

# NATIONALS On Parade

## 70 Years of Washington Nationals Photos

by

Mark Stang and Phil Wood

ORANGE FRAZER PRESS
Wilmington, Ohio

**(preceeding page)**
**American League Park**
**Opening Day, 1917**

With World War I raging in Europe, the Washington Nationals march on to the field to practice military-style drilling using their bats as rifles.

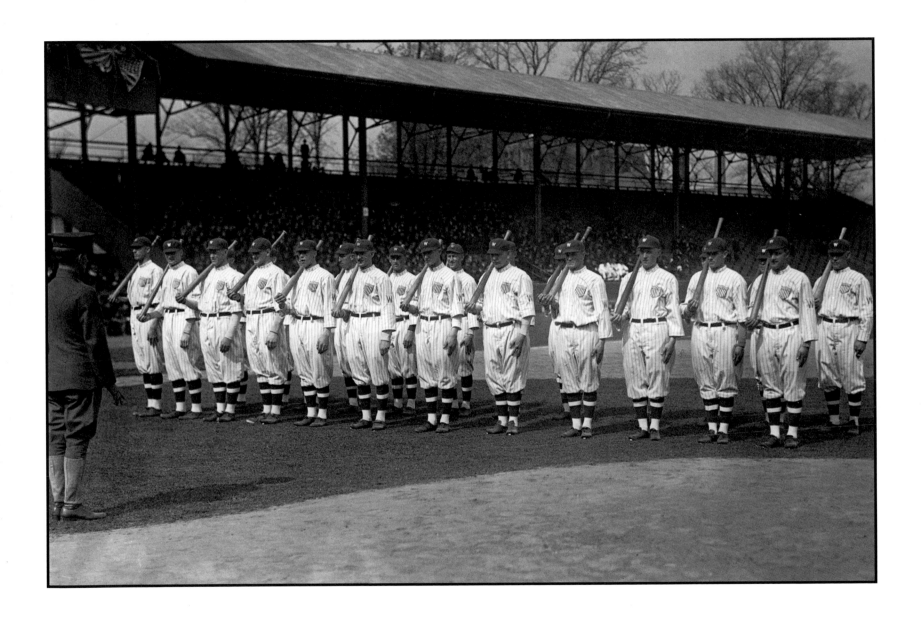

# Acknowledgments

This project would not have been possible without the assistance of many individuals. We were given complete access to the photo and clip files at *The Sporting News* in St. Louis, where archivist Steve Gietshier offered invaluable help. Many thanks to Tim Wiles and Pat Kelly (and their staffs) at the National Baseball Library in Cooperstown for their assistance.

Thanks also to Rob Medina at the Chicago Historical Society for his assistance with *The Daily News* negatives collection. Our thanks to Peggy Appleman at the MLK Library in Washington for her assistance with the defunct *Washington Star* photo files.

Vintage photo collectors Alan Feinberg, Dennis Goldstein, Mike Mumby, Bill Loughman and Kent Feddeman graciously shared their troves of treasured images with Nationals fans everywhere. Walter Johnson's grandson, Hank Thomas, provided an elusive final image.

A deep debt of gratitude is again owed to Rosemary Goudreau for her tireless editing of the text. Thanks also to Elaine Olund at Lamson Design for the original cover concept.

The format used in *Nationals on Parade* owes its inspiration to a 1999 publication co-authored with Greg Rhodes entitled: *Reds in Black and White, 100 Years of Cincinnati Reds Images.* That book, in turn, owes a debt of gratitude to the classic work by Neal and Constance McCabe, *Baseball's Golden Age: The Photographs of Charles M. Conlon* (published in 1993).

Finally, the behind-the-scenes star, as always, is Ryan Asher. His technical wizardry and tireless dedication to providing the best possible image is evident on every page. Ryan also executed the page layout and the cover design.

To all these folks, we offer our sincere appreciation for their hard work and cooperation in making this project possible.

### William "Boileryard" Clarke
### Catcher, 1901 - 1904

Washington started the 20th century - like the 21st century - without a baseball team. It lost its first major-league team in 1900, when the cash-strapped National League shrank from 12 teams to eight. A year later, in 1901, the city got back in the game when a rival league formed calling itself the American League. The president of the upstart league was Ban Johnson, a former newspaperman who quickly installed franchises in eight cities. The league's owners raided the rosters of the senior circuit and pried away dozens of star players with promises of larger contracts. Before long, they'd stocked 60 percent of their line-ups with players from the National League.

Among the defectors was an aging catcher with a colorful nickname and a strong throwing arm. William "Boileryard" Clarke had played with the legendary Baltimore Orioles during the pennant-winning seasons of 1894, 1895 and 1896. Those Orioles teams included five future Hall of Famers and gained a reputation for their "win at all costs" style of play. Teammates called him "Boileryard" because they said his booming voice could be heard anywhere in the ballpark. But Clark made himself best heard behind the plate, keeping base runners on their toes. He once threw out future Hall of Famer "Sliding Billy" Hamilton on three straight attempted steals of second base. Hamilton would go on to steal 937 bases during his career and lead the National League in stolen bases seven times.

Clarke was 32 when he moved south to catch for Washington, a team that would later be called the Senators. But while strong on defense, the young team had problems at the plate and finished a disappointing sixth its first season. Clarke suffered through four consecutive losing seasons before being released at the end of 1904. He spent a single season with the New York Giants before retiring at age 37.

Clarke went on to manage in the minors for several years before spending 34 years as the head baseball coach at Princeton University. When major league baseball returned to Baltimore in 1954, Clarke, then 85, rode in the welcome parade - the only surviving player from the Oriole's golden days.

### "Big Ed" Delahanty
### Outfielder, 1902 - 1903

Big Ed Delahanty was one of the game's greatest sluggers, but he is best remembered for the way he died. Delahanty, one of five brothers in the majors, played mostly for the Phillies where he led the National League in doubles four times and runs batted in three times. In 1896, he became the second player ever to hit four home runs in a single game. In 1899, he hit .408 and his 234 hits led the league. Delahanty was not only powerful at the plate, he could really run. He stole 456 bases in his career, including 58 in a single season.

For this he was paid $3,000, the maximum annual salary allowed by the league. So when the American League's newly formed Washington franchise offered him $4,000. Delahanty jumped. In 1902, his .376 batting average and 43 doubles led the league and gave Washington its first batting champion. But manager John McGraw of the New York Giants wanted Delahanty's bat back in the National League and so advanced the slugger $4,500 for a promise to play the 1903 season in New York.

During the off-season, Delahanty spent most of his new-found wealth at the racetrack in New Orleans. At the same time, unfortunately for him, the two leagues settled their differences and agreed to stop raiding each other's rosters. Delahanty was ordered to return the $4,500 and play a second season back in Washington. Unable to repay McGraw, Delahanty began drinking heavily and soon his marriage fell apart. On a western road trip in late June, Washington manager Tom Loftus suspended him from the team. Depressed and threatening suicide, Delahanty left the team in Detroit on July 2 and took a train east, hoping to reconcile with his wife.

Onboard, he began drinking heavily, accosting fellow passengers and bothering everyone by ringing the alarm bell. The Pullman crew finally threw him off the train near the international bridge separating Canada from the United States. In the dark, as he staggered towards the bridge, he came upon watchman Sam Kingston and the two argued. What happened next is still in dispute.

Some accounts say Kingston warned Delahanty that the bridge was open to let a boat pass beneath. Others claim Delahanty threatened Kingston with a beating. Kingston's version of the events, as later told to the police, changed several times. The only certainty was that Delahanty had fallen from the open span into the river. His body was found seven days later below Niagara Falls. He was 35 years old.

Delahanty's career batting average of .345 is the fourth highest ever. He stands behind only Ty Cobb, Rogers Hornsby and Shoeless Joe Jackson. He was elected to the Hall of Fame in 1945.

**Case "Casey" Patten**
**Pitcher, 1901 - 1908**

Casey Patten was a very good pitcher on some very bad teams. During his seven seasons with Washington, the team never finished higher than sixth place and placed last three times. In the American League's inaugural season, Patten won 18 games, threw four shutouts and became the workhorse of Washington's pitching staff.

Talented and tough, this pitcher finished what he started. Consider these numbers: Starting in 1902, Patten threw at least 300 innings for four straight seasons. In seven seasons with Washington, he threw over 2,000 innings.

He started 239 big league games and completed 206 of them.

Ultimately, Patten could not overcome Washington's pathetic offense. In 1904, he lost 23 games, including nine in which his teammates failed to score a single run. In 1906, he won 19 games, threw six shutouts and had an ERA of 2.17. Still, the team finished 55-95 and in seventh place. By 1908, the heavy workload had finally taken its toll. The 31-year-old lefthander was traded to Boston early in 1908 and later that year, he retired.

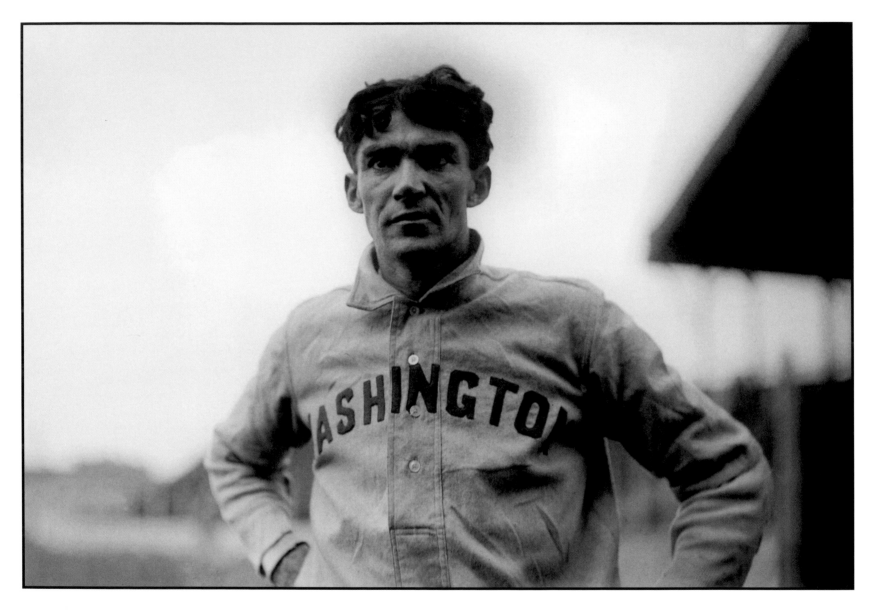

**Bill Coughlin**
**Infielder, 1901 - 1904**

Bill Coughlin was a scrappy infielder who overcame a childhood accident to spend a lifetime in organized baseball. When he was three, Coughlin lost his left index finger after picking up a gun that went off. He played his entire career with a specially designed glove, claiming it helped him execute the "hidden ball trick" against base runners.

During his three seasons in Washington, Coughlin helped anchor one of the best defenses in the American League. His best season was 1902 when he hit .301 and drove in 71 runs. Fast on the base paths, he stole 29 and 30 bases in successive seasons. Midway through the 1904 season, Coughlin and a backup catcher, Lew Drill, were sold to Detroit for $7,500. There he became the Tigers' permanent fixture at third base. He helped the Tigers reach the World Series in 1907 and 1908. During the second game of the 1907 series against the Chicago Cubs, Coughlin caught base runner Jimmy Slagle with his hidden ball trick.

A bad knee forced Coughlin to retire after the 1908 season. He spent the next nine years managing in the minors. In 1919, he became head baseball coach at Lafayette College, a position he held until his death in 1943.

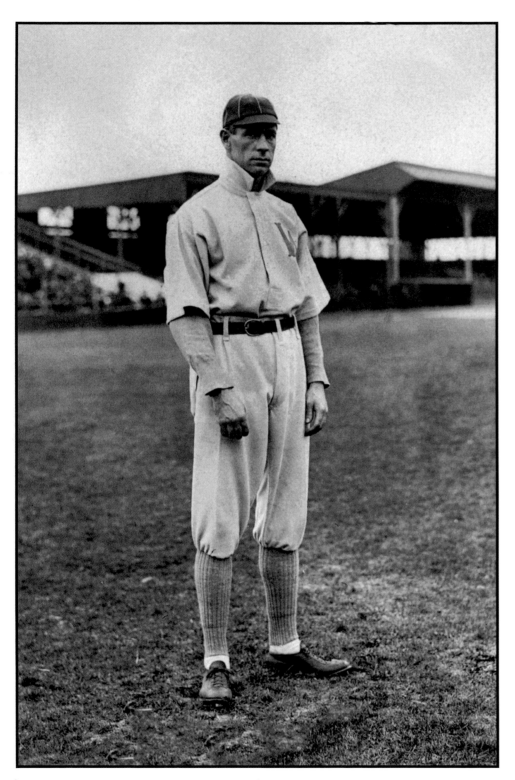

### "Long Tom" Hughes
### Pitcher, 1904 - 1913

Tom Hughes had already won 20 games and thrown a 17-inning shutout by the time he arrived in Washington in 1904. As a rookie in 1901 with the Chicago Colts (later Cubs) of the National League, Hughes out-dueled Boston's star pitcher, "Big Bill" Dineen, for a 1-0 victory in 17 innings. After jumping to the rival American League in 1902, Hughes went 20-7 for the Boston Pilgrims (later Red Sox) in 1903 to help them to the first-ever World Series.

Traded to Washington midway through the 1904 season, Hughes had an up-and-down career for the Senators. His best season was 1908, when he won 18 games for a seventh-place team. But like other Washington pitchers of his era, Hughes often lost more than he won.

Sent to the minors in 1910, Hughes won 31 games for Minneapolis and earned a recall back to Washington for another three years before retiring at age 35. Hughes spent the next five seasons in the Pacific Coast League before returning to Chicago to work for the city parks department.

## Joe Cantillon
### Manager, 1907 - 1909

Joe Cantillon spent nearly 50 years as a player, manager and umpire in professional baseball, most of it in the minor leagues. Cantillon was a colorful character who loved practical jokes and once owned a saloon in Chicago. As an umpire, he was known for starting more arguments than he ended. As a manager, he proved an exceptional judge of talent, developing dozens of star players. His success as a minor-league manager earned him the chance to manage in the majors.

Cantillon took over Washington after the team's seventh-place finish in 1906. He overhauled the roster, but finished dead last the next year. Still, he kept his eye out for new talent and in 1907 made his greatest contribution to the club's eventual success by signing outfielder Clyde Milan and pitcher Walter Johnson. The two would spend the next 14 seasons as roommates and their entire careers with Washington.

Three straight poor finishes cost Cantillon his job after the 1909 season. He moved to Minneapolis to manage Washington's top farm club. There he won three straight league titles and four American Association crowns over the next 14 years. Cantillon later managed and scouted in the minors before being named supervisor of umpires for the American Association in 1929. He died less than two years later at age 65.

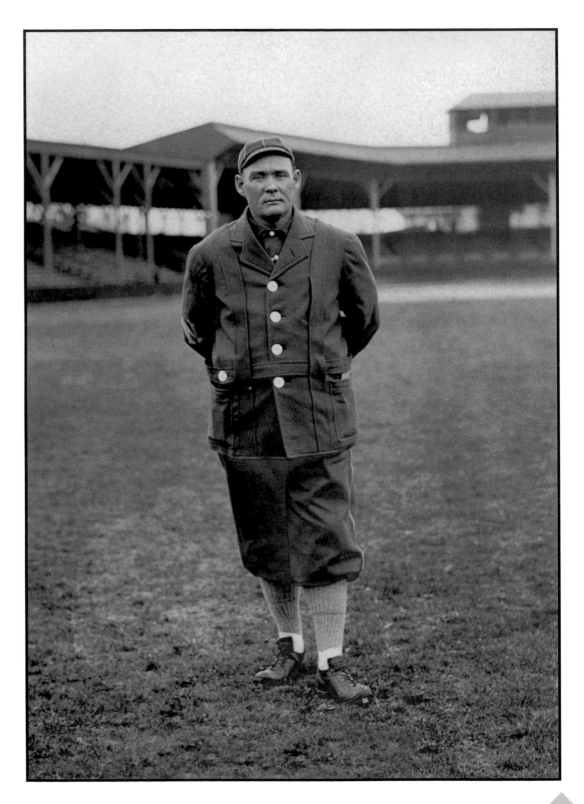

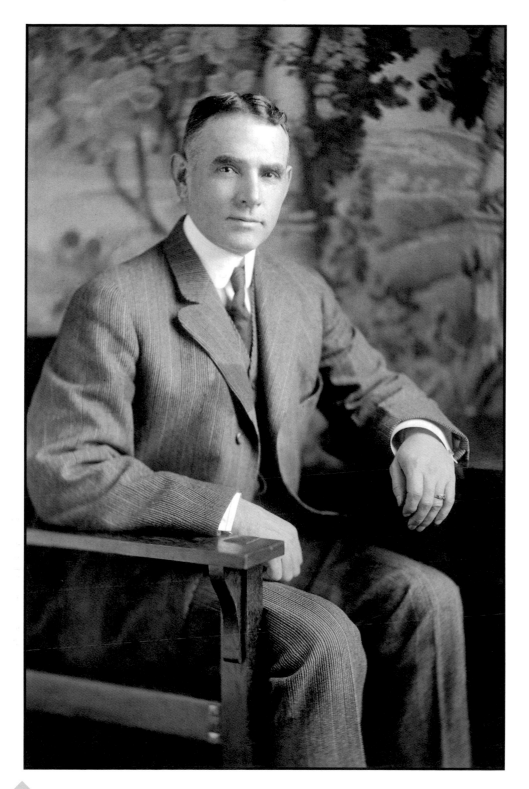

**Clark Griffith**
**c. 1908**

Before he became owner of the Washington Senators, diminutive Clark Griffith was one of the most dominating pitchers of the 19th Century. Griffith stood small for a pitcher, only 5-foot-6 and 165 pounds. But he harnessed an assortment of trick pitches that baffled hitters for more than a decade. While pitching for the National League's Chicago Colts, he won 20 or more games for six straight seasons.

In 1901, when he was 31, Griffith took his shot at management when he, like so many other veterans of the National League, joined the upstart American League. He became player-manager of the new Chicago White Sox and his first year, his team finished first and Griffith led the league with 24 wins, including five shutouts. Two years later, he moved to New York to take over the struggling New York Highlanders. And six years later, he moved to Cincinnati to manage the Reds. But Griffith found managing in the majors didn't offer much job security or produce much of a nest egg.

In 1911, Griffith set his sights on becoming an owner. He had long been close friends with Washington newspaperman Tom Noyes, principal owner of the Senators. Noyes and his partners wanted to raise cash and so agreed to sell stock in the team to outside investors. Griffith was given the chance to buy a 10 percent share. Griffith scrambled to put together the $27,000 he needed. He mortgaged his Montana ranch then rushed back to Washington to sign the papers that made him the largest single stockholder in the ball club.

Griffith also signed a three-year contract to manage the club for $7,500 a year. There was a new sheriff in town and changes were sure to be made.

## Walter Johnson
### c. 1908

The Senators landed a powerful gate attraction when pitcher Walter Johnson arrived in the middle of the 1907 season, but Johnson's mastery on the mound did little to improve the team's place in the standings. Still, the 19-year-old rookie's sidearm delivery and pinpoint control became the talk of the town as local sportswriters fell over each other to find new superlatives to describe his blazing speed. The result was a big increase in attendance on the days he was scheduled to pitch.

Washington manager Joe Cantillon had acquired Johnson on the cheap. He brought him to town for the cost of a train ticket and had him pitch two games before signing him to a contract for the miserly sum of $450 a month. Johnson's first professional start was at home against the Detroit Tigers, an explosive offensive team. The Tigers' 1907 roster included future Hall of Famers Ty Cobb and "Wahoo Sam" Crawford, who helped Detroit win the American League pennant that year.

And so it was on August 2, Johnson took the mound to face Cobb and the Tigers. The Detroit dugout was ready for an unknown, bush-league rookie, but Johnson quickly got their attention and their respect. The Tigers managed just six hits, only three of which left the infield. Cobb had to bunt to reach base safely twice. In the end, the Tigers won, 3-2, but everyone walked away knowing they had witnessed something extraordinary. Cobb would later remark, "The first time I faced him, I watched him take that easy windup and then something went past me that made me flinch. I hardly saw the pitch, but I heard it. The thing just hissed with danger. Every one of us knew we'd met the most powerful arm ever turned loose in a ballpark."

Several Detroit players approached their owner, Frank Navin, about purchasing Johnson's contract at once, for any amount. Cobb reportedly told Navin, "Even if he costs you $25,000, get him!" It might have happened if Navin had known that at that moment, Johnson wasn't under contract to Washington.

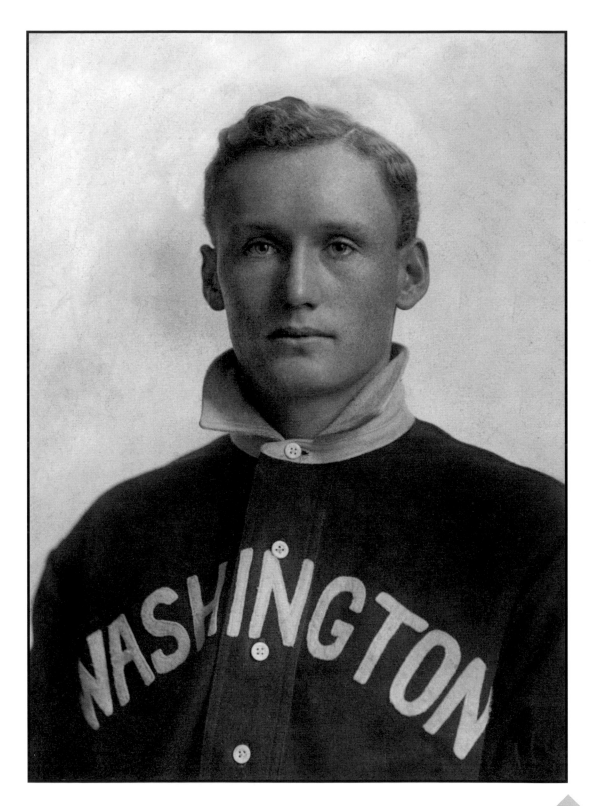

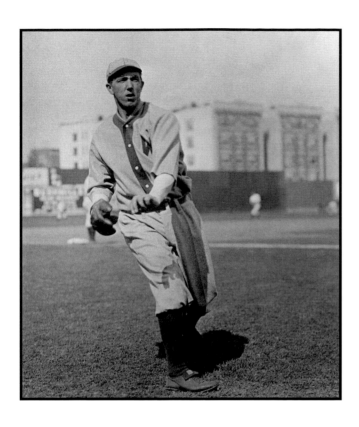

## William "Dolly" Gray
## Pitcher, 1909 - 1911

Dolly Gray was 30 years old when he made his major-league pitching debut with Washington in 1909. He came from the Pacific Coast League, where he had won 26 games the year before and 32 games the year before that. Washington's hapless bats did little to elevate Gray's career, but he did pitch some notable games for the Senators.

His rookie season, he and fellow pitcher Bob Groom threw 18 scoreless innings against the defending American League champion Detroit Tigers, only to have the game end in a tie and be called due to darkness. In 1910 he hurled three shutouts, but ended the season with a disappointing record of 8-19.

After three mediocre seasons with Washington, Gray returned to the PCL for parts of two seasons. He retired in California, where he operated a restaurant for 40 years until his death in 1956.

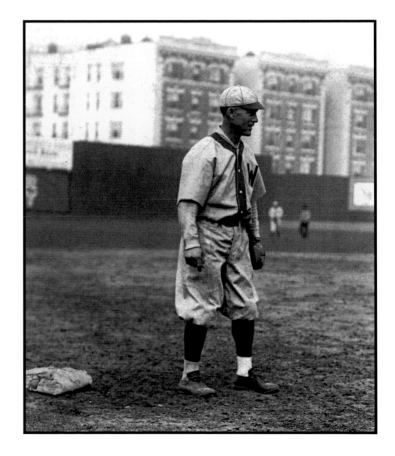

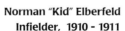

## Norman "Kid" Elberfeld
## Infielder, 1910 - 1911

Kid Elberfeld was fiery player whose small size and volatile temper made him a fan favorite everywhere he played. Nicknamed "The Tabasco Kid" for baiting umpires around the league, Elberfeld spent nine years in the American League with Detroit and New York before being sold to Washington in 1910 for $5,000.

At age 35, Elberfeld's best years were behind him. Still, he could coax a walk by crowding the plate and occasionally steal a base when needed. His 24 stolen bases in 1911 were a career high. With the arrival of new owner and manager Clark Griffith in 1912, Elberfeld was released to the minors. There he later began a long career managing and scouting, primarily in the Southern Association.

### Herman "Germany" Schaefer
### Infielder/Outfielder, 1909 - 1914

Germany Schaefer was one of the game's most colorful characters. Tales abound but one incident stands out from his days with the Detroit Tigers.

Schaefer shook things up in a 1907 game against Cleveland. He reached first base, advancing teammate Davey Jones to third. The third base coach signaled for a double steal, hoping to score Jones from third. When the Cleveland pitcher released the ball, Schaefer took off for second. But the catcher held onto the ball, not wanting to risk Jones scoring the winning run. At that point, Schaefer announced, "Let's do it again."With the next pitch, he raced back to first base, bewildering his teammates and the opposition. An argument with the umpire ensued, but since no rule existed to forbid a player from stealing first base, the play stood. The Cleveland catcher was so distraught that on the next pitch, when Schaefer broke for second, he threw wildly to second, allowing Jones to score from third. Schaefer slid safely into second base and the Tigers took the lead. Schaefer's only concern was petitioning the umpire for credit for three stolen bases.

Baseball later passed a regulation forbidding players from stealing bases in reverse.

### John Henry
### Catcher, 1910 - 1917

John Henry was a light-hitting catcher who spent his entire eight seasons in Washington as a back-up catcher, sharing duties behind the plate with Eddie Ainsmith, Walter Johnson's personal catcher. Henry's glove, not his bat, kept him on the roster. He never hit higher than .249 in a season and hit only two home runs in his major-league career.

In 1917, Henry tried to organize fellow ballplayers into a union, arguing for better pay and improved playing conditions. American League President Ban Johnson promised to run organizers like him out of the league. In the press, Henry called Johnson "crazy for power" and challenged his right to dictate policy. When the season ended, Henry was sold to Boston in the National League and retired a year later.

Henry spent 1920 as the varsity baseball coach at Cornell, then played several seasons in the minors. He later umpired in the minors for two seasons.

**George McBride**
**Shortstop, 1908 - 1920**
**Manager, 1921**

George McBride was the best American League shortstop of his era. He led the league in fielding for four straight years and double plays for six. He joined the Senators in 1908 and his flashy glove work anchored the infield for nine seasons.

By 1917, however, the 36-year old McBride was no longer an everyday player. He played sparingly while helping tutor young players. When owner Clark Griffith finally stepped aside as manager after the 1920 season, he named McBride as his replacement. In the middle of a mediocre first season, McBride had a freak accident. He was hit on the side of the head with a ball during infield practice and one side of his face was paralyzed, ending his season. McBride suffered a nervous breakdown and veteran outfielder Clyde Milan took over as manager.

McBride later coached with Detroit and even joined his old teammate, Walter Johnson, as a coach when Johnson managed Newark for one season in 1928. In retirement, McBride returned to his native Milwaukee and lived to be 92.

### Charles "Gabby" Street
### Catcher, 1908 - 1911

Gabby Street spent more than four decades as a player, manager and broadcaster, but he may be best remembered for a single catch while with Washington.

In August 1908, two fans persuaded Street to settle a bet. The men had wagered $500 on whether someone could catch a ball dropped from the top of the Washington monument. The two men took a basket of baseballs to the top of the monument and began tossing them over the side, one at a time. The first balls all hit the ground. On the 15th try, Street corralled the ball in his mitt and held it high over his head. The drop was estimated at 504 feet, a distance record that stood until 1930, when Chicago Cubs catcher Gabby Hartnett caught a ball dropped from the Goodyear blimp 550 feet overhead.

In 1938, that mark was bettered still by two Cleveland Indians players who each caught a ball dropped from the city's tallest building, the Terminal Tower, from a reported height of 708 feet.

Traded to New York after the 1911 season, Street later managed the St. Louis Cardinals and the St. Louis Browns. Beginning in 1945, he joined Harry Caray in the Cardinals radio booth until his death in 1951.

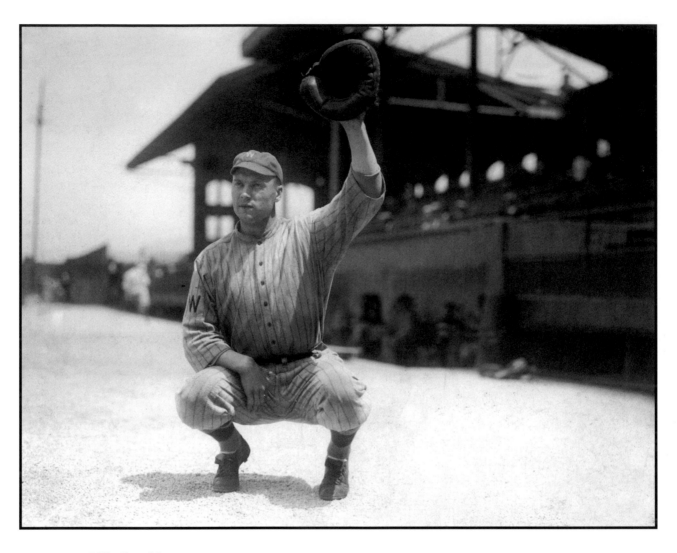

**Eddie Ainsmith**
**Catcher, 1910 - 1918**

In an era of tough ballplayers, Eddie Ainsmith may have been the toughest of the bunch. He had a chiseled physique, muscular hands and a readiness to brawl. One time, while playing for the Cardinals late in his career, he stood up to heckling from the New York Giants' dugout in dramatic fashion. Having heard enough, he dropped his catching gear at home plate, strode over to the Giants dugout and challenged manager John McGraw and his entire team to take him on. There were no takers.

Ainsmith joined Washington in 1910 at age 20. When manager Clark Griffith took over in 1912, he tapped Ainsmith over three others to catch Walter Johnson. "There really wasn't any other catcher who could hold me when I opened up with full speed," Johnson said later. For his part, Ainsmith found catching Johnson a joy, recalling "Johnson was not only the greatest

pitcher, but the easiest to catch. He had perfect control and the ball he threw was light as a feather."

The duo had a surprisingly simple system. "We only had two signs - for a fastball and a curve. He liked to get rid of the ball in a hurry, so when I threw the ball back to him, I would give him the sign by brushing my thumb across my chest protector. Thumb up for fastball, thumb down for a curve. I didn't worry about the other clubs getting my signs. What difference did it make?"

After nine years with Washington, Ainsmith, who was making $6,500 a year, asked for a raise. The Senators instead decided to trade him to Detroit for the 1919 season. He played another six seasons for four teams before retiring in 1924 at the age of 34.

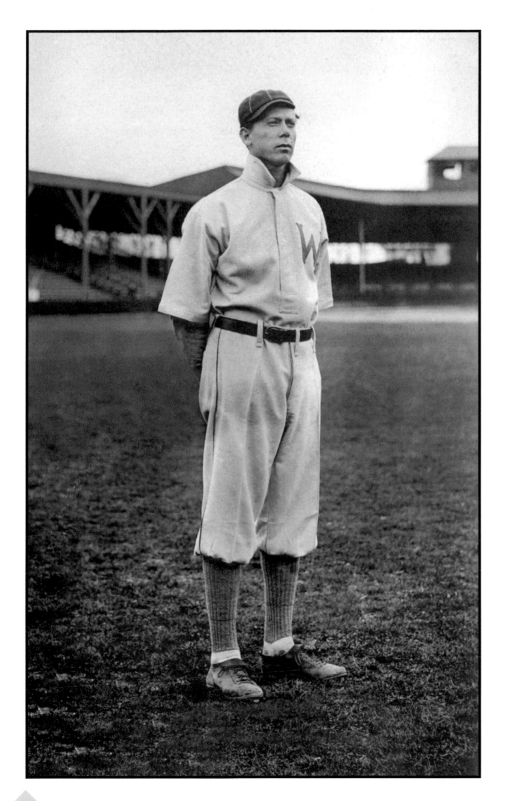

## Bob Groom
### Pitcher, 1909 - 1913

Bob Groom was a 20-game winner who threw a no-hitter, but his rookie season in Washington was anything but stellar. Groom joined Washington for the bargain price of $1,750 after winning 20 games in the minors three years in a row. But as a rookie, he stunk. He lost 26 games and led the league in walks.

Over time, however, Groom developed a devastating overhand curveball and by 1912, his 24 victories were second on the team only to Walter Johnson. He threw 316 innings that year, including 28 complete games. He also struck out 179, the fifth highest total in the American League. When Groom won 15 games in 1913, the team's ownership tried to cut his salary. He refused and left to join the new Federal League, where he spent two seasons pitching for the St. Louis Terriers. When that league folded, he moved across town to the St. Louis Browns in 1916. There he tossed a no-hitter against the Chicago White Sox on May 6, 1917.

After one final season with Cleveland in 1918, Groom retired and went into the coal business in Illinois.

## Clark Griffith
### Manager, 1912 - 1920

Clark Griffith, 42, became manager of the Senators in 1912 after purchasing a 10 percent share of the team. When he took over, the club had not had a winning season in its first 11 years and had never finished higher than sixth place.

Griffith quickly decided to overhaul a roster full of older players. He released several veterans and brought in young talent from the minors. His best move was buying a 24-year-old first baseman named "Chick" Gandil from Montreal for $12,000. Gandil would hit .305 and power the offense. In early June, the club reeled off 17 straight wins.

Griffith stressed speed and the club, led by outfielder Clyde Milan's 88 thefts, led the league with 274 stolen bases. The pitching staff, highlighted by Walter Johnson's 32 wins and Bob Groom's 24 victories, would win the league's ERA crown and lead the league in strikeouts. The result was 91 wins and a second-place finish. Griffith's continued infusion of talent resulted in 90 wins the next year and another second place finish. He also began mixing up the way he used his ace, Walter Johnson. Instead of starting Johnson every four days, he began calling on Johnson to relieve whenever a game was on the line.

The team's success brought a big boost to the gate. Griffith happily used the increased revenue to scout and sign more talent. Griffith's nine seasons as manager never secured a pennant for the nation's capital, but the team was no longer considered the doormat of the American League. The changes he made in talent and tactics ensured that better days were just ahead.

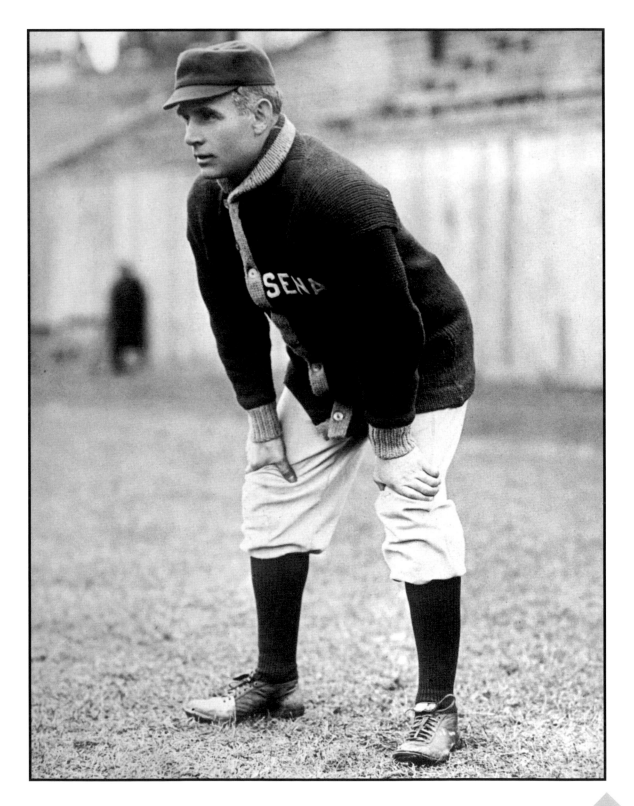

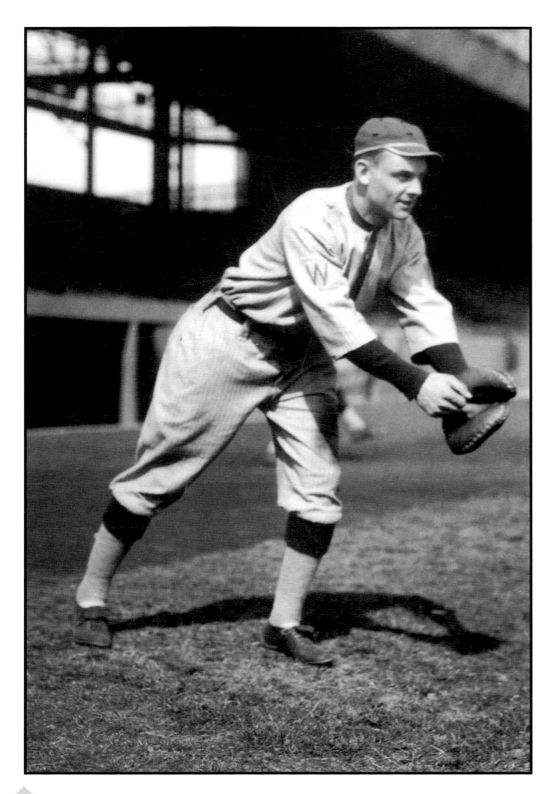

### Charles " Chick " Gandil
### First baseman, 1912 - 1915

Chick Gandil is best remembered for being one of the eight Chicago White Sox players who fixed the outcome of the 1919 World Series, receiving a lifetime suspension from baseball.

Gandil's arrival in Washington in May 1912 gave the team the two things they were sorely lacking - a graceful fielding first baseman and a power hitter capable of driving in runs. His first year with the club, Gandil hit .305. The next year, he hit .318. He also led the team in RBI for two straight seasons.

But Gandil was a hell raiser off the field. A former professional boxer, who'd played ball in outlaw leagues all over the States and Mexico, Gandil ran with a rough crowd. For one thing, he insisted on smoking in the dugout between innings, a violation of team rules. When Manager Clark Griffith threatened to fine him $10 for every offense, Gandil demanded a trade. Griffith had rookie Joe Judge ready to take over at first, so he accepted Cleveland's $5,000 offer and shipped Gandil to the Indians. A year later, Cleveland sold Gandil to the White Sox.

After the 1919 World Series, the 31-year-old Gandil never played in the major leagues again. He lived out his days in California working as a plumber. When he died in 1970, his wife kept it a secret from the press for more than two months for fear of what they would write about him.

## Smokey Joe Wood and Walter Johnson
## Fenway Park, 1912

Three pitchers posted record-setting winning streaks in 1912.

In the National League, "Rube" Marquard of the New York Giants set a new major league record with 19 straight wins. In the American League, Walter Johnson ran off 16 straight victories between July 3 and August 23. And up in Boston, Red Sox ace "Smoky Joe" Wood was closing in on Johnson with 13 consecutive wins.

So it was on September 6, when Johnson was scheduled to pitch in Boston. Washington manager Clark Griffith told the press that Wood's streak was meaningless unless he defeated Johnson head-to-head to keep it alive. Red Sox Manager Jake Stahl responded by moving Wood up a day in the rotation to face Johnson in a challenge match. The press went into a frenzy publicizing the dream match-up: Johnson's 29-9 record versus Wood's 29-4 mark and 13 straight.

So many people showed up at Fenway that the overflow crowd had to be roped off behind the outfield. Near the dugouts, the crowd closed in, barely giving the two pitchers enough room to warm up. Johnson allowed five hits that day and struck out five. Wood allowed six hits but struck out nine. In the end, Wood and the Red Sox won, 1-0. A pair of doubles in the sixth inning brought home the lone run.

Wood's winning streak ended at 16, tied with Johnson's.

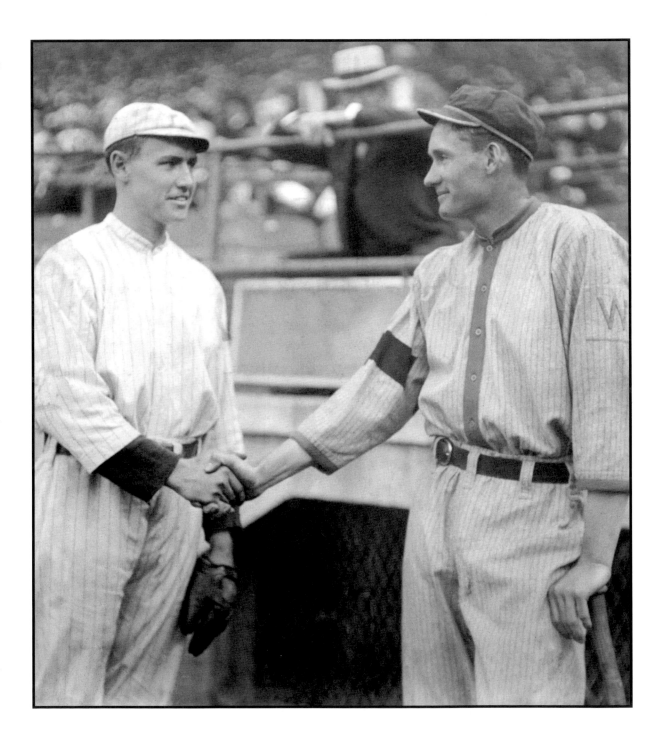

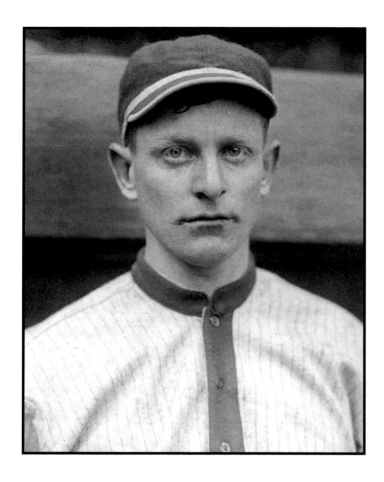

## Joe Gedeon
## Infielder/Outfielder, 1913 - 1914

Joe Gedeon was suspended for life by Commissioner Kennesaw Mountain Landis for his knowledge of the fixing of the 1919 World Series.

Brought to the majors at the age of 19, Gedeon played 30 games for Washington over two seasons. He could play a variety of positions, but couldn't hit. After Washington released him, he spent five seasons playing second base for the Yankees and Browns.

When news of the Black Sox scandal broke in 1920, Gedeon was one of a number of players on other teams who said they had advance knowledge of the deal. He was called before the grand jury in Chicago, where he said he learned the details from gamblers in St. Louis. Later, when White Sox owner Charles Comiskey offered $10,000 for proof of the fix, Gedeon stepped forward to claim the reward. Landis suspended him for life, along with several other players, claiming their advance knowledge made them guilty, too.

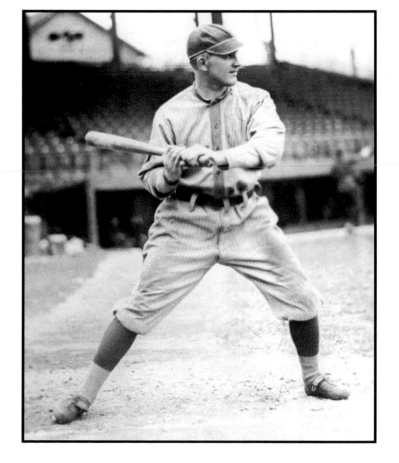

## Ray Morgan
## Infielder, 1911 - 1918

Ray Morgan was one of the group of young infielders Clark Griffith installed during his first season as manager in 1912. Morgan spent four seasons playing with fellow rookies Eddie Foster and Chick Gandil, and together, they placed Washington among the leaders in fielding percentage in the American League.

In 1915, however, Morgan missed two months of the season because of injuries sustained in an automobile accident. When it happened a second time in 1918, word began circulating that Morgan was spending too much time out drinking with hometown friends in nearby Baltimore. Manager Griffith evidently agreed as he suspended Morgan and eventually waived him to the Phillies. Morgan refused to report to Philadelphia and was sold into the minors. He was out of professional ball by 1920. He later ran a café in Baltimore.

## Joe Boehling
### Pitcher, 1912 - 1916

Joe Boehling's first full season in the majors was his best. Former pitcher and Washington coach Nick Altrock took Boehling under his wing early on and tutored him on the finer points of mound work. In 1913, Boehling won 17 games, including 11 straight to start the season. Perhaps the strain of pitching 235 innings at age 22 caught up with him because the next two years were less than stellar: 12-8 and 14-13.

During four seasons with Washington, Boehling won 52 games. Midway through the 1916 season, he was traded to Cleveland, where he won only three games before being sent to the minors. He later retired to his native Richmond and ran a feed store with his brother until his death in 1941 at age 50.

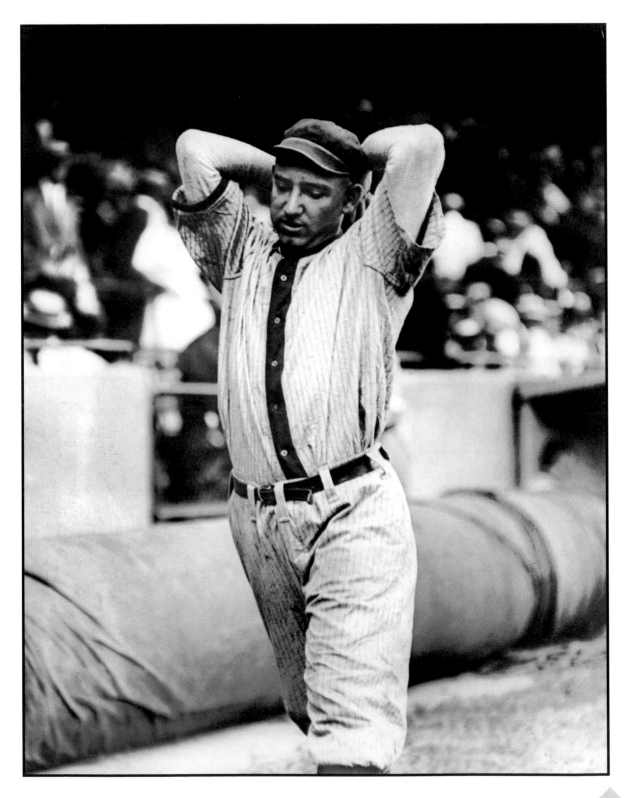

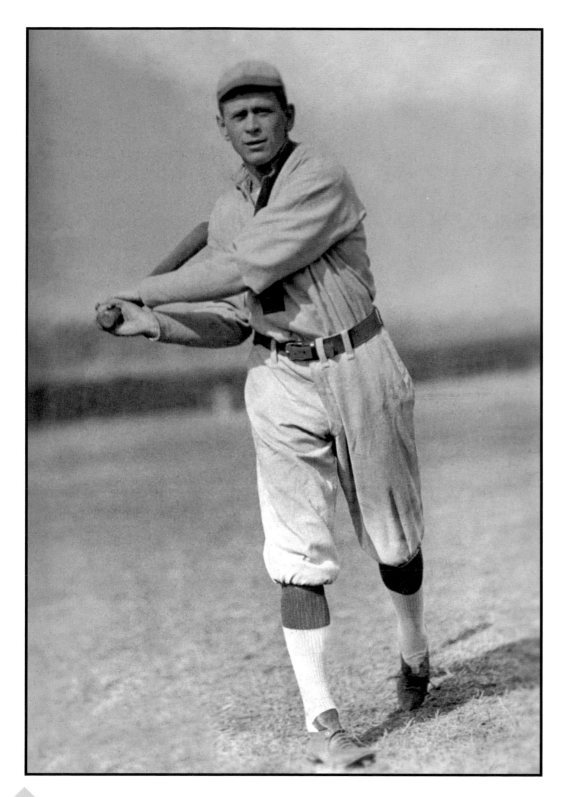

### Danny Moeller
### Outfielder, 1912 - 1916

Danny Moeller was a speedy daredevil who made acrobatic catches in right field, but a chronic shoulder problem cut short his career.

Moeller's left shoulder would dislocate at the slightest movement. The problem was so severe that noted baseball fan, President William Howard Taft, asked his chief army surgeon to operate on Moeller and fix the underlying problem.

A bad shoulder didn't slow him on the base paths, however. In 1913, the Senators ran wild and racked up 287 stolen bases, a mark not surpassed until 1976. Washington's Clyde Milan's 75 thefts and Moeller's 62 stolen bases ranked one-two in the league. However, Moeller also led the American League with 103 strikeouts, dropping his batting average to .236.

Traded to Cleveland midway through the 1916 season, Moeller was back in the minors the next year. He spent fours years there before retiring in 1921. He moved to Memphis and went into the auto parts business.

## Eddie Foster
### Third baseman, 1912 - 1919

Eddie Foster was nicknamed "the Kid" because of his small size, but he was better known for his flashy glove work that anchored the left side of the Senators' infield for eight years.

Purchased from Rochester with teammate Danny Moeller, Foster was part of the "kiddie corps" installed when manager Clark Griffith overhauled the roster for the 1912 season. Foster proved an immediate success, batting .285 as a rookie and providing Washington with stellar defense. Despite standing only five-foot-six and 145 pounds, Foster was extremely durable, playing every game in four of his first five seasons.

His success at the plate led Griffith to call Foster the best "run and hit" batsman since Hall of Famer Willie Keeler, whom Griffith had played with and later managed. Griffith was so sure of Foster's ability to hit the ball where he wanted that he'd start the base runner from first to gain an advantage.

Foster also was fast on the base paths, stealing 20 or more bases in six of his eight seasons with Washington. In 1916, in a game against the Philadelphia A's, he broke up pitcher Eddie Plank's no-hitter with two outs in the ninth inning.

By 1919, however, Foster was 31 and slowing down. Griffith traded him to the Boston Red Sox for veteran outfielder Braggo Roth, who drove in 92 runs for Washington in his only season with the team. Foster played parts of another four seasons in the American League before retiring in 1923.

In 1937, Foster was killed when his car was struck by a hit-and-run driver in suburban Maryland.

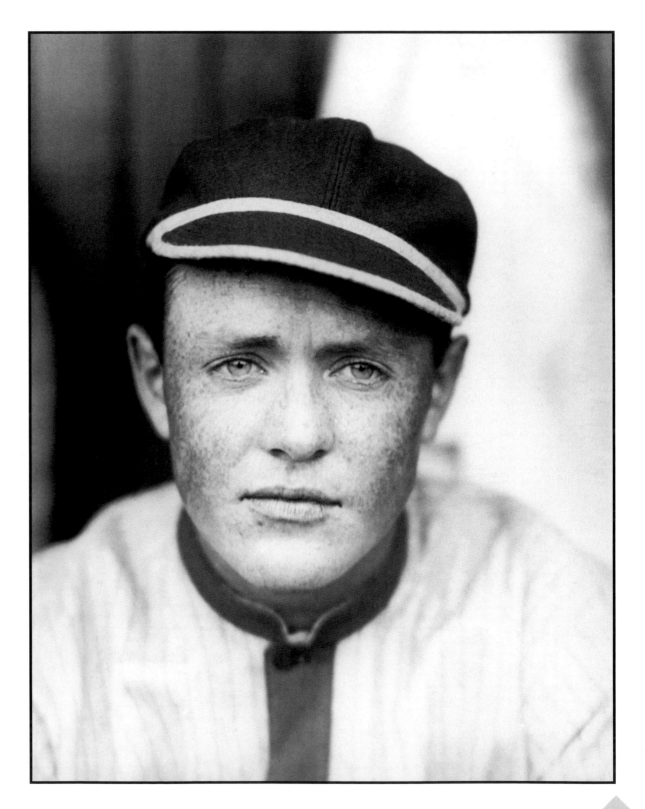

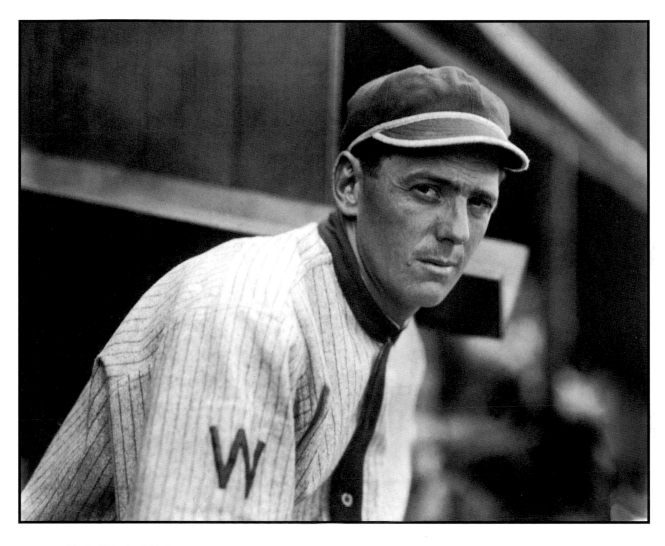

**Clyde "Deerfoot" Milan**
**Outfielder, 1907 - 1922**
**Manager, 1922**

Clark Griffith called Clyde Milan the greatest centerfielder in franchise history.

Milan was 20 and playing for Wichita when Washington manager Joe Cantillon spotted him during an exhibition game against the Senators. He was signed for $1,250 on the same scouting trip that netted Walter Johnson. The two roomed together on the road over the next 14 years.

Exceptionally quick, Milan used his speed to play a shallow centerfield, preferring to run back on fly balls. He also twice led the league in stolen bases. He stole 495 bases with Washington, tops in franchise history.

Ty Cobb was Milan's chief rival as a base stealer. A year after Cobb broke the single-season record with 83 steals, Milan stole 88 in 1912. After Cobb stole 96 bases in 1915, Milan later recalled, "Ty was tops. He had the nervous foot of the born stealer. He never liked the base he was on. I was geared the same way. The bag ahead always looked more attractive."

In 1922, Milan was named manager of the club after George McBride's accident, but his tenure was short. A sixth-place finish was followed by a trip to the minors, where he played another four seasons before becoming a full-time manager. He alternated between coaching with the Senators and managing in the minors for the next decade until he returned to Washington for good in 1938.

In 1953, Milan was hitting fungoes during spring training in Orlando when he suffered a heart attack and died in the team's clubhouse.

## Jim Shaw
### Pitcher, 1913 - 1921

Pitcher Jim Shaw was nicknamed "Grunting Jim" because of the noise he made when he released the ball, a sound that could be heard up in the grandstands.

His rookie season, Shaw threw 257 innings, won 15 games and led the American League in walks allowed. But a hunting accident cost him nearly half of the 1916 season. He was hunting deer in the off-season near his home in western Pennsylvania when his shotgun discharged, striking him in the shoulder and neck. His hunting companion carried him more than a mile to a nearby farmhouse, where he was rushed to a Pittsburgh hospital by train.

Healthy again, Shaw led the league in walks allowed for the 1917 season. Over the next three years, his record barely surpassed .500, but he continued to eat up a lot of innings. He led the league in innings pitched in 1919. A hip injury forced him to retire early in 1921. Shaw stayed in the Washington area and became an inspector for the Internal Revenue Service.

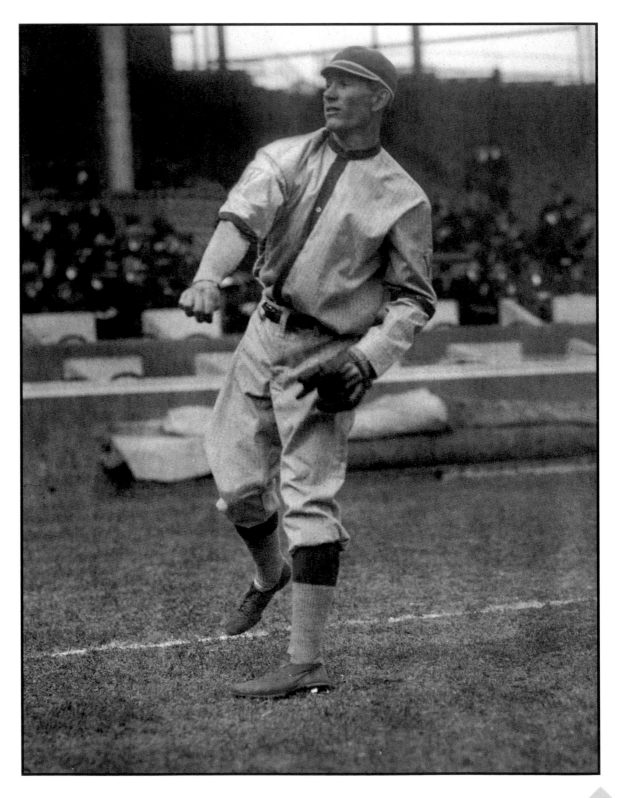

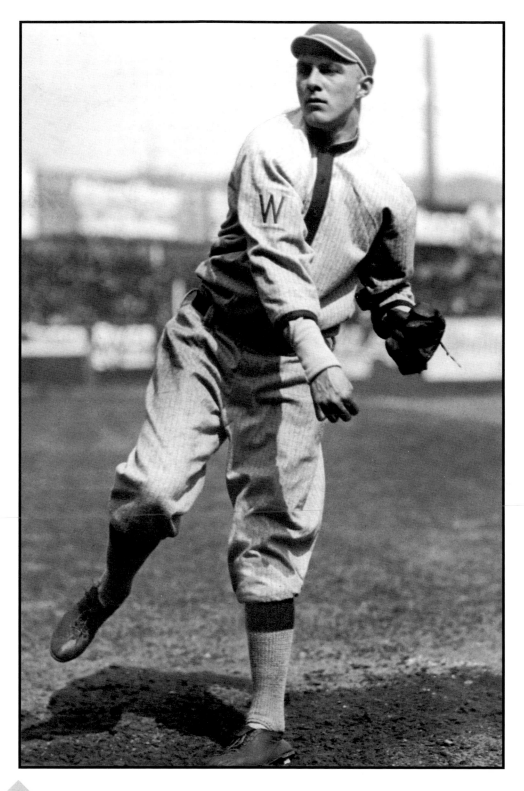

## Joe Engel
### Pitcher, 1912 - 1916

Long before Joe Engel became known as the man who brought the circus to the minor leagues, he was a pitcher, briefly, for Washington.

He got his start during a conversation at Engel's beer hall on E Street, run by his father and located right next door to *The Washington Post*. Not infrequently, a few sportswriters joined Senators manager Clark Griffith there to toss back a few steins. On one such occasion, it was revealed that Engel's 18-year-old son, Joe, was a pitcher of some note, having amassed a stellar record at Mount St. Mary's College in nearby Emmitsburg, Maryland. Desperate for pitching help, Griffith invited young Engel to spring training.

Engel proved to be a big, strong right-hander who threw hard, but had trouble finding the plate. He walked more batters than he struck out. The only team he seemed able to beat was the St. Louis Browns. Five of his eight wins in 1913 came against St. Louis. During one 12 day stretch, Engel defeated the Browns with three consecutive complete games, two of them shutouts. More amazingly, he allowed a total of seven hits over 27 innings. His inability to throw strikes got Engel shipped to the minors in 1915. After bouncing around for the next four seasons, he returned to Washington and became Griffith's lone talent scout.

On the road hunting talent, Engel developed a reputation as a first class wheeler-dealer. In 1919, he signed Bucky Harris from Buffalo for $2,500. In 1921, he signed Ossie Bluege and Goose Goslin. Over the next decade, he scouted and signed Firpo Marberry, Earl McNeely, Buddy Myer and Joe Cronin. His scouting talent built the nucleus of Washington's pennant-winning teams of 1924, 1925 and 1933.

In 1930, Griffith purchased the Chattanooga franchise in the minor league Southern Association and appointed Engel team president. Engel built a state-of-the-art, brick-and-steel stadium and continued scouting for Washington. In Chattanooga, Engel became known as the "Barnum of the Bushes" for his wild promotional stunts. During the height of the Depression, he gave away a fully furnished house and new cars to lucky ticket holders. He staged opening-day parades with circus animals and once traded a shortstop for a 25-pound turkey that he fed to visiting sportswriters. Over the next 30 years, the Chattanooga franchise was the Senators' top farm club, preparing dozens of players for the major leagues.

**Edward "Patsy" Gharrity**
**Catcher/First baseman,**
**1916 - 1923; 1929 - 1930**

Patsy Gharrity became Walter Johnson's personal catcher when Eddie Ainsmith was traded to Detroit after the 1918 season. For three years, Gharrity was the team's starting catcher. He could also play a respectable first base.

In 1923, when his batting average dropped dramatically, Gharrity accepted an offer to return to his native Wisconsin and play for a local industrial-league team. The decision meant he missed playing in two consecutive World Series and didn't see a dime of the bonuses that his teammates received for winning the 1924 and 1925 American League pennants.

In 1929, Gharrity rejoined Washington as a bullpen catcher and eventually coached under his old teammate, Walter Johnson. The two spent three years together in Cleveland when Johnson managed the Indians. Gharrity later worked for two seasons as an umpire and as a minor-league manager for two more.

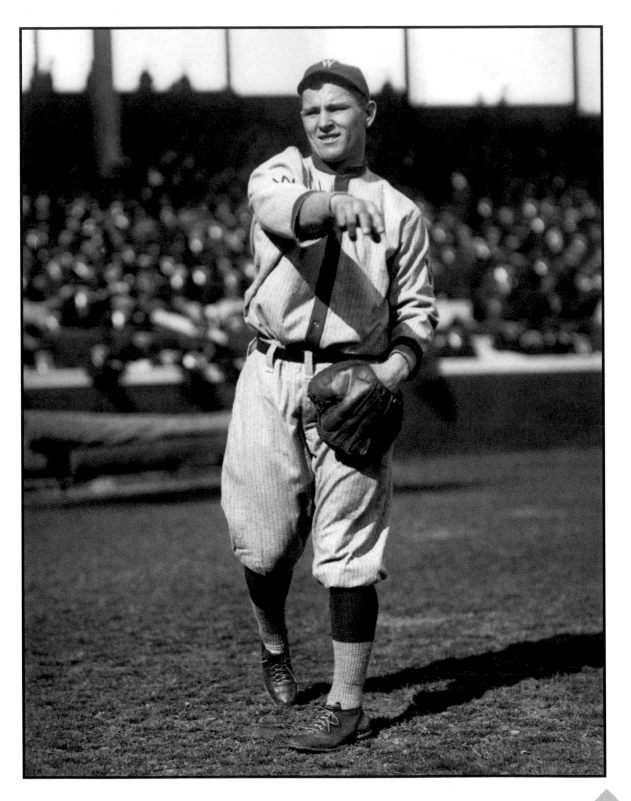

**Walter Johnson's pitching grip**

This is the right hand that terrorized American League hitters for 20 years, no year tougher than 1913.

That year Johnson, 25, put together one of the most dominating pitching performances of the 20th Century. He won 36 games and threw 11 shutouts. Five of his wins were one-hitters and Johnson led the majors in innings pitched and strikeouts. No one else even came close. During one stretch in April and May, he threw 56 straight scoreless innings, a record that stood for 55 years until Don Drysdale broke it in 1968. Additionally, Johnson's ERA was 1.14, a mark bettered only once in the last 90 years - by the Cardinals' Bob Gibson, also in 1968.

Johnson's 1913 season was all the more remarkable because he pitched for a team that ranked near the bottom of the American League in most offensive categories.

For all his excellence, Johnson was paid an annual salary of $7,000. He would soon discover that he was worth a lot more.

## Walter Johnson
## Polo Grounds, New York

The career statistics compiled by Walter Johnson almost defy description.

By the time he retired, Johnson had won 417 games, second only to Cy Young. He won 20 or more games for 10 straight seasons. He threw 110 shutouts, a mark that will never be equaled. He threw 531 complete games, the most by any pitcher in the 20th Century. His 5,923 innings pitched are the most ever in the history of the American League.

Johnson's single-season accomplishments also stand out. In 1908, he threw three complete-game shutouts in four days against the New York Highlanders, a feat he later told *The Sporting News* was his greatest personal achievement.

In 1918, he threw 18 shutout innings against the Chicago White Sox, an endurance record that has never been surpassed. Johnson also had three complete seasons in which he didn't give up a single home run. His 371 innings in 1916 without a single four-bagger remain the gold standard in this category.

In 1920, Johnson hurled the only no-hitter of his career. Facing the Boston Red Sox at Fenway Park on July 1, he struck out 10 and walked none. He lost his chance for a perfect game, however, when second baseman Bucky Harris misplayed a routine ground ball in the seventh inning.

However, Game 7 of the 1924 World Series would provide Johnson with his greatest moment in the spotlight.

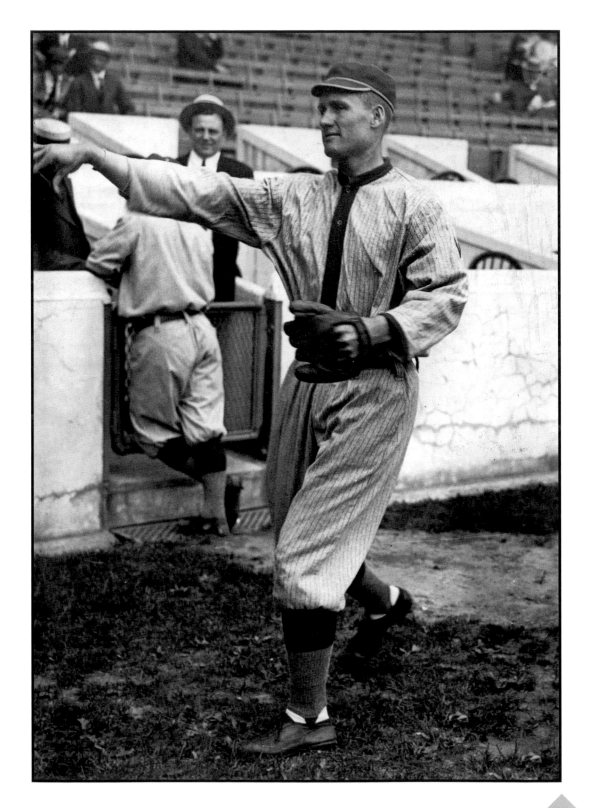

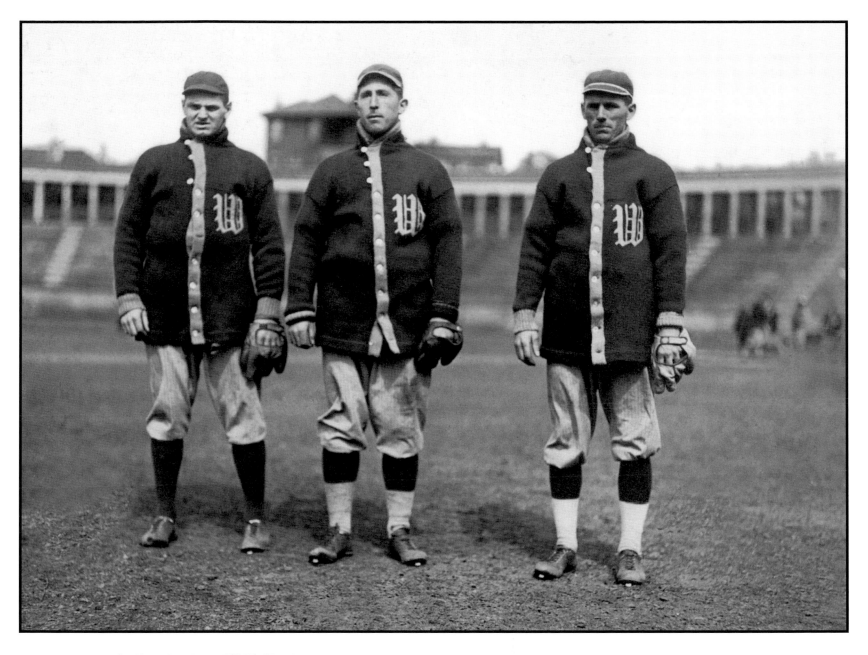

**Jim Shaw, Doc Ayers, Bill "Bird Dog" Hopper**
**Spring Training, 1915**

The Senators' pitching staff won the American League ERA title in 1915. Besides Walter Johnson winning 27 games, the team's hurlers led the league in shutouts and strikeouts. But the team's weak offense limited the Senators to a fourth-place finish. The team hit only 12 home runs that year, the lowest total in the American League.

Shown above at Charlottesville, Virginia, are pitchers Jim Shaw, who won 15 games in 1914, but only six in 1915; Yancy "Doc" Ayers, who won 14 games; and Bill Hopper, who pitched in relief.

### Howard "Hank" Shanks
### Outfielder/Infielder, 1912 - 1922

Hank Shanks' strong throwing arm and versatility kept him in the Washington line-up for 11 seasons.

He was 21 when Clark Griffith brought him to the majors in 1912. An aggressive fielder, Shanks gained fame for his hustle. In one noted game in Chicago, he backed up a play in which a runner was caught off third. Shanks raced in from leftfield, grabbed an errant throw and ran down another base runner between first and second. Then he threw to the plate in time to get the first base runner trying to score from third. Even Chicago fans stood and applauded the play.

After three seasons as the everyday left fielder, Shanks was moved to the infield, alternating between shortstop and third base. His best year was 1921 when he hit a career high .302 and his 19 triples led the American League. The arrival of veteran shortstop Roger Peckinpaugh left Shanks without a position and he was traded to the Red Sox in 1923.

Released during the 1925 season, Shanks played three years in the minors. He later coached with the Cleveland Indians for four-plus years before returning to the minors as a manager.

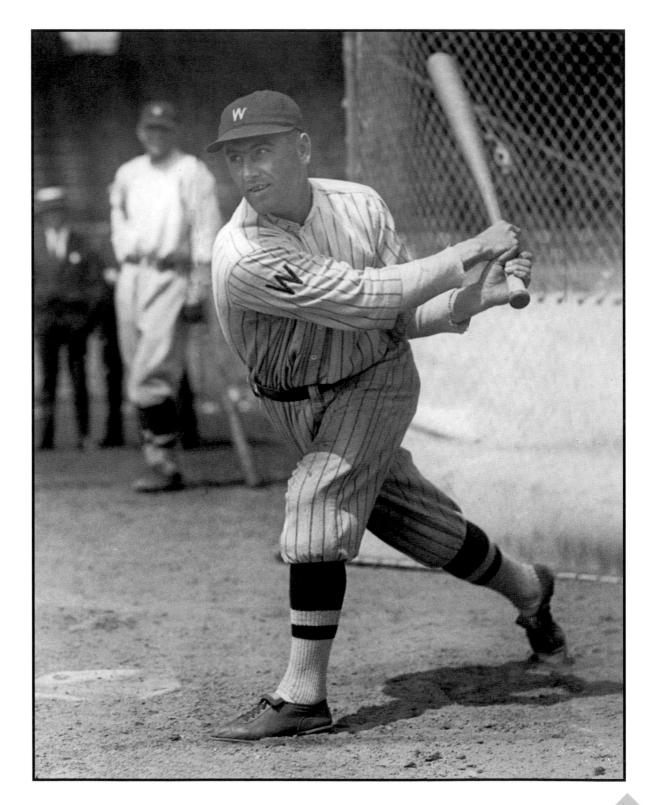

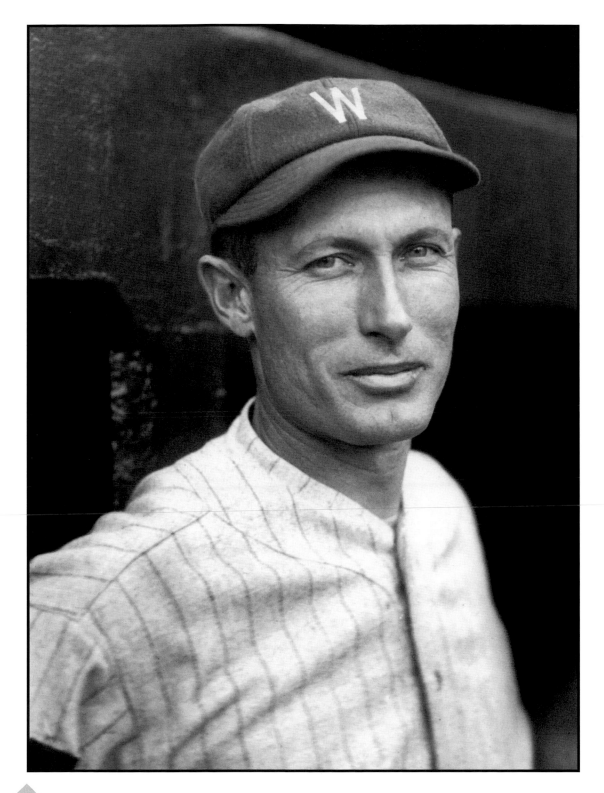

### Edgar "Sam" Rice
### Outfielder, 1915 - 1933

Outfielder Sam Rice ended his career with almost 3,000 career hits so it's understandable that people would forget he made his Senators debut as a pitcher whose right fielder was Walter Johnson.

Or that his given name wasn't Sam, it was Edgar. Owner Clark Griffith signed him sight unseen out of the Virginia League and when sportswriters asked his name, Griffith told them Sam. The unassuming Rice never bothered to correct the record.

Rice threw about 40 innings for Washington before becoming the team's everyday right fielder because of his batting prowess. He was an outfield fixture for 16 years, helping lead the franchise to three American League pennants. His strong arm and ability to run down anything hit his way were legendary. At the plate, Rice had six seasons with over 200 hits and in 1924 and 1926 led the American League in that category. In 1924, he hit safely in 31 consecutive games.

Rice's speed was his greatest asset. His 346 career steals rank second in franchise history. He remains the franchise's career leader in singles, doubles and triples.

For all his achievements on the field, Rice may be best remembered for two closely guarded secrets he carried for years. The secrets involved the death of his family and a pivotal catch made in Game 3 of the 1925 World Series. It would be more than 40 years before the world learned the first and 50 years before Rice revealed the truth about the second.

### Joe Judge
### First baseman, 1915 - 1932

Joe Judge's graceful glove work made him a Washington fixture at first base for nearly two decades, but he joined the Senators almost by accident.

In 1915, owner Clark Griffith went to Buffalo to look at outfielder Charlie Jamieson. With the price tag for Jamieson firmly fixed at $7,000, Griffith asked that Judge be thrown into the deal. Jamieson would be gone from Washington 101 games later, but Judge would help form one of the greatest infields of any era.

Along with Ossie Bluege, Bucky Harris and Roger Peckinpaugh, Judge's talent at first base earned him rave reviews. He led the American League in fielding percentage for nine straight years. And he preserved Walter Johnson's lone no-hitter in 1920 by spearing a line drive off the bat of Boston's Harry Hooper. Judge later recalled, "Walter was so overjoyed at that play that he jumped on my back and road me off the playing field. I was so delighted I never realized what a big fellow I was carrying." Johnson weighed 210 pounds, Judge 155.

Judge was a steady and dependable hitter who hit over .300 ten times. In the 1924 World Series against the New York Giants, he hit .385 to help lead the team to its only championship. In 1931, he missed almost the entire season because of a bout of appendicitis. But it was the arrival of rookie Joe Kuhel, purchased from Kansas City for $60,000, that put an end to Judge's time in Washington. He was traded to Brooklyn that off season and retired early in 1934.

### Stanley "Bucky" Harris
### Second baseman, 1919 - 1928
### Manager, 1924 - 1928; 1935 - 1942

Bucky Harris' nine seasons at second base marked the beginning of Washington's golden era of baseball. His leadership on and off the field revitalized the franchise and gave Washington back-to-back American League pennants. Nicknamed "the Boy Manager" when Griffith named him skipper in 1924, the 27-year-old Harris became the youngest manager in either league.

But Harris hadn't even been Clark Griffith's first choice as manager. Griffith was angry that Harris had defied his advice and spent three consecutive off-seasons playing professional basketball to supplement his income. As the 1924 season approached, Griffith quietly started talks with another second baseman, White Sox veteran Eddie Collins. Harris wasn't offered the manager's job until March, when he was already in camp in Florida. Eager to prove he was up to the challenge, Harris sent Griffith four telegrams confirming his acceptance of the offer.

Expectations in Washington were low, given that the Senators finished 1923 with a losing record and in fourth place. Still, when Washington got off to a mediocre start, the press began referring to Harris as "Griffith's folly."

Slowly, however, the team began to find its stride and a 10-game winning streak in late June put Washington atop the American League standings. By late August, they were in first place to stay.

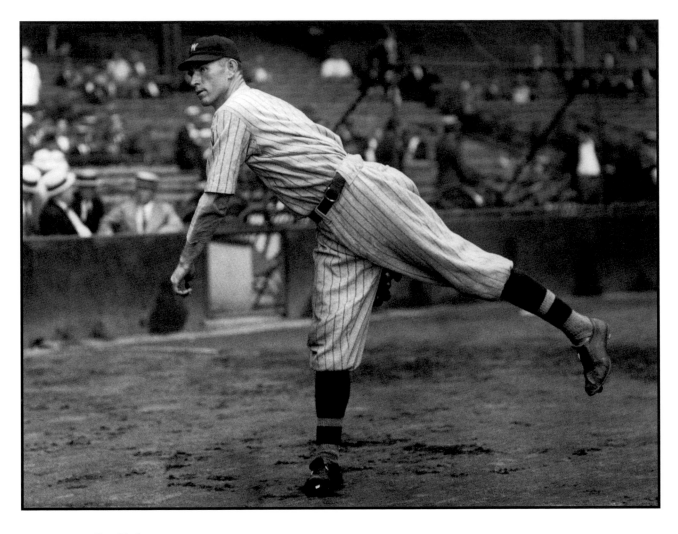

**Tom Zachary**
**Pitcher, 1919 - 1925; 1927 - 1928**

Tom Zachary won two games for Washington in the 1924 World Series, but he is best remembered for giving up Babe Ruth's 60th home run in 1927.

Zachary never played in the minor leagues, a rarity for his day. Signed out of college by the Philadelphia Athletics in 1918, Zachary pitched under an assumed name to protect his college eligibility. He won two games for the Athletics before leaving to serve in Europe at the end of World War I. With the war over the next year, Zachary came back and joined Washington, where he won 85 games over the next six years.

In the 1924 World Series, Zachary won Game 2 to even the series. More importantly, when the Senators trailed New York, three games to two, Zachary held the Giants to one run and won Game 6.

After the 1925 season, Washington traded Zachary to the St. Louis Browns for veteran pitcher Joe Bush. It was a bad deal. Bush went 1-8 for Washington and was traded before the season was over. Zachary, on the other hand, won 14 games for the seventh-place Browns.

Washington owner Clark Griffith reacquired Zachary from the Browns halfway through the 1927 season, but it soon seemed the pitcher's glory days were behind him. Pitching at Yankee Stadium on the next to the last day of the season, he gave up Ruth's historic 60th home run.

In 1928, Zachary had won only six games by August and was released. Picked up by the New York Yankees on waivers, Zachary surprised everyone by throwing a complete game victory in Game 3 of the 1928 World Series. Better yet, he went 12-0 the next season and continued pitching in the majors for another eight years.

Finally, at age 40, he retired to North Carolina and became a tobacco farmer.

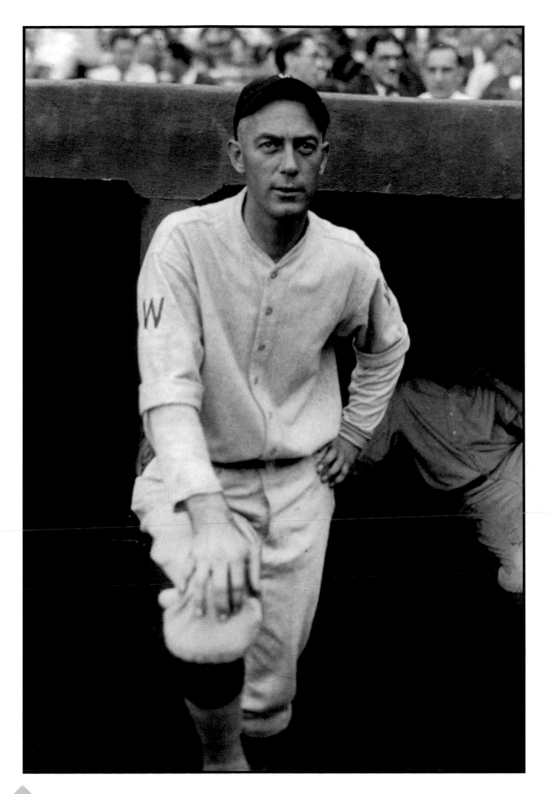

### George Mogridge
### Pitcher, 1921 - 1925

George Mogridge came to Washington after six seasons with the New York Yankees, where he threw the second no-hitter in team history. Mogridge had an immediate impact on the Senators, winning 18 games in each of his first two seasons.

He also had a little secret that helped his success. In 1920, after Cleveland Indians batter Ray Chapman was killed by a pitch, the American League prohibited pitchers from doctoring the ball with any foreign substance, including rosin, which helped absorb perspiration from the throwing hand.

Mogridge knew that the only part of the uniform not affected by perspiration was the bill of a player's cap, so he kept some rosin under the brim, where he could re-supply his fingers with a simple touch. Opposing managers and hitters complained, but no one could discover the source of his success. The league even sent his uniforms to the lab and had his gloves cut apart to find his hiding place. The one thing they never checked was his cap.

After Mogridge was traded to the National League, Commissioner Landis cornered him in spring training and demanded to know his secret. Mogridge told Landis that he might find himself back in the American League some day and so refused to tell. Landis assured him that if that ever happened, he would forget the two ever spoke. Mogridge relented and revealed his secret.

In 1928, the year after Mogridge's final season in the majors, the American League once again began allowing pitchers to use rosin.

### "Oyster Joe" Martina
### Pitcher, 1924

Joe Martina spent 20 years pitching in organized baseball, but only one year in the majors.

Martina was a star in the Southern Association, twice winning 20 or more games for his hometown team, the New Orleans Pelicans. He was also extremely durable. In 1919, Martina led the Texas League with 28 wins and threw an astronomical 378 innings. During one season with New Orleans, he pitched both games of a doubleheader, winning the first and throwing 12 scoreless innings in the second against future Senators star hurler Earl Whitehead, then pitching for Birmingham.

Nicknamed "Oyster Joe" because he worked in his family's oyster business during the off-season, Martina was almost 35 by the time he got his start with Washington. He went 6-8 for the Senators, threw eight complete games and helped the franchise to its only championship. He threw a single scoreless inning of relief in the 1924 World Series.

Returning to New Orleans in 1925, Martina twice won 23 games and at age 38, threw 275 innings. He retired after the 1931 season and later worked as a beer salesman for a local brewery in New Orleans.

### Leon "Goose" Goslin
**Outfielder, 1921 - 1930; 1933, 1938**

Goose Goslin was one of the greatest sluggers ever to play for Washington. He started his career as a pitcher, but a minor league manager moved him to the outfield to get his bat in the everyday lineup. At age 20, Goslin's .390 batting average caught the eye of Baltimore owner Jack Dunn, known for signing Babe Ruth in 1914.

In Baltimore one day, Washington owner Clark Griffith overheard Dunn bragging about a hot young prospect down south named Goslin, who he planned to sign for $5,500. Griffith stood up, left the ballpark and caught the next train to Columbia, S.C., to see for himself. He promptly signed Goslin for $6,000 and had him join Washington for the final two weeks of the 1921 season.

The next year, his first full season, Goslin batted .324 and in 1923, his 18 triples led the American League. The next season he led the league with 129 runs batted in. It was the first of Goslin's 10 seasons with more than 100 runs batted in.

Though he often turned the pursuit of fly balls into an adventure, Goslin's prowess at the plate made him one of the most feared hitters in either league. He was at his best in big games. In both the 1924 and 1925 World Series, Goslin hit three home runs. And in 1928, he won the American League batting title with a .379 average.

With this kind of performance, it would be hard for Washington fans to imagine that Goslin would be gone in just 18 months.

## Roger Peckinpaugh
### Shortstop, 1922 - 1926

Roger Peckinpaugh was the premier shortstop of his day in the American League.

Playing with a young Bucky Harris at second and rookie Ossie Bluege at third, the veteran Peckinpaugh anchored the infield for Washington's pennant-winning run. His first year with the Senators, he helped set a new American League record for double plays with 168. Bluege remembered Peckinpaugh barking, "Get your tail back towards the line, kid. I'll handle the stuff around here."

In the 1924 World Series against the New York Giants, Peckinpaugh was a star. In the ninth inning of Game 1, he hit a double that knocked in the tying run. In the bottom of the ninth in Game 2, he drove home the winning run. In the ninth inning of Game 6, his glove saved the day. With the tying run on first and Washington clinging to a 2-1 lead, Peckinpaugh ranged far behind second base and snared a rocket shot off the bat of the Giants' Irish Meusel. His gloved toss to Bucky Harris at second just nipped the advancing base runner and preserved a Washington win. But the play came at a cost. Peckinpaugh collapsed with torn muscles in his left leg. Blood stained his uniform pants and he had to be helped off the field.

Peckinpaugh rebounded to have his greatest season ever in 1925. He hit .294 and was named the Most Valuable Player in the American League. But his eight errors in the 1925 World Series against the Pittsburgh Pirates saw him branded a "goat" in the press.

At age 35, he was no longer up to playing every day and Washington traded him to the White Sox after the 1926 season. Peckinpaugh later managed the Indians for seven years and became their general manager in 1942.

**Ossie Bluege**
**Third baseman, 1922 - 1939**
**Manager, 1943 - 1947**

Ossie Bluege spent 18 years in the major leagues, all of them with Washington where owner Clark Griffith called him the greatest third baseman of all time because of his lightning quick reflexes.

Washington scout Joe Engel found Bluege in the minors, where the quiet, unassuming infielder was dogged by speculation about a bad knee. Engel challenged Bluege to race him to the outfield fence. Engel, 29, told Bluege, 22, that if he won, the Senators would sign him. The foot race was no contest and Engel was thus satisfied that Bluege's knee was sound.

Washington had needed a dependable third baseman ever since the 1919 trade of Eddie Foster. Bluege's glove and exceptional range secured him the "hot corner" for the next 15 years. He played an amazingly shallow third base, believing he could cut off more base hits by playing closer to the batter. Although he never hit above .300 in any one season, he was remarkably consistent and his 98 RBI in 1931 were the second highest total on the team.

The arrival of rookie Cecil Travis in 1934 meant Bluege became a part-time player, subbing mostly at shortstop and second base. He became a coach with Washington in 1940 and was named manager in 1943. The Senators twice finished second during his five years at the helm.

### Herold "Muddy" Ruel
### Catcher, 1923 - 1930

At five-foot-nine, Muddy Ruel was small for a catcher, but he blocked the plate like a brick wall. Because of his defensive skills, he was the Senators' everyday catcher for six seasons.

Fellow catcher and Hall of Famer Al Lopez recalled, "Muddy was a dandy. He was one of the few small catchers. In the olden days they didn't call obstruction. You could block the plate without the ball." As a result, Ruel three times led American League catchers in fielding, putouts and double plays.

Ruel caught all seven games of the 1924 and 1925 World Series. In Game 7 of the '24 Series against New York, he doubled in the bottom of the 12th inning and later scored the winning run to give Washington the title.

In an era of tough players and tougher conditions, Ruel was considered an intellectual. He had a law degree and was licensed to practice before the U.S. Supreme Court. He brought books on the road, never used profanity and favored chewing gum over chewing tobacco. Pitcher Walter Johnson recalled: "He was the smartest catcher baseball ever had. He had an unbelievable knack for thinking one step ahead of the base runners. It took a lot of guts to steal on him."

Sold to the Boston Red Sox after the 1930 season, Ruel played another four years in the American League as a backup. He then spent 10 years coaching with the White Sox and later managed the St. Louis Browns for a single season in 1947.

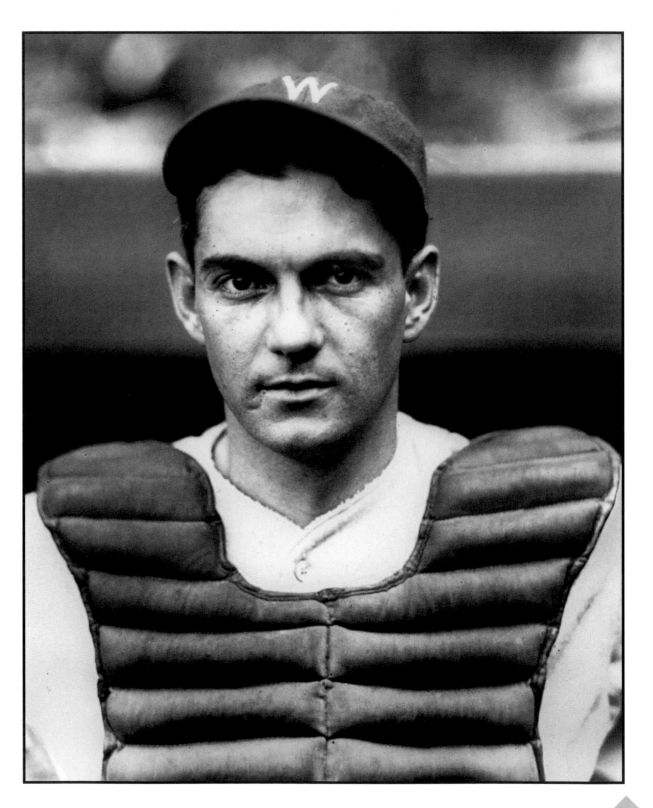

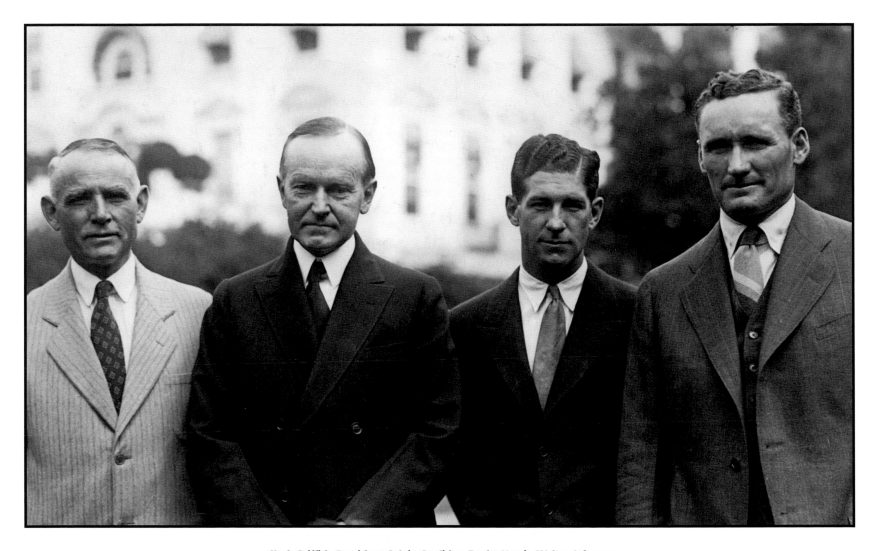

**Clark Griffith, President Calvin Coolidge, Bucky Harris, Walter Johnson**
**The White House, 1924**

With the race for the 1924 American League pennant still to be decided, President Calvin Coolidge decided to provide a little encouragement. When the Senators returned from a road trip to New York, having taken three of four from the Yankees, Coolidge invited the entire team to the White House on September 5.

The President asked Walter Johnson to demonstrate his pitching grip for him and the assembled newspaper photographers recorded the entire event. For their part, the team played superbly down the stretch, finally clinching their first pennant on September 29, the next to last day of the season.

### Art Nehf and Walter Johnson
### World Series, 1924

By 1924, Walter Johnson was in his 18th season with Washington. A brief flirtation in 1914 with the short-lived Federal League had gotten Johnson a hefty pay increase as Griffith responded by signing him to a five-year deal at $16,000 per year. Now Johnson was making nearly $20,000 a year. But even a fatter paycheck could not take the place of getting to pitch his team to a World Series championship.

On October 4, 1924, Johnson finally got a chance to fulfill his dream. Chosen to pitch Game 1 of the World Series, he's shown here with New York Giants starter, Art Nehf. The game developed into a classic back and forth struggle and by the end of 11 innings the score was knotted at two apiece. Despite striking out 12 batters and throwing an amazingly high 165 pitches, Johnson eventually allowed two runs in the top of the twelfth inning as Washington's late tally made the score 4-3 for New York. When Johnson also lost Game 5, it looked as if Washington's hope for a title would have to wait.

But Senators pitcher Tom Zachary won Game 6 2-1 to force a decisive Game 7. On October 10, before President Coolidge and an overflow crowd at Griffith Stadium, Johnson was provided with one final chance. Like Game 1, this one was a classic, with the score tied at three after eight innings. Johnson entered the game to start the ninth and held the Giants scoreless for four nerve-wracking innings. When outfielder Earl McNeely's batted ball bounced over the head of the Giants third baseman, Muddy Ruel raced home with the deciding run. Washington and Walter Johnson finally had their long-awaited championship flag.

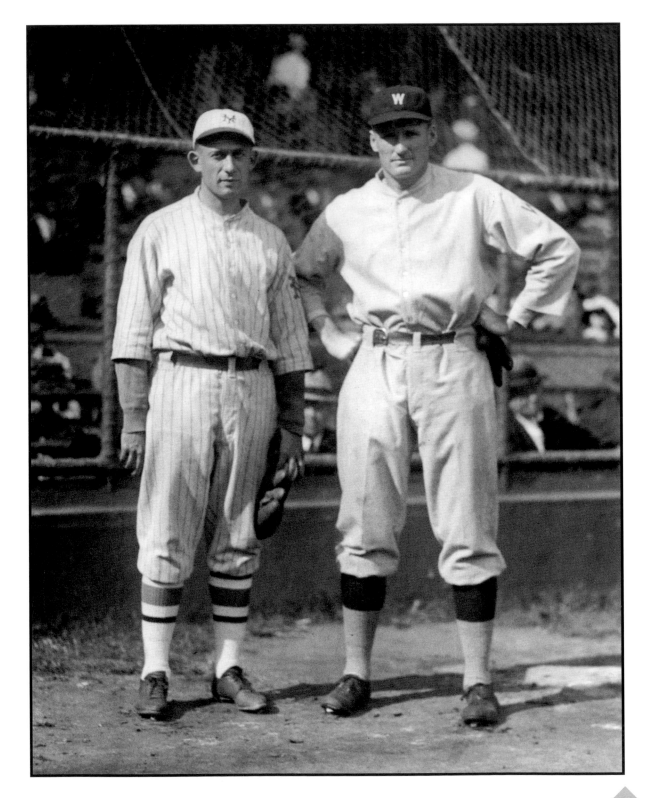

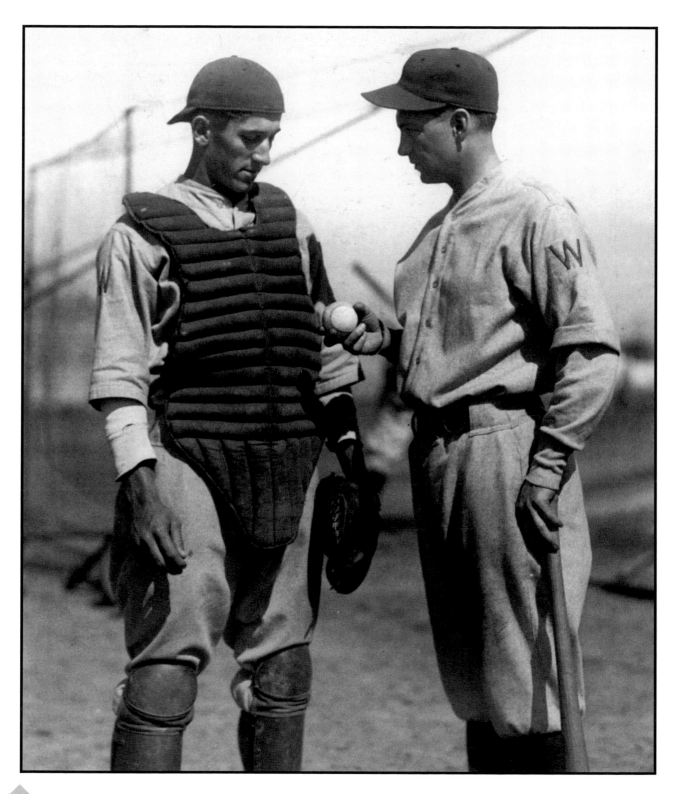

## Al Lopez and Muddy Ruel
### Spring Training, 1925

In 1925, the Washington Senators held spring training in Tampa, Florida. Brought in to help out with catching batting practice was a local high school kid, 16-year old Al Lopez. Lopez received $40 a week to help warm up the pitchers.

Washington's trainer, Mike Martin, urged Clark Griffith to keep Lopez with the club when they started north, but to no avail. Lopez would break in with Brooklyn in 1928 and make the big leagues to stay in 1930. There he spent the next 18 seasons as one of the most talented and durable catchers in the National League.

Years later, Lopez ran into Griffith in the stands in Washington and Griffith admitted he had erred in not signing Lopez. Lopez later managed Cleveland and Chicago to American League pennants in the 1950's and was elected to the Hall of Fame in 1977.

## Fred "Firpo" Marberry
### Pitcher, 1923 - 1932, 1936

Firpo Marberry was one of the first pitchers to be used almost exclusively in relief. Nicknamed "Firpo" because of his physical resemblance to a heavyweight boxer of the day, Luis Firpo, Marberry was an intimidating presence on the mound late in a game.

He was an iron man among pitchers. In his first four full seasons with Washington, Marberry never pitched in less than 50 games in any season. In 1926, he appeared in 64 games, eventually leading the American League in appearances six times. That same season, his 22 saves made Marberry the first pitcher to ever record 20 or more saves in a single season. It would be 1949 before another major league pitcher equaled his mark.

Marberry also developed a routine to ward off overly aggressive hitters. Upon entering the game, he'd throw his first several warm-up pitches wildly to encourage opposing hitters not to "dig in" at the plate. Once it was time to go, he'd rear back, kick his left leg high in the air and let go with a blazing fastball. Marberry thought nothing of "dusting off" hitters, and he developed an intense rivalry with the Philadelphia Athletics' Al Simmons, who called Marberry "the greatest relief pitcher of all time."

When Walter Johnson replaced Bucky Harris as manager in 1929, Johnson began using Marberry as both a starter and reliever. Marberry proved more than up to the task, winning 19 games while saving another 11. His record of 31-9 over the next two seasons made Johnson look like a genius. But Clark Griffith was seeking additional pitching help, and so Marberry was dealt to Detroit for starter Earl Whitehill prior to the 1933 season.

In Detroit, pitching for his former manager, Bucky Harris, Marberry continued toiling as both a starter and reliever and was 31-16 in his first two years for the Tigers. His 15-5 record in 1934 helped Detroit capture its first A.L. pennant in 25 years. But arm problems in 1935 spelled the end of the line for the big Texan. He spent one season umpiring in the American League before returning to Washington in 1936 for a final five games. He spent the next six years as a player/manager in the minors.

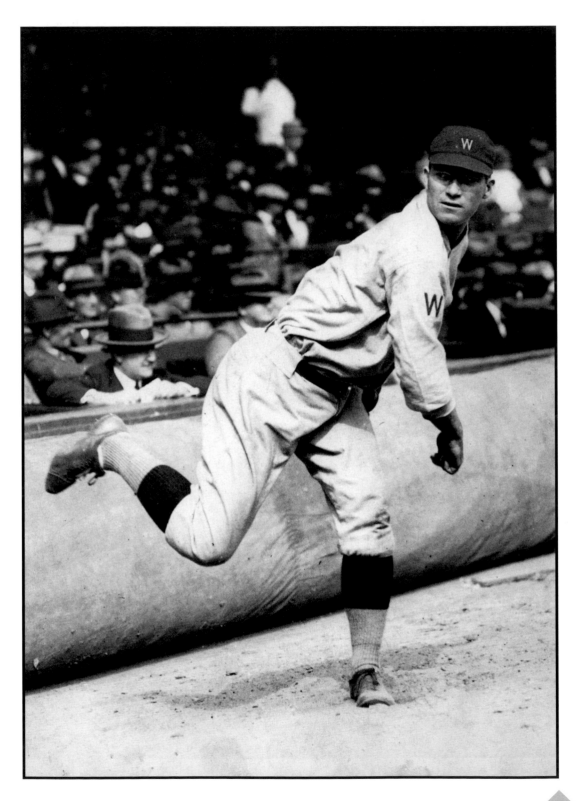

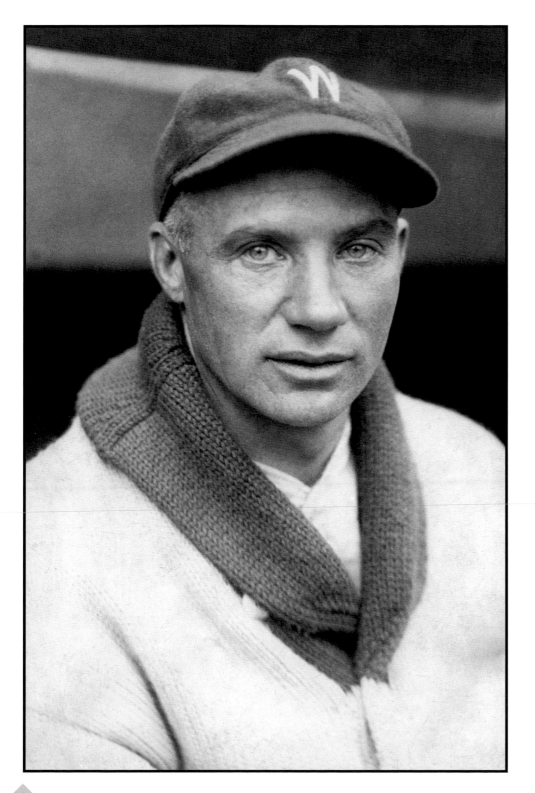

### Stan Coveleski
### Pitcher, 1925 - 1927

Stan Coveleski was already 35 and a veteran of nine big league seasons when he arrived in Washington. Coveleski was a spitball pitcher who had racked up four 20-win seasons and won 172 games for the Cleveland Indians. Despite winning the American League ERA title in 1923, everyone in baseball was sure Coveleski was through. His first year with the Senators would prove them all wrong.

In 1925, Coveleski was 20-5 and his ERA of 2.84 was the lowest in the league. At one point he reeled off 13 consecutive victories. Backed up by Washington's steady defense, Coveleski baffled hitters with his spitball, which was really aided by a healthy dose of slippery elm. Coveleski recalled "There was an art to throwing a good spitter. One thing you needed was a jawful of slippery elm. Elm would make the ball slippery as ice. It would react like a knuckleball and wouldn't spin. I could throw it much faster and I could control the break."

For all his success during the regular season, Coveleski's 1925 World Series performance would be less impressive. He lost Game 2 3-2 when he gave up a two-run homer in the bottom of the eighth Then, he was knocked out of Game 6 with the score tied at 2-2 in a game the Pirates eventually won 6-3. Despite the loss to Pittsburgh in seven games, the Washington players each received $3,800. as their share of the gate receipts. Clark Griffith also awarded Coveleski an additional $1,000 bonus for his stellar regular season.

14 wins in 1926 would represent Coveleski's last full season in the majors. Waived by Washington early in 1927, he retired after one more partial season with the Yankees in 1928. Coveleski was elected to the Hall of Fame in 1969.

## Earl McNeely
### Outfielder, 1924 - 1927

Earl McNeely drove in the winning run in Game 7 of the 1924 World Series. Purchased out of the Pacific Coast League during the 1924 season by Griffith for $35,000, McNeely made his debut with Washington in early August. He paid immediate dividends, batting .330 over the final two months of the season and displaying a lot of range in centerfield.

It would prove to be the high point of his brief career in the big leagues. Despite stealing 18 bases and hitting .303 in 1926, McNeely was dealt to the Browns following the 1927 season. In St. Louis he was a regular for only one season and returned to the PCL in 1932. There he became president and manager of the Sacramento franchise for two years until returning to Washington in 1936 to coach for two seasons. Finally in 1938, he retired to the life of a cattle rancher near Sacramento.

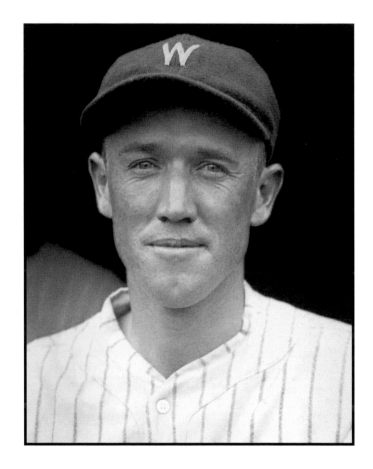

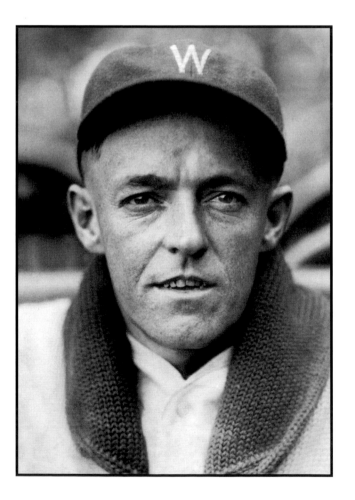

## Walter "Dutch" Ruether
### Pitcher, 1925 - 1926

"Dutch" Reuther was one of two veteran pitchers Clark Griffith brought in for the 1925 season to shore up the pitching staff. Though his stay would be short, his impact was immediate. He was 18-7 for the Senators in 1925. Together Reuther and Stan Coveleski would combine for 38 wins in 1925, and another 26 the following season. Ruether was a seasoned lefty who knew how to pitch. He had won 19 games for the 1919 Cincinnati Reds and put up 21 wins for Brooklyn in 1922.

Reuther also knew how to handle a bat. In 1925 he hit .333 for Washington including one home run. It was one of seven career long balls by him. Observers were shocked when Ruether, despite winning 18 games, was not chosen to start a single game in the 1925 World Series. His only appearance was one at-bat as a pinch hitter.

Sold to the Yankees midway through the 1926 season, Ruether would finish up with 13 wins for New York in 1927. He then spent another eight seasons pitching in the Pacific Coast League, where he later managed Seattle for three years in the 1930's.

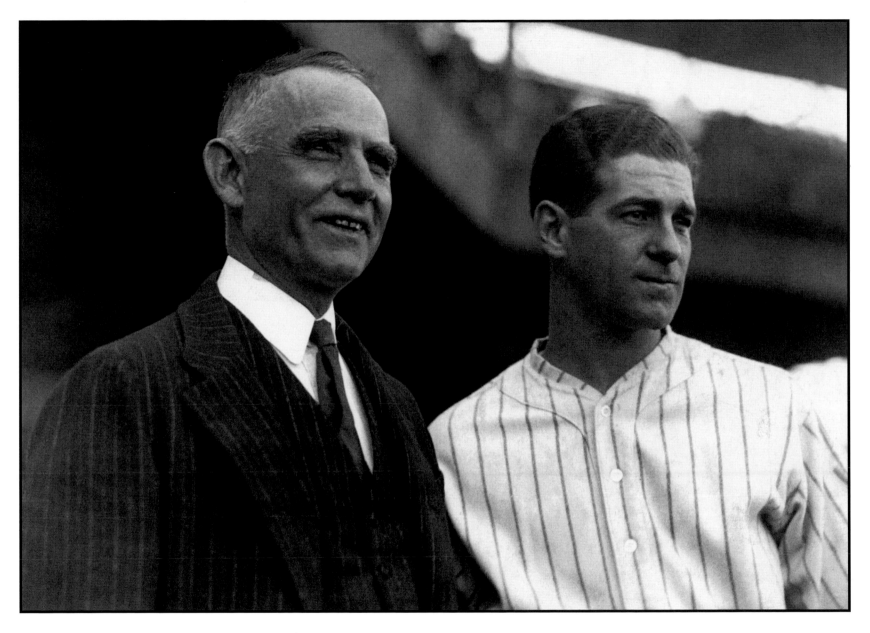

**Clark Griffith and Bucky Harris**
**Griffith Stadium, 1925**

At the time this picture was taken in September, 1925, these two men had plenty to smile about. Washington was about to clinch its second consecutive American League pennant. The Senators would end the season with 96 wins, second most in franchise history, and finish 8 ½ games in front of Philadelphia.

Washington's team featured a balanced lineup of excellent pitching, stellar defense and an abundance of speed. The 1925 Senators would lead the American League in fewest runs allowed, double plays and stolen bases. For good measure the pitching staff won the league ERA crown. The inspirational play of Harris on the field and his leadership in the dugout had rewarded Griffith's faith in his "Boy Manager".

**Ossie Bluege, Roger Peckinpaugh, Bucky Harris, Joe Judge**
**1925**

This Washington infield combination was only together for two full seasons, but what a run they had. Harris and Peckinpaugh would lead the American League in double plays at their positions in 1924. Joe Judge batted .324 and .314 in consecutive seasons while leading all A.L. first baseman in fielding percentage in 1925. Bluege's 79 RBI in 1925 were the second highest total on the team.

More importantly, the foursome provide solid defense behind the league's best pitching staff, which won the ERA crown for two straight years. In addition, Washington allowed the fewest runs of any team in the American League in both of their pennant winning seasons. By 1926, rookie Buddy Myer would take over for Peckinpaugh at shortstop. Bucky Harris left after the 1928 season.

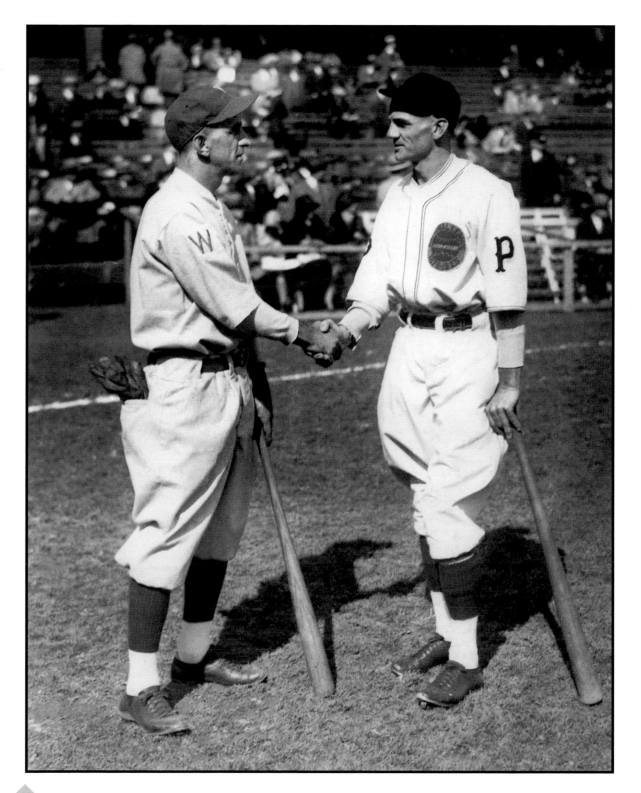

**Roger Peckinpaugh and Max Carey**
**World Series, 1925**

The two veteran shortstops shake hands for the photographers prior to Game 1 of the 1925 World Series at Forbes Field in Pittsburgh. Carey would be the hitting star for the Pirates, batting .458 while swatting four doubles and scoring six runs. Peckinpaugh's miscues in the field would severely tarnish his reputation.

When Washington won three of the first four games, a second straight championship looked certain. But the Pirates came storming back to win in seven games, becoming the first team ever to rally from a 3-1 defecit to win a World Series.

**Clark Griffith family**
**Washington, 1925**

Following the success of his team in 1925, owner Clark Griffith and his wife, Addie, decide to expand their family. Mrs. Griffith's brother, James Robertson, and his wife Jane, were living in Montreal with their seven children. A visit by Addie in 1922 resulted in two of the children, 11-year old Calvin and his sister, nine -year old Thelma, traveling to Washington for a visit. The visit soon became permanent. Neither of them ever returned to Montreal.

Clark and Addie Griffith owned a palatial home near Decatur and 16th Street N.W. , close to Embassy row. This became Calvin and Thelma's new home.

Back in Montreal, their father, James Robertson had died in 1923, and things soon became difficult for a widowed mother and her five remaining children. So in November, 1925, Jane Robertson and her other children also joined the Griffiths in Washington. Clark Griffith soon bought them their own home near Walter Reed Hospital. Calvin and Thelma continued living with the Griffiths.

Though young Calvin and Thelma would never be formally adopted by the Griffiths, they did have their last names legally changed. And for the rest of their lives, the Griffith children would all be involved in the baseball business.

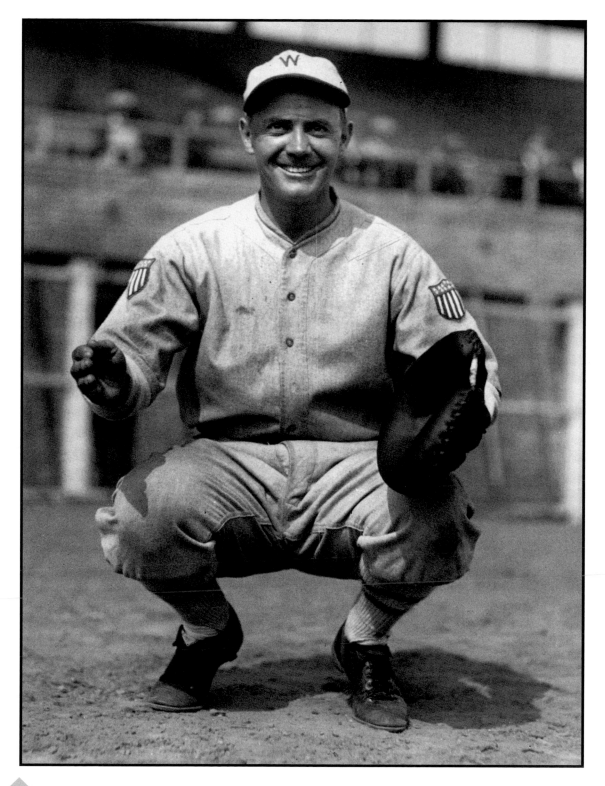

## Benny Tate
### Catcher, 1924 - 1930

Benny Tate spent parts of 10 seasons in the major leagues, all of them as a part-time player. In Washington, Tate was catcher Muddy Ruel's backup for six seasons. Like Ruel, Tate was small for his position, standing just 5'8" and weighing 165 pounds.

Tate could hit for average but generated almost no power. And he wasn't going to displace the veteran Ruel's signal calling and defensive skills. Tate's three plate appearances in the 1924 World Series all resulted in walks. He was behind the plate in 1927 when Tom Zachary gave up Babe Ruths' 60th home run. Years later, Tate recalled, "Ruth either hit a knuckleball or a curveball. I really don't know. All I can remember is watching the ball disappear."

Tate once challenged Manager Bucky Harris to "Play me or trade me", but neither happened until 1930 when Tate was sent to the Chicago White Sox. There he caught half the games for the hapless White Sox until being traded again, this time to the Red Sox early in 1932.

Boston released him the next spring and he spent another four seasons with Montreal in the minor leagues.

## Sam Rice
### c. 1926

Outfielder Sam Rice could keep a secret. And for over 40 years he kept two dandies. In Game 3 of the 1925 World Series, the Senators were nursing a 4-3 lead in the eighth inning when Rice raced toward the right centerfield gap to spear a fly ball off the bat of Pittsburgh batter Earl Smith. Rice clearly caught the ball just short of the temporary stands erected in the outfield. What happened next remained a mystery for the next 49 years.

Rice fell awkwardly into the bleachers and disappeared from the view of the umpires. After a moment, he was helped back onto the field by fellow outfielder Earl McNeely. Rice had the ball in his glove and the umpires ruled Smith out to end the inning. The Pirates' manager, Bill McKechnie and their owner, Barney Dreyfus, stormed onto the field to challenge the ruling. But had Rice really kept possession the ball the entire time, or as the Pirates claimed, had he dropped it after tumbling into the stands? For the rest of his life, Rice refused to tell anyone, always preferring to answer inquiries with "The umpires ruled him out."

Finally in 1965, Rice, now a member of the Hall of Fame, wrote a letter while attending the induction ceremonies in Cooperstown. He gave it to the president of the Hall and made him promise not to open it until after Rice's death. In 1973, Rice died and the letter was finally opened. Written in longhand by Rice, it spelled out the play in great detail and ended with the proclamation, "At no time did I ever lose possession of the ball."

Rice's other secret involved the death of his family. In 1912, Rice, then 22, traveled from his home in rural Indiana to a baseball try-out camp in Illinois. While away, a tornado struck the family farm, killing Rice's wife, two children, his mother and two sisters. With Rice at his father's bedside, his father lived for another nine days before also passing away.

His entire family gone, Rice's grief was so great he began drifting aimlessly around the country working odd jobs on farms and in factories. Finally in 1913 he enlisted in the Navy. Years after he became a star with Washington, Rice married a second time in 1929. The story of the tragedy of 1912 was never shared with either his wife or daughter.

Sometime in the mid-1960's a newspaper reporter showed up at Rice's Maryland farm to interview him about his career. When the subject of his first family's deaths was raised it was the first time Rice's second wife, Mary, had ever heard the story. No one, not even his own family, knew about Sam Rice's secret life.

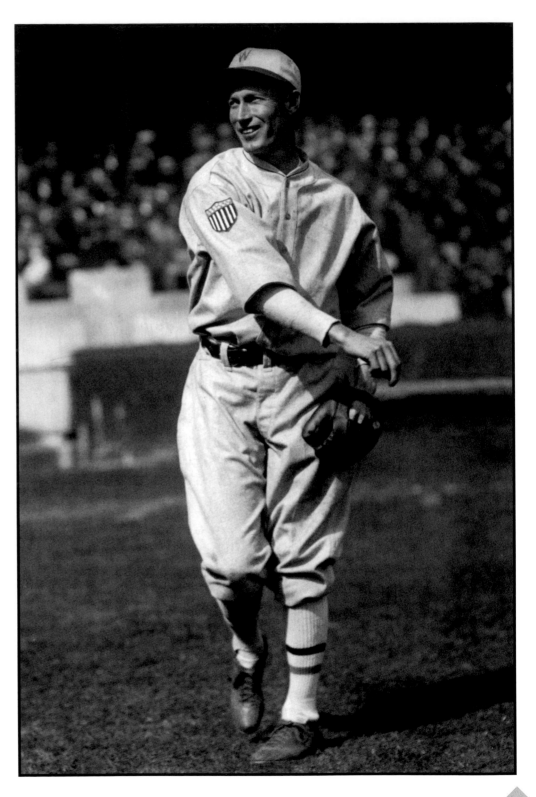

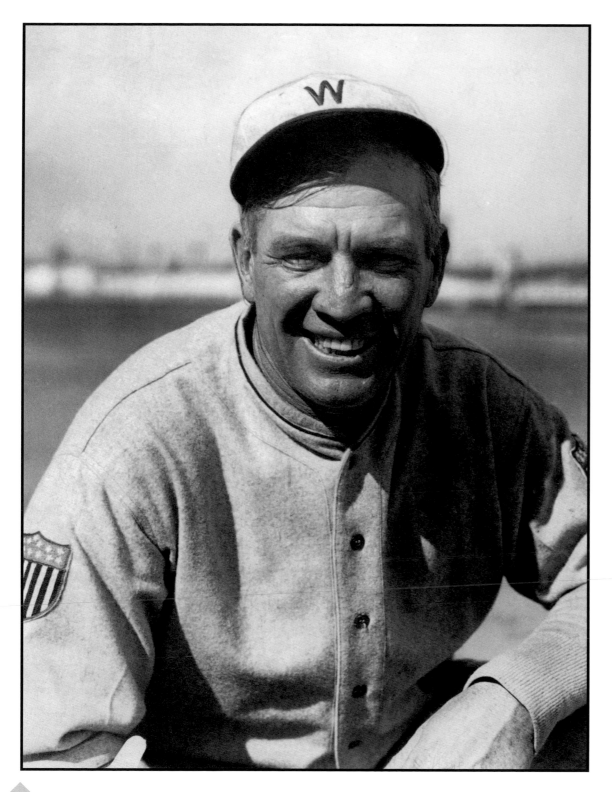

## Tris Speaker
### Spring Training, 1927

Outfielder Tris Speaker was already a legend in the American League for his prowess with a bat and his range in centerfield. Speaker was a veteran of 20 seasons with the Red Sox and then the Indians, where he had served as player/manger for the past eight years. He had already amassed nearly 3300 hits and 727 doubles to go with his 11 seasons of batting .340 or better. In 1916 Speaker had hit .386 to win the A.L. batting title.

Speaker was nearly 39 when he arrived in Washington to begin the 1927 season. His time in Cleveland had ended when the rumors of a betting scandal involving him and Ty Cobb had become public. Both players changed teams immediately, Cobb from Detroit to the Philadelphia A's and Speaker to Washington. Griffith signed Speaker for $35,000. and put him in centerfield, although he would also play 17 games at first base that season. Speaker responded to his new surroundings by hitting a robust .327.

But Speaker's lasting imprint on Washington was not a good one. He convinced Bucky Harris and Clark Griffith that 23-year old Buddy Myer wasn't up to the job at shortstop and urged a trade with Boston for veteran "Topper" Rigney. Following the trade, Rigney would hit just .253 for the Senators and be released after 45 games. Myer developed into one of the games' premier shortstops, stole 30 bases in 1928 to lead the A.L. and cost Washington five players in a trade to re-acquire him.

Speaker was released by Washington after one season, joined Cobb in Philadelphia the following year and retired after the 1928 season. He was elected to the Hall of Fame in 1937.

**George Sisler**
**1928**

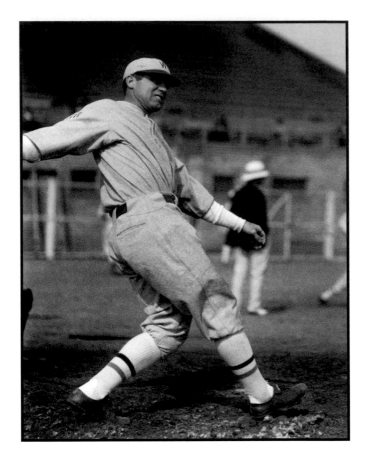

Veteran George Sisler was another player near the end of his career when Clark Griffith paid the St. Louis Browns $25,000 for his contract just prior to the 1928 season. At age 35, Sisler was considered the best pure hitter in the American League. In 12 seasons with the Browns, Sisler has won two batting titles and led the American League in stolen bases four times.

But when Sisler hit just .240 in 20 games to start the season, Washington panicked and sold him to the Boston Braves for $7,500. It was a very shortsighted move. Sisler rebounded to hit .340 the rest of the year and played another two seasons with the Braves. In 1932 he racked up 205 hits and batted .326. He was elected to the Hall of Fame in 1939.

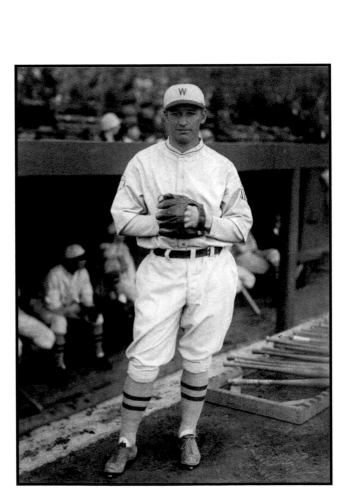

**Irving "Bump" Hadley**
**Pitcher, 1926 - 1931, 1935**

"Bump" Hadley was a mediocre pitcher best remembered for throwing the pitch that ended Mickey Cochrane's playing career.

Hadley had a fastball that rivaled those of the best pitchers, but his lack of control meant he twice led the league in walks. His first full season in Washington, he went 14-6. Sidelined by appendicitis in 1929, he won only six games, though he came back in 1930 to win a career-high 15 games.

In 1931, Hadley led the league in appearances because he served both as a starter and a reliever. But early in 1932, Washington traded him to the White Sox, where his lack of control got him traded to St. Louis, where his 21 losses led the league.

In 1937, Hadley, pitching for the Yankees, threw a pitch that fractured the skull of Tigers catcher Mickey Cochrane. Cochrane was 34 and never played another day. But Cochrane didn't blame Hadley, telling a reporter "He's not the type of man who would throw at a batter's head, and besides, why would any pitcher try to bean a hitter with the count 3 and 1?"

With New York, Hadley appeared in three World Series and won the third game of the 1936 and 1939 Series. He retired after the 1941 season and worked as an analyst on Boston Braves radio broadcasts. Later, he hosted one of the first television sports shows in the Boston area.

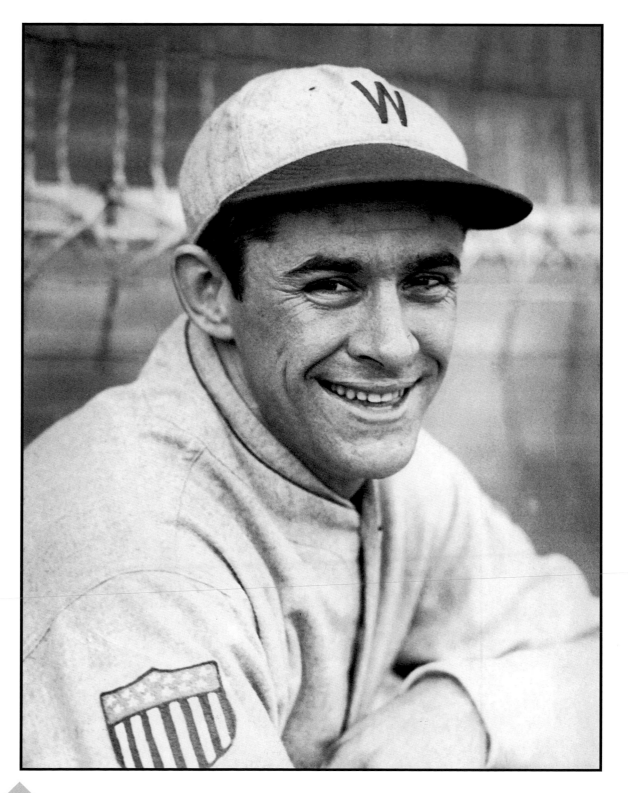

### Horace "Hod" Lisenbee
### Pitcher, 1927 - 1928

His first season in the majors, Hod Lisenbee won five games against Babe Ruth's 1927 Yankees, a team that won 110 games that year and is considered to be the greatest team of all time.

A farm kid from Clarksville, Tennessee, Lisenbee never held a baseball until he was 21. But when he won 17 games for the Memphis Chicks in 1926, Washington bought his contract for $44,000. His second start, Lisenbee was called from the bullpen to face Ruth with two men on base. He struck Ruth out on three pitches and struck him out twice more that day. Later in the year, Ruth got his revenge on Lisenbee by hitting his 58th home run of the season, on his historic march to 60.

Following a game at Yankee Stadium, Lisenbee asked Ruth to sign a ball autographed by members of the Senators and the Yankees. Ruth signed the ball, but as Lisenbee walked away, he heard him ask teammate Earl Coombs, "Say, that kid seems to know me. Who is he anyway?" Coombs explained that "that kid" had beaten the Yankees five times that season.

Lisenbee never came close to duplicating his rookie success. He had a losing record in each of the next seven seasons. He spent another seven years in the minors before retiring in 1941. He came out of retirement in 1944 to win 15 games and throw a no-hitter for Syracuse at the age of 45. He also pitched briefly for the Reds in 1945. After that, he returned to his Tennessee farm to raise Hereford cattle.

## Garland Braxton
## Pitcher, 1927 - 1930

Garland Braxton was a left-handed reliever who anchored the Washington bullpen with Firpo Marberry for three years. Acquired in a trade with the New York Yankees for pitcher "Dutch" Ruether, Braxton paid immediate dividends in 1927. His 58 appearances and 13 saves led American League hurlers in both categories.

The next year, Braxton was used as both a starter and reliever and responded by winning the A.L. ERA crown. The pencil-thin Braxton won another 12 games in 1929, but his effectiveness was slipping and he was traded to the Chicago White Sox early in 1930 for slugger Art Shires, who played only 38 games before being released. Braxton pitched sparingly for the White Sox and the Browns and was out of the major leagues for good early in 1933..

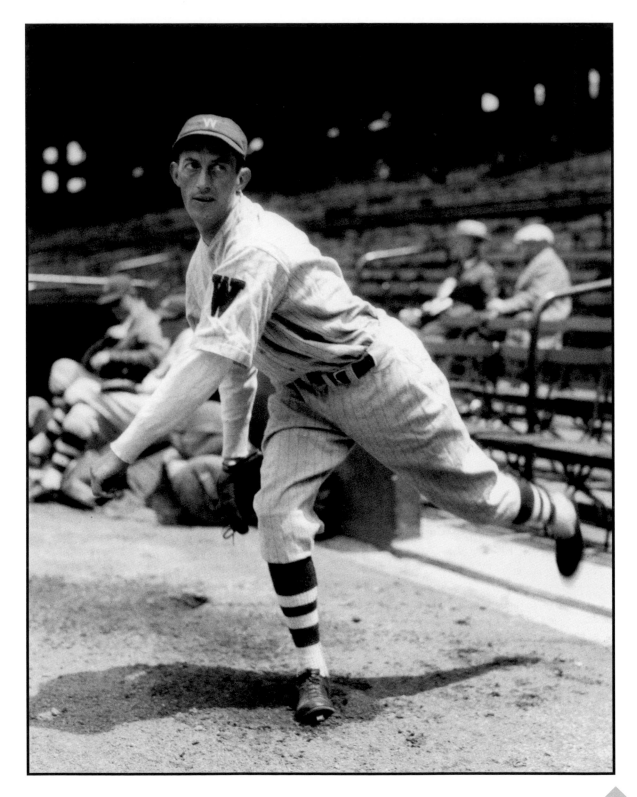

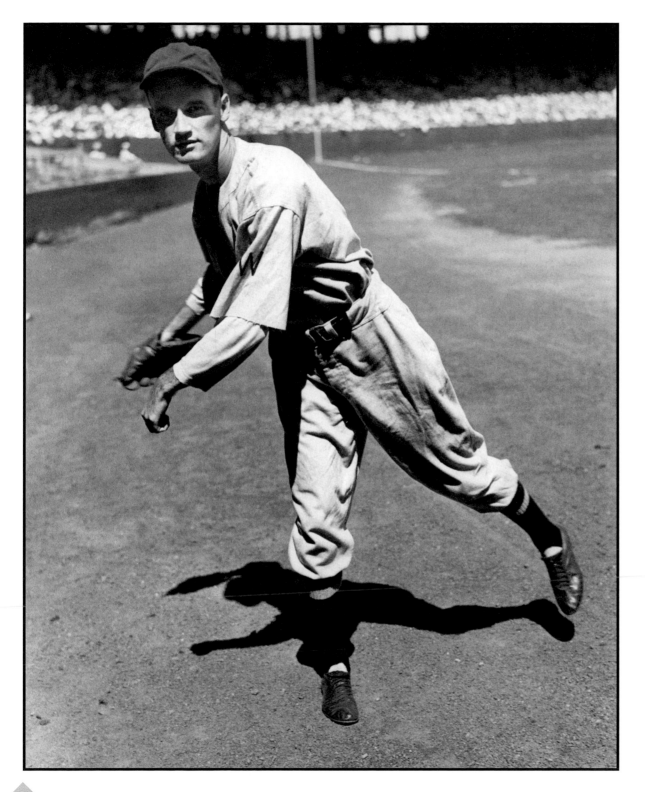

## Bobby Burke
## Pitcher, 1927 - 1935

Bobby Burke threw the second no-hitter in Senators history. On August 5, 1931, facing the Boston Red Sox at Griffith Stadium, he struck out eight and walked five to win, 5-0. No other Washington pitcher has thrown a no-hitter since.

The win made Burke 8-2, a typical season for him. Despite pitching in the majors for 10 seasons, Burke never won more than eight games a year. Because of that, he never made the starting rotation and saw only limited action out of the bullpen.

In an interview later in life, Burke commented on his career: "Ordinarily when a pitcher failed to win more games than I did, he found himself back in the minors. But I was allowed to hang around, start a game occasionally and then wait for a relief assignment."

During the 1933 pennant-winning season, Manager Joe Cronin considered Burke his slump buster, recalling: "Whenever we'd lose two or three games in a row, I would send Burke to the rubber. He always won for us and we would get away on another winning streak. He was the unsung hero of our championship team."

In 1935, Burke's 1-8 record got him demoted to the minors, where he pitched until 1938. He also umpired for a year in 1941 before returning to his native Illinois and running a fishing resort.

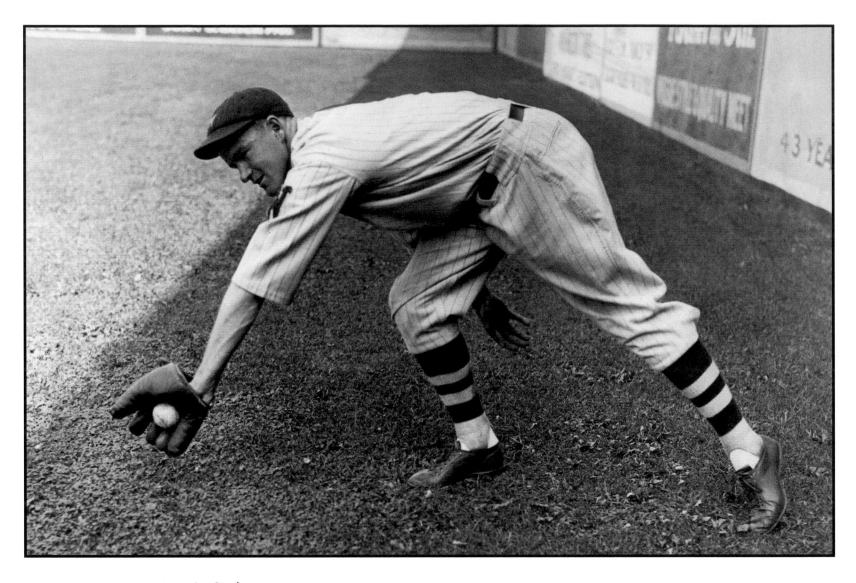

**Joe Cronin**
**Griffith Stadium, 1928**

Washington scout Joe Engel first spotted Joe Cronin, 20, taking infield practice with the Pittsburgh Pirates during the 1927 World Series. Engel liked the young rookie's quick hands and strong arm, and made a mental note when Cronin was later sold to Kansas City.

The next year, with Washington needing a starting shortstop, Engel headed to Kansas City to take a closer look. Cronin muffed four ground balls in a single game, but that night, Engel joined the club's owner for a drink to talk about a deal. Cronin was struggling at the plate and the owner was happy to unload him - for $7,500. Engel sent Griffith a telegram about his find, and said the pair would be back in Washington after stopping in Ohio to scout a couple of other prospects.

Knowing Griffith would question his sanity for paying such a price for someone hitting just .241 in the minors, Engel also let Griffith's niece, Mildred, know he was bringing her a husband. His letter read, "Am bringing home to you a real sweetie. So be dolled up to meet him. Tall and handsome. Hold all our mail. Don't show this to anyone. Yours, Joe."

In Washington, Cronin joined the starting lineup immediately. He stayed there for the next seven years.

Cronin and Mildred later married and were together nearly 50 years until his death in 1984.

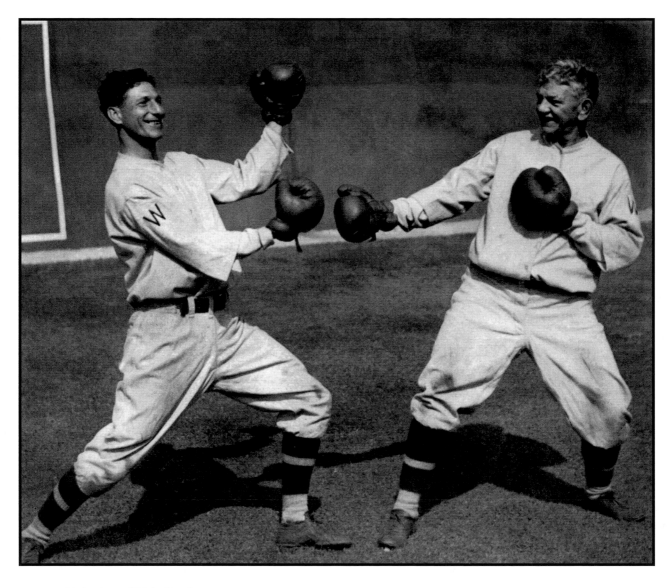

**Al Schacht and Nick Altrock**
**World Series, 1929**

Al Schacht and Nick Altrock spent over 40 years clowning for baseball fans everywhere. Both were former big league players. Altrock had twice won 20 games for the White Sox and both had pitched briefly for the Senators.

Together, and later separately, they entertained baseball audiences with their pantomime routines. Beginning in 1921, they appeared together at 13 straight World Series. They staged fake boxing and tennis matches, performed golf tricks, mimicked the umpires and generally made a nuisance of themselves between innings. They also served as coaches for the Washington ball club for decades. During the mid-1920's they spent three off-seasons on the Vaudeville circuit.

Eventually Altrock's heavy drinking caused the pair to have a falling out. They stopped speaking to each other completely in 1927. Schacht later recalled, "We took separate cabs to the theater and separate cabs to get home. For six years we didn't speak, on or off the field or stage."

When Schacht became a coach with the Red Sox in 1933, the pair split up for good. Schacht continued as a solo act for another 30 years, even performing for serviceman overseas during WWII. Altrock continued coaching for Washington until 1957, when he was 81.

## "Goose" Goslin
### Yankee Stadium, 1929

In 1928, Goose Goslin won the American League batting title with a .379 average. It was his fifth straight year hitting over .330. His 102 RBI also marked the fifth straight season he'd knocked in over 100 runs for Washington. Goslin accomplished all this despite having injured his throwing arm in spring training by fooling around with a shot put in front of a local high school track team in Tampa.

Goslin was among that rare breed of sluggers who could hit for power and average. His career would include 10 seasons with 30 or more doubles. But Goslin's lingering arm problems concerned owner Clark Griffith and when his average slumped to .288 in 1929, Griffith thought his star's time might be up.

In 1930, Goslin got off to a slow start, hitting just .271 by early June. Griffith decided to make a move. He shipped Goslin to the St. Louis Browns for two players, outfielder Heinie Manush and pitcher "General" Crowder, who Griffith had previously traded to the Browns in 1927, the year before Crowder won 21 games. It proved to be a trade that benefited both teams. Goslin regained his stride and finished the season with 37 home runs and 138 RBI, both career highs. Crowder and Manush would help lead Washington back to the World Series in 1933.

Goslin would re-join the Senators two more times, in 1933 and 1938. In between, he'd play in two straight World Series for the Detorit Tigers in 1934 and 1935. Goslin was elected to the Hall of Fame in 1968.

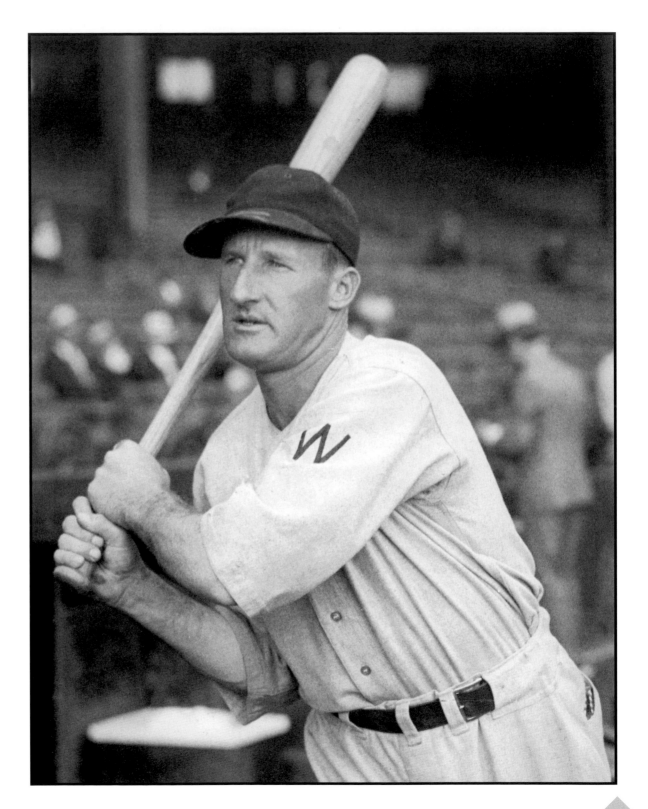

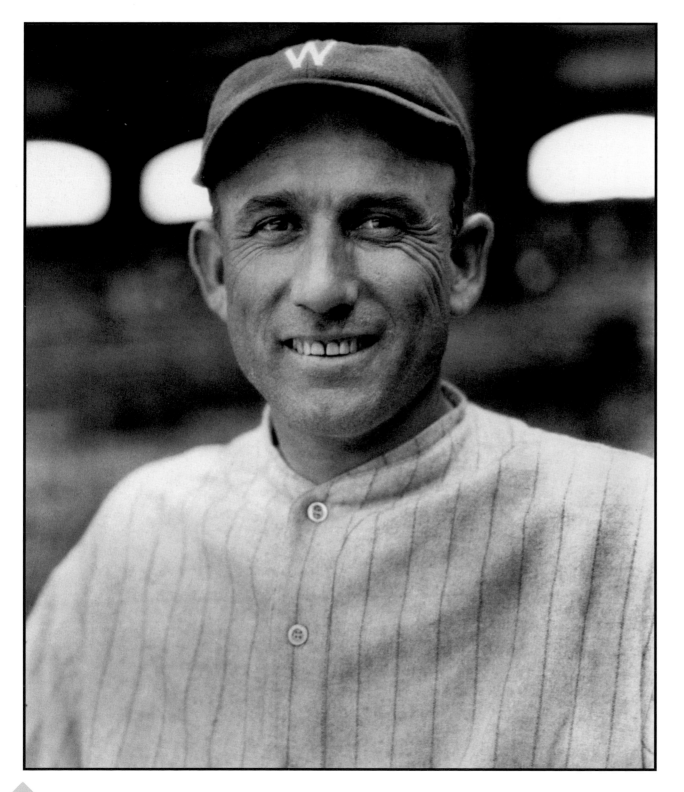

**"Sad Sam" Jones**
**Pitcher, 1928 - 1931**

Nicknamed "Sad Sam" because he pulled his ball cap so low, Sam Jones baffled hitters with off-speed pitches for 22 seasons.

When Jones arrived in Washington, he had a no-hitter under his belt and two 20-win seasons. One of those wins was a no-hitter against the Philadelphia Athletics, making Jones the first Yankees pitcher to ever throw a no-hitter.

His first season in Washington, Jones went 17-7 and threw four shutouts. His last good year was 1930, when he won 15 games. He was traded to the White Sox in 1932 and retired four seasons later at 43.

Jones briefly coached and managed in the minor leagues before moving to Ohio, where he became a bank president.

## Walter Johnson
### Manager, 1929 - 1932

For all his success on the mound, Walter Johnson was never able to have the same impact in the dugout.

When Johnson requested his release after the 1927 season, he was deluged with offers to manage. He chose to take over the Newark Bears in the International League. However, a severe kidney infection kept him from joining the club until mid-May and the team finished in seventh place.

Back in Washington, Clark Griffith was maneuvering to replace player-manager Bucky Harris. Harris, at 31, was no longer an everyday player and the team's first losing season in five years had not sat well with the Washington fans. Harris soon left for Detroit and Griffith signed Johnson to a three-year contract.

Johnson won 90-plus games each of his three years as manager, but no American League club could challenge Connie Mack's Philadelphia A's. The Athletics were a dynasty, winning more than 100 games three years in a row.

Johnson was criticized for his handling of the pitching staff. Many fans thought him "too nice." But an infusion of new talent gradually improved the club, setting the stage for the 1933 pennant-winning season.

By then, Johnson was in Cleveland, where he managed the Indians for three years. When that didn't work out, he retired to his Maryland farm. In 1939, he briefly served as the Senators' radio announcer and in 1940, ran unsuccessfully for Congress.

When the Baseball Hall of Fame opened in Cooperstown, N.Y., in the summer of 1939, Johnson was in the first class of inductees.

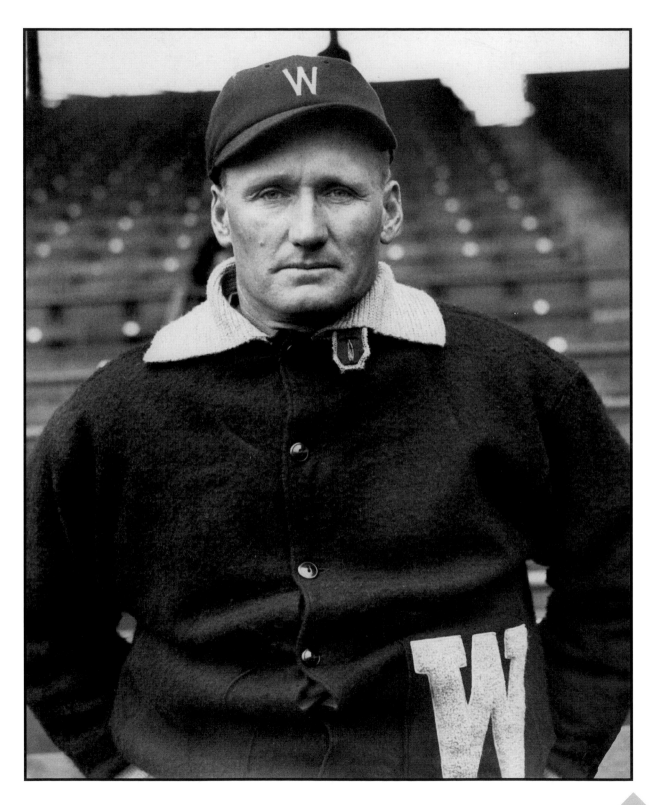

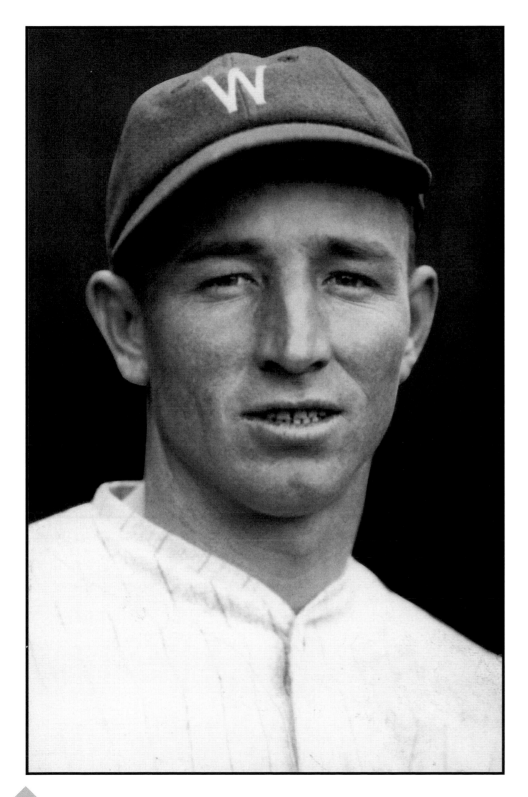

### Sammy West
### Outfielder, 1927 - 1932; 1938 - 1941

Senators scout Joe Engel signed Sammy West after spotting him with Birmingham in 1926. But before he got to Washington, West was hit in the head by a pitch and spent half the season in the hospital.

When West finally made it to Washington late in the 1927 season, veteran outfielder Tris Speaker schooled him on the finer points of playing the outfield. West became the everyday center fielder the following year and hit .302. He would hit .300 or better eight times in his career.

In 1932, with owner Clark Griffith looking for a way to bring star outfielder "Goose" Goslin back to Washington, West became part of a package traded to the Browns. In St. Louis, West put together five solid seasons and earned a reputation as one of the finest flycatchers in the American League. During his first week with the Browns in 1933, West went six for six in a game against the White Sox. But that May, he was again hit in the face by a pitch. His cheek bone was broken and West was sidelined for nearly a month. Still, he finished the season at .326.

West returned to Washington midway through the 1938 season, but by 1940, at 35, his days as an everyday player were over. He spent part of 1942 with the White Sox before serving as a stateside instructor during World War II. West coached with Washington for two years before retuning to Texas to run a sporting goods store.

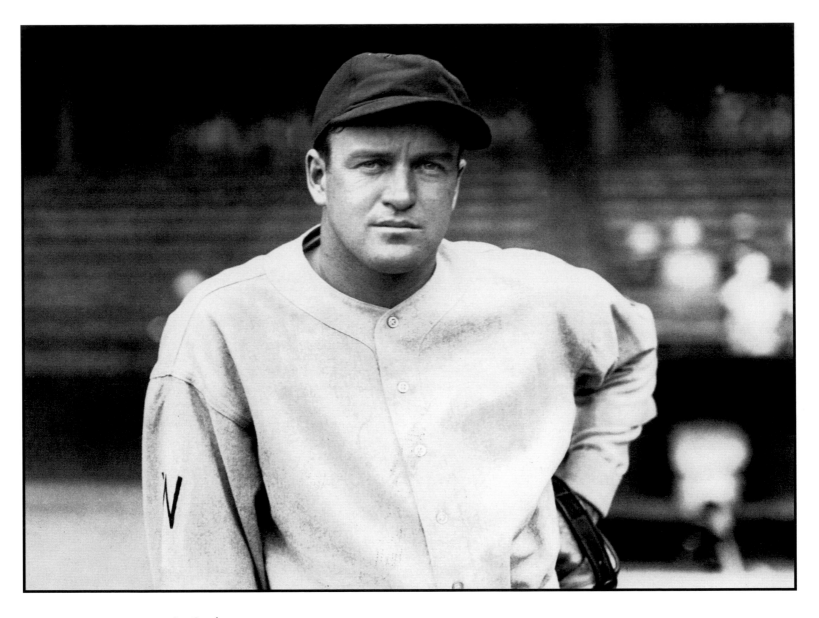

**Joe Cronin**
**Shibe Park, 1933**

Shortstop Joe Cronin was the model of consistency during his seven seasons with Washington. By 1930, Cronin had matured into a steady, dependable force in the middle of the Washington lineup. That season, he racked up 203 hits, batted a career-high .346 and drove in 126 runs. In fact, beginning in 1930, Cronin hit over .300, drove in at least 100 runs and had more than 40 doubles for four straight seasons. Cronin also proved remarkably durable, missing a total of 11 games over those four seasons.

In the field, Cronin was the anchor in the middle of the Senators infield.

Beginning in 1930, he led all American League shortstops in putouts and double plays for three straight seasons. Cronin also topped all other A.L. shortstops in fielding percentage in 1932 and 1933.

His inspirational play would soon earn him the title of player/manager. But his steady play would also earn him a one-way ticket to Boston. Following the 1934 season, Clark Griffith sold his new son-in-law to the Red Sox for the unheard of sum of $250,000.

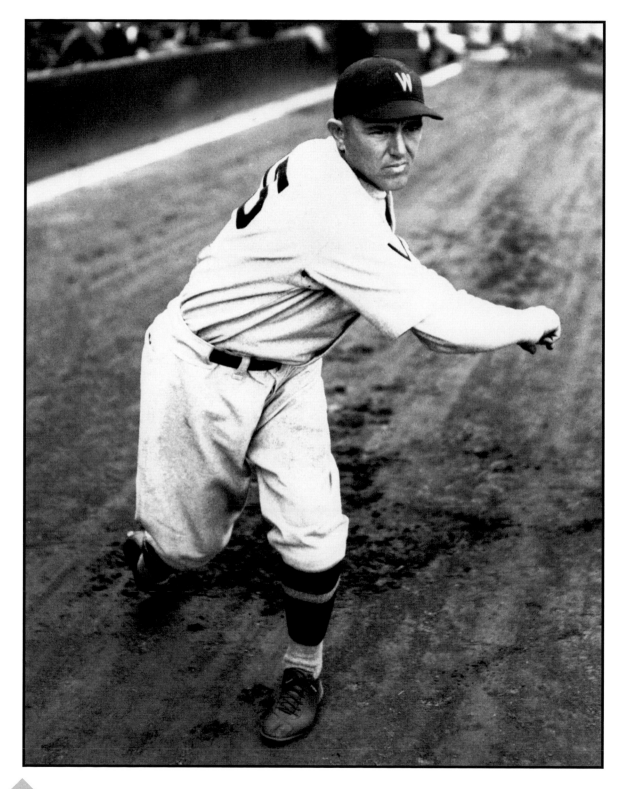

### Alvin "General" Crowder
### Pitcher, 1926 - 1927; 1930 -1934

General Crowder was nicknamed for a World War I general during his playing days in the military, but he was starring in Birmingham when Washington came a calling in 1926.

Crowder went on to spend 11 years in the American League and win more than 20 games three times. But his first 12 months with the Senators, he was a mediocre 11-11. Midway through 1927, Crowder was traded to St. Louis for veteran pitcher Tom Zachary, where he promptly won 21 games.

Crowder came back to Washington in the 1930 deal for slugger Goose Goslin. The move seemed to agree with him because he won 18 games in 1931. And in 1932, he reeled off 15 straight wins and led the league with 26 victories. When the Senators won the American League pennant in 1933, Crowder was the league's top pitcher with 24 wins. He was chosen to pitch in the first-ever All-Star Game at Chicago's Comiskey Park.

In 1934, off to a lousy 4-10 start, Crowder was waived to Detroit, where he played in two straight World Series with the Tigers. His last big year was 1935, when he won 16 games. A year later, he returned to North Carolina and managed in the minors for several years.

## Joe Kuhel
### First baseman,  1930 - 1937; 1944 - 1946

Joe Kuhel was a magician with the glove at first base. Kuhel was noted for his acrobatic footwork and uncanny ability to reign in errant throws. He was considered the finest first baseman of his era.

Washington acquired Kuhel from Kansas City in 1928 for a reported $50,000 and two other players. The plan was to slowly groom him to succeed Joe Judge at first base, but when appendicitis sidelined Judge in 1931, Kuhel produced 85 RBI and Judge's time was up.

In 1933, Kuhel helped power Washington to a third American League pennant. He hit .322, drove in 107 runs and stole 17 bases. His offensive numbers dropped dramatically the next two seasons, but in 1936 his 16 home runs and 118 RBI were tops on the team.

Still, Kuhel was primarily a singles hitter and owner Clark Griffith wanted more power in his lineup. He traded Kuhel to the White Sox for first baseman Zeke Bonura, one of the most hotly debated trades in Washington history. Fans in both cities were outraged and Griffith regretted the deal almost immediately.

Although Bonura had twice hit more than 20 home runs and driven in more than 100 runs in three of his first four seasons, he was a major liability with the glove. Bonura lasted only one year before being traded to the New York Giants. Kuhel, however, spent six seasons playing flawless defense in Chicago and adjusting his batting stance to produce more power at the plate.

In 1944, Griffith reacquired Kuhel from the White Sox. Now 37 and his best days behind him, he played two more years before being sent back to the White Sox in 1946. He retired after the 1947 season.

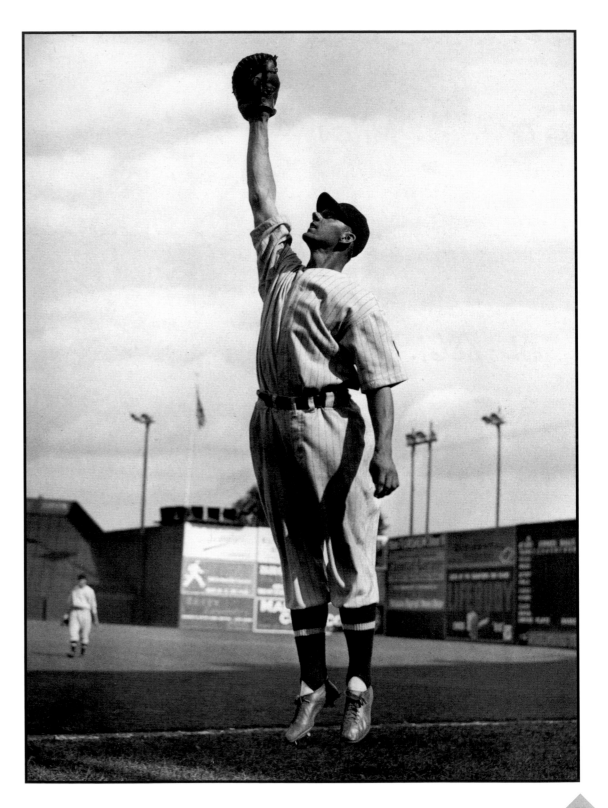

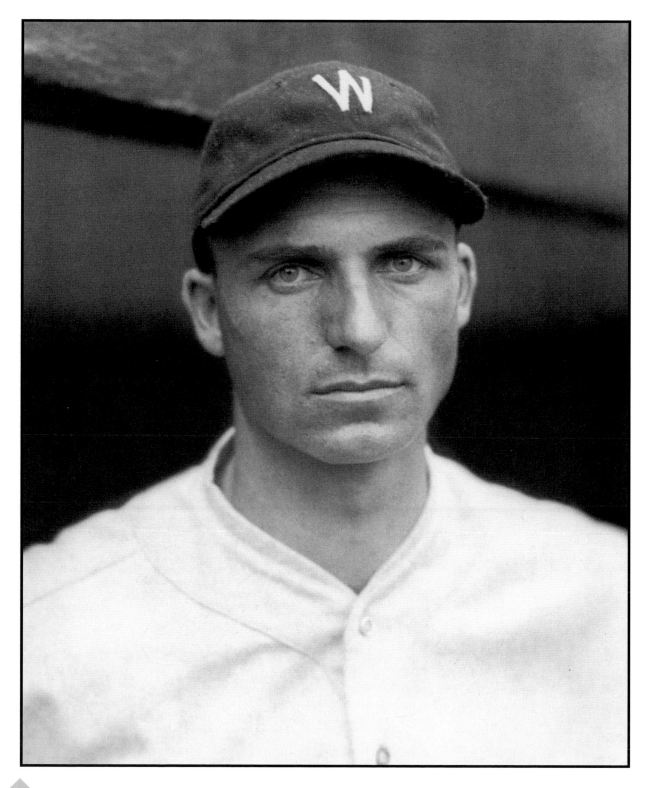

## Monte Weaver
### Pitcher, 1931 - 1938

Monte Weaver won 22 games - including nine in a row - during his first full major-league season in Washington. He also beat the defending American League champion Philadelphia A's four of the five times he faced them that year.

Nicknamed "Professor" because he held a master's degree in mathematics and taught analytical geometry at the University of Virginia, Weaver was the master of the curveball. In fact, he did his master's thesis on the physics of the curveball. He put his theories to the test with the Senators, delivering pitches from two angles, overhand and sidearm.

In the 1933 World Series against the New York Giants, Weaver threw 11 innings in Game 4 but lost, 2-1. But arm problems limited his effectiveness and Weaver never won more than 12 games in any of the next six seasons. He was sold to the Boston Red Sox in 1939 and spent another two seasons in the minors before retiring in 1941. After serving in Europe for three years during World War II, Weaver retired to Florida and went into the citrus grove business.

## Charles "Buddy" Myer
### Second baseman, 1925 - 1927; 1929 - 1941

Buddy Myer was a career .300 hitter and the only Washington second baseman ever to win a batting title. His first season with the Senators, he hit .304 and took over shortstop duties from the aging Roger Peckinpaugh. But on the advice of Tris Speaker, Washington dealt him to the Red Sox a year later, a trade that owner Clark Griffith called the worst of his career. In Boston, Myer batted .313 and led the American League with 30 stolen bases. The next year, Griffith traded five players to bring Myer back to Washington to stay.

Myer had a career year in 1935, with 215 hits, 100 RBI and a .349 average. He won the A.L. batting title in a race that came down to the season's last day. Cleveland's Joe Vosmik, ahead by mere percentage points, chose to sit out the first game of a doubleheader to protect his slim lead. Myer, in turn, went 4-5 against the Philadelphia A's and eked out the title.

Myer was a superb bunter. Many of his 2,131 career hits were drag bunts pushed into the gap between the pitcher's mound and the first base bag. Never one to shy away from a scrape, he often dealt with taunts about his Jewish heritage. In 1933, after a double play, he and the Yankees' Ben Chapman exchanged punches at second base and a bench-clearing brawl broke out.

Myer played for the Senators until 1941, but his last three seasons were as a backup. He turned down numerous offers to manage before retiring to Baton Rouge, where he became wealthy as a mortgage banker.

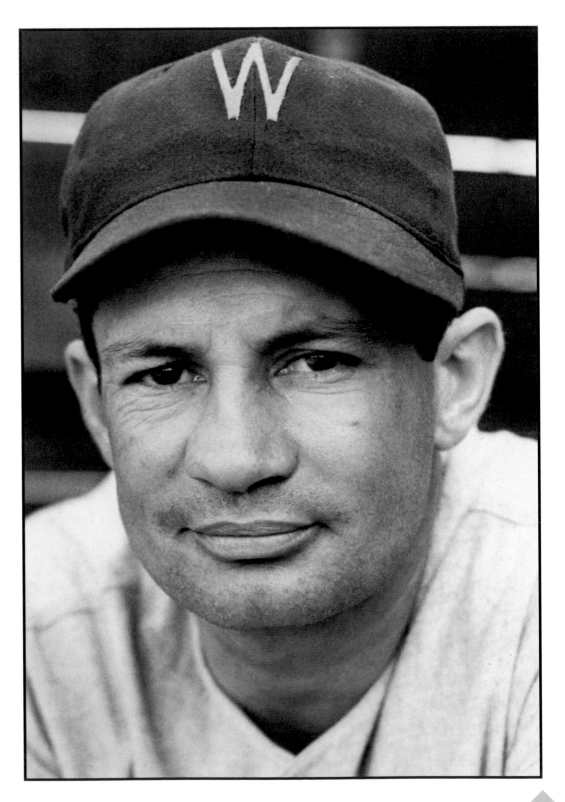

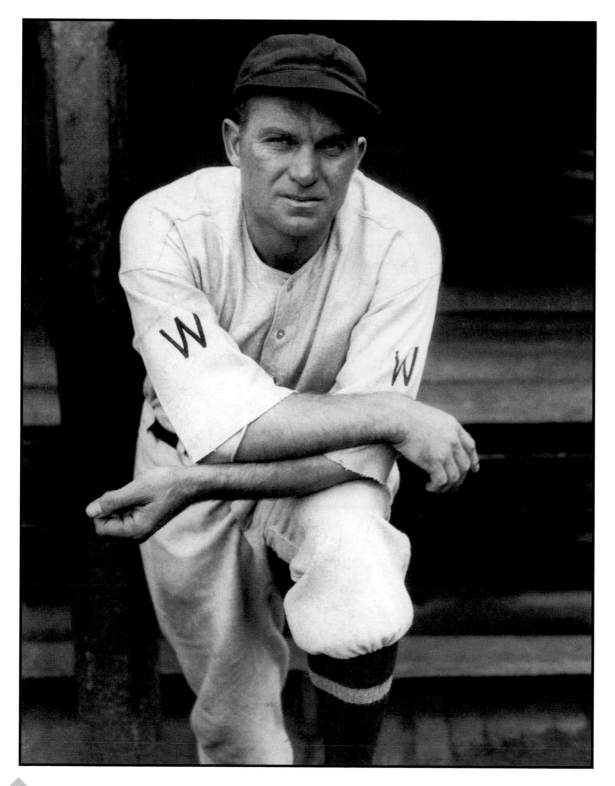

## Heinie Manush
### Outfielder, 1930 - 1935

After tasting success in 1924 and 1925, Washington owner Clark Griffith focused on rebuilding a winner in 1930. He traded slugger Goose Goslin to St. Louis for two players who would star in the 1933 championship season: starting pitcher General Crowder and outfielder Heinie Manush, who had won the 1926 American League batting title with Detroit.

In 1932, Manush banged out 214 hits, batted .342 and drove in 116 runs as the Senators finished third for the second straight year. The next year, he put together a 33-game hitting streak, batted .336 and led the league with 214 hits and 17 triples. But his power numbers fell sharply in 1935, when he hit below .300 for the first time in eight seasons. During the off season, Griffith shipped him to the Boston Red Sox.

Manush spent his last four years in the majors with three different teams as a reserve player. After the Pittsburgh Pirates released him early in 1939, he managed in the minors for five years before returning to Washington as a coach in 1953. He was elected to the Hall of Fame in 1964.

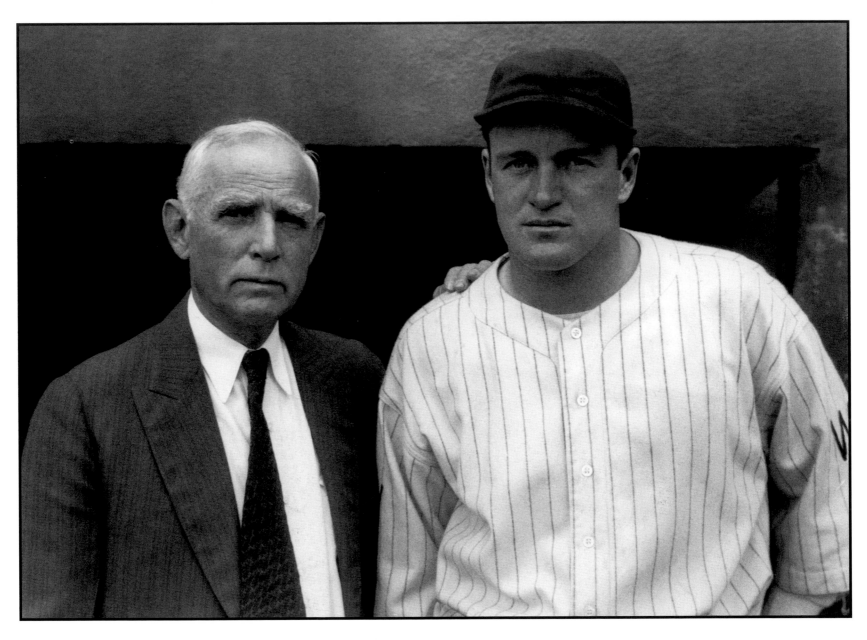

**Clark Griffith and Joe Cronin**
**Griffith Stadium, 1933**

During the Depression, many team owners saved expenses by asking star players to fill two positions: everyday player and team manager. It worked well for Washington owner Clark Griffith with young Bucky Harris in 1924, so he decided to try it again with 25-year-old Joe Cronin.

Four days before his 26th birthday, Cronin was named manager for the 1933 season. He got a tidy raise of $2,500, but Griffith must have smiled at the savings. He'd been paying Walter Johnson $25,000 a year to do the same job just three years earlier.

Cronin took his new duties to heart and quickly drew up a list of players he wanted Griffith to acquire. Over the next 90 days, the two re-made the Senators roster with a series of high-profile trades. Cronin now had the tools to bring a championship back to Washington.

**Moe Berg**
**Catcher, 1932 - 1934**

Moe Berg, a major-league catcher for 15 years, was educated at Princeton and spoke 12 languages fluently. He was also an eccentric. He believed his daily newspaper was "alive" and that no one else could touch it. He never married, never learned to drive a car and never wore anything but a black suit.

Berg was an excellent catcher but regularly switched teams because his bat too often got him benched. He played less than three years in Washington, sharing time behind the plate with Cliff Bolton and Luke Sewell. Midway through 1934, he was traded to Cleveland. He finished his career after five years with the Red Sox.

In 1934, Berg joined Babe Ruth and other major-league players on a baseball Tour of Japan. While there, he secretly photographed Tokyo's skyline, photos that were later used to plan U.S. bombing raids during World War II. Berg was awarded - and turned down - the Medal of Freedom. After retiring from baseball, he was a frequent guest on radio and television quiz shows.

## Jack Russell
### Pitcher, 1933 - 1936

Jack Russell wasn't a great pitcher. In fact, he posted a pathetic 41-91 record during six years with the Red Sox. Still, he could beat Washington consistently and so new Manager Joe Cronin signed him up to eliminate the threat.

Cronin put Russell in the bullpen, where the pitcher found success. His first year, he went 12-6 and saved 13 games. In 1934, he pitched in 54 games and led the American League in appearances. He was the first reliever ever selected to the All-Star game.

Russell's effectiveness faded the next year and in 1936, he was traded back to the Red Sox. He pitched four more years before retiring to Clearwater, Florida, where he was elected to the city commission. He pushed through the construction of a baseball stadium that would bear his name. Until 2003, Jack Russell Stadium was the long-time spring training home of the Philadelphia Phillies.

## Walter "Lefty" Stewart
### Pitcher, 1933 - 1935

His first year in Washington was Lefty Stewart's last big year in the majors. After joining the Senators in the Goose Goslin trade with St. Louis, he won 15 games and was chosen to start Game 1 of the 1933 World Series against the New York Giants. But he lasted just two innings, giving up the four runs that New York needed to win, 4-2.

Off the field, the tall, thin lefthander suffered a series of maladies. As a young man, he lost a finger on his right hand, but taught himself to throw left-handed. After the 1927 season, his appendix burst during a hunting trip in his native Tennessee, and he almost died before reaching the hospital. And during the 1934 season with Washington, Stewart's face became temporarily paralyzed, causing him to miss nearly half the season. Stewart was traded to Cleveland early in 1935 and left the majors later that year.

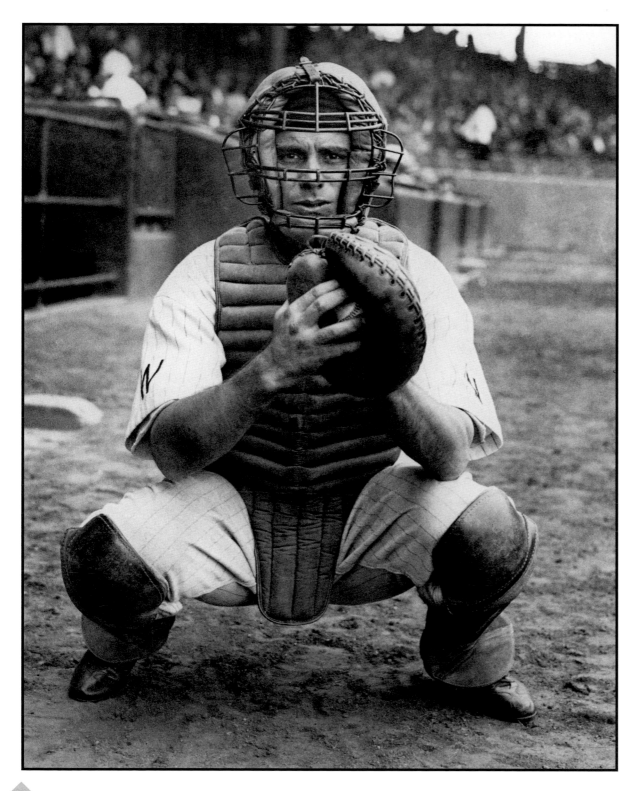

**Luke Sewell**
**Catcher, 1933 - 1934**

Veteran catcher Luke Sewell spent nearly 30 years playing and managing in the majors, but his stay in Washington was brief. The Senators had been searching for a dependable catcher ever since Muddy Ruel left after the 1930 season. When Moe Berg and Cliff Bolton proved unreliable, Sewell was brought in to provide veteran leadership behind the plate. He caught 141 games in 1933 and worked seamlessly with the club's veteran pitching staff.

A broken finger limited Sewell to 72 games the next year and his .237 batting average made him expendable. He was shipped to the St. Louis Browns for pitcher Bump Hadley, who won 10 games for Washington before being traded. Sewell later spent 10 seasons managing the St. Louis Browns and Cincinnati Reds.

**Dave "Sheriff" Harris**
**Outfielder, 1930 - 1934**

Dave Harris spent five seasons as the Senators' fourth outfielder and primary pinch hitter. He played 70-80 games a year and batted over .300 his first three. In 1932, he led the American League in pinch hitting. And in August of that year, he hit a double that broke up a no-hitter by the Tigers' Tommy Bridges with two outs in the ninth inning. After the game, Bridges asked Harris for his bat as a memento.

Harris was released after the 1934 season and spent another four years playing in the minors. He later became a police office in Atlanta.

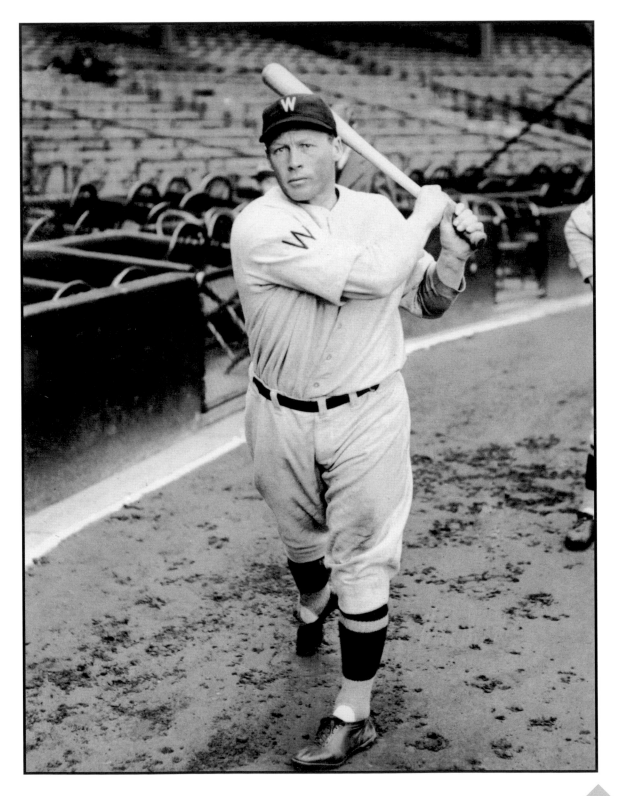

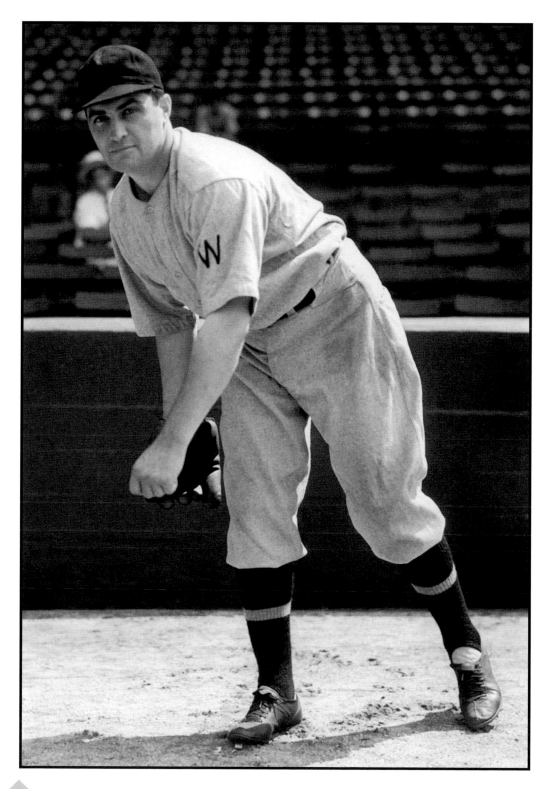

## Earl Whitehill
### Pitcher, 1933 - 1936

Lefty Earl Whitehill won 22 games during Washington's 1933 championship season, but he fought with umpires, teammates and anyone who got in his way. He came from Detroit, where he sparred with manager Ty Cobb. "I got tired of Cobb coming in from centerfield and telling me how to pitch," he said later. The pair didn't speak for two years.

The Senators acquired Whitehill from the Tigers for star reliever Firpo Marberry and one other pitcher. The change of scenery did him good. He led the American League in starts in 1933 and threw more than 270 innings twice in four years. Still his fierce temper was on display. In one game against the Yankees, an enraged Whitehill confronted umpire Brick Owens about a home run by Lou Gehrig. The ball was clearly foul when it went over the wall, but Owens ruled it a home run. Whitehill was so angry that he heaved Owen's whisk broom over the grandstand. Owens responded by heaving Whitehill out of the game.

Whitehill saved his greatest wrath for opposing batters, saying, "Any fellow who walks up there with a bat in his hands is trying to take bread and butter out of my mouth. So I pitch hard." He never pitched harder than Game 3 of the 1933 World Series. He threw a five-hit shutout against the New York Giants to keep Washington from being swept in four straight.

Known as a flashy dresser, Whitehill married a model who gained lasting fame on the Sun Maid raisin box. After retiring in 1939, Whitehill coached briefly with the Phillies and later worked as a salesman for the Spaulding sporting goods company.

He was killed in a 1954 car accident when a 21-year-old driver ran a stop sign.

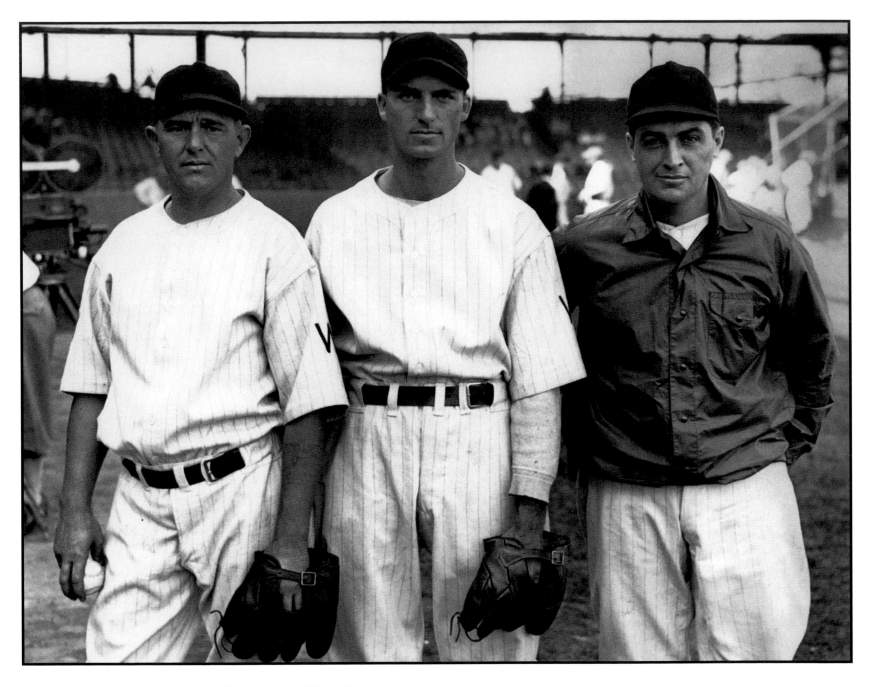

**General Crowder, Monte Weaver and Earl Whitehill**
**Griffith Stadium, 1933**

Optimism reigned about the 1933 World Series because Washington's "big three" pitchers had won 56 games during the year. Crowder led the league with 24 victories, Whitehill won 22 and Weaver 10. The Senators' pitchers allowed the fewest runs in the league and their ERA was the second lowest. Only pitcher Carl Hubbell and the New York Giants stood in the way of another championship.

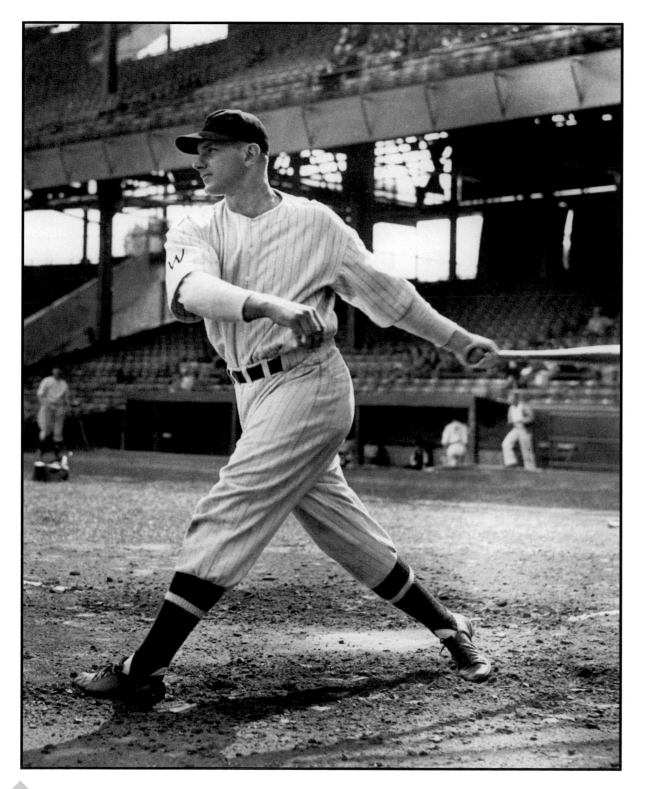

### Fred Schulte
### Outfielder, 1933 - 1935

Fred Schulte spent three years patrolling the cavernous center field of Griffith Stadium. Originally signed by the St. Louis Browns for $85,000 after leading the American Association in batting in 1926, Schulte developed a reputation for his all-out style of play. His rookie season in St. Louis, he hit .317 despite missing half the year with a broken arm and three fractured ribs suffered in a run-in with the outfield wall. He also hit his first major-league home run off of an aging Walter Johnson that year.

In Washington, Schulte drove in a career-high 87 runs and stole 10 bases his first year. In the 1933 World Series, his three-run home run in Game 5 tied the score before Washington lost 4-3 in 10 innings. Injuries cost Schulte the first half of the 1935 season. The next year, he was waived to the Pittsburgh Pirates, where he played sparingly. He spent two years playing again in Milwaukee, then managed and coached in the minor leagues until 1946. He later spent more than a decade scouting for several major-league teams.

**Joe Kuhel, Buddy Myer, Joe Cronin and Ossie Bluege**
**Griffith Stadium**

Washington's starting infield not only played stellar defense, they supplied most of the team's offense in 1933. First baseman Joe Kuhel hit .322 and knocked in 107 runs. Shortstop Joe Cronin led the American League with 45 doubles. Second baseman Buddy Myer batted .302, with 29 doubles and 15 triples. And Ossie Bluege's 71 RBI were the second most of any third baseman in the league.

In the field, there was no better defensive foursome. Cronin and Kuhel led their positions in fielding percentage and the Senators committed the fewest errors of any team in the majors. Washington fans had every reason to be optimistic about the upcoming Fall Classic.

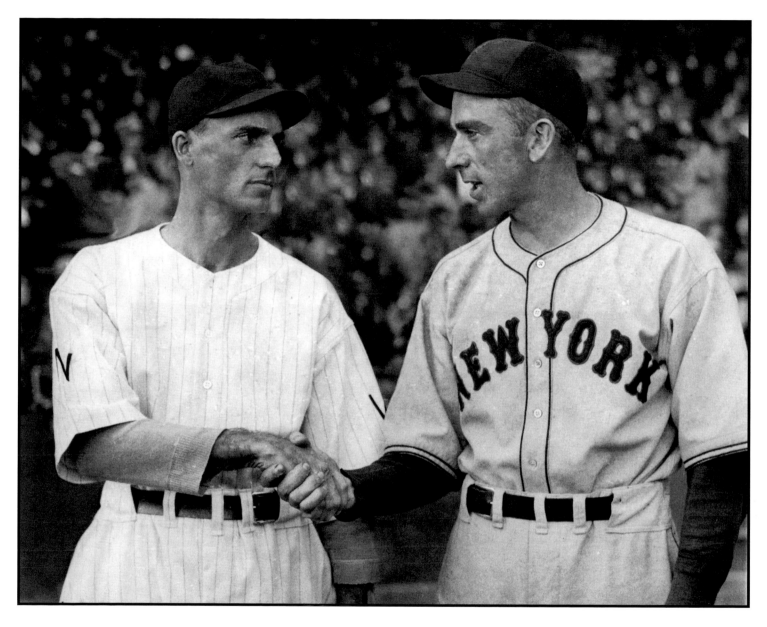

**Monte Weaver and Carl Hubbell**
**World Series, 1933**

With the New York Giants leading the 1933 World Series two games to one, the two starting pitchers of Game 4 posed for cameramen at Griffith Stadium. Their match-up became an old-fashioned pitcher's duel. Through 10 innings, they surrendered only one run apiece.

In the top of the 11th inning, Monte Weaver gave up a lead-off bunt to Giants third baseman Travis Jackson. Jackson was sacrificed to second and later scored on a single off of Senators reliever Jack Russell. In the bottom of the inning, Washington loaded the bases with one out, but Carl Hubbell got Senators pinch-hitter Cliff Bolton to ground into a game-ending double play.

The Giants won the Series the next day with a 4-3 victory in a game that lasted 10 innings.

### Jake Powell
### Outfielder, 1930, 1934 - 1936; 1943 - 1945

Jake Powell was a rough-and-tumble player who tested the limits. When he missed the train north from spring training in 1936, he chartered a plane and then billed the club. At the start of the season, he crashed into Tigers first baseman Hank Greenberg and broke his wrist, putting the Tiger's first baseman out for the season. Midway through the year, owner Clark Griffith had seen enough and traded Powell to the Yankees for Ben Chapman.

With the Yankees' vaunted lineup, Powell played sparingly as the team's fourth outfielder. Still, he continued to stir things up. After coming to blows with Washington first baseman Joe Kuhel, Powell was showered with soda and beer bottles by Senators fans. He responded by picking up the bottles and hurling them back. Still, Powell was the hero of the 1936 World Series, batting .455 with five RBI in six games. He promptly blew his $7,000 bonus check in a single night of gambling.

In 1938, Powell was being interviewed on the radio from the Yankees dugout when the announcer asked him about life outside of baseball. Powell said that he spent the off-season as a cop in Dayton, Ohio, "clubbing niggers over the head." His remarks sparked huge protests and Commissioner Landis suspended him for 10 days. He had one more famous fight that season, with former teammate Joe Cronin, who'd been hit by a pitch. After umpires ejected the two from the game, they continued their fight under the grandstand.

During an exhibition game in 1940, Powell crashed into a steel outfield wall and fractured his skull, missing all but 12 games of the season. He was out of the majors by 1946 and spent another two years playing in the minors.

In the fall of 1948, he was picked up by police in Washington, D.C., for passing bad checks. When Powell got to the police station, he pulled out a pistol and shot himself twice, dying instantly. He was 40 years old.

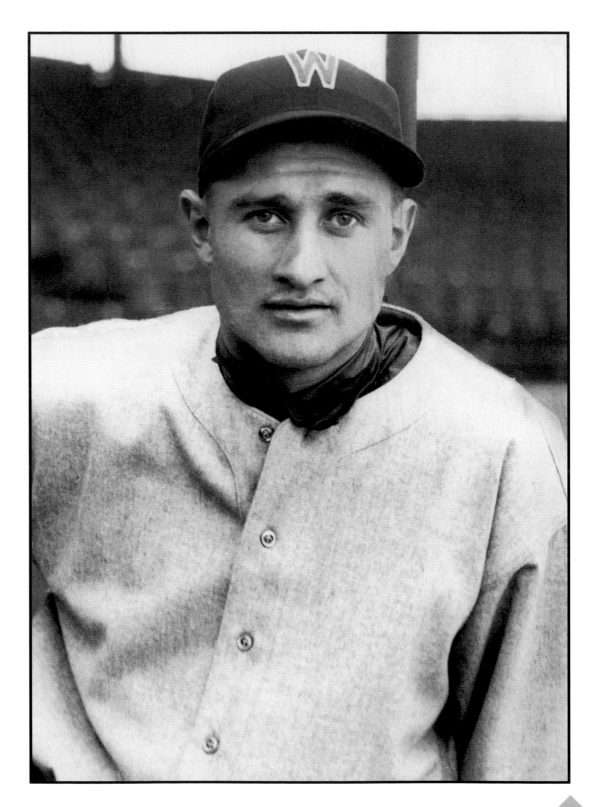

## Mike Martin
### Trainer, 1912 - 1946

Trainer Mike Martin spent nearly 50 years at Clark Griffith's side tending to injured ballplayers. They met in 1904 when Martin was working with the football team at Columbia University and Griffith was managing the New York Highlanders. Griffith convinced Martin to join the team as head trainer, a novelty in those days.

Martin followed Griffith to Cincinnati, then to Washington in 1912. He spent most of his time nursing spike wounds. He once recalled: "Grudges were common between players and they settled their arguments by sharpening their spikes and riding high, wide and ugly into the enemy on the bases."

Martin became known as someone who could help. In 1920, he treated Walter Johnson the only time the legendary pitcher ever complained of arm trouble. Johnson thought he'd have to retire, but after Martin's treatment, he pitched another seven years. And the White House thought so much of Martin that in 1916, he visited an ailing President Woodrow Wilson as many as four nights a week.

Over the next three decades, Martin nursed the aches and pains of Washington players. He even developed and marketed his own brand of rubbing liniment for sore arms. After the 1946 season, he became a scout for Washington. He was killed in an auto accident in 1952 on his way to the ballpark.

## Ed Linke
### Pitcher, 1933 - 1937

Ed Linke was a mediocre pitcher who had his best year after a freak accident. Linke was pitching against the Yankees on July 26, 1935, when he was struck in the head by a line drive. The ball bounced to Washington catcher Jack Redmond, who caught the ball for an out and fired to second for a double play. Washington won the game and knocked the Yankees out of first place.

Linke spent three days in a New York hospital with a slight concussion but took the mound again and reeled off eight straight wins. Manager Bucky Harris jokingly told him: "The only mistake you made was not being knocked out earlier in the season. Think what a record you'd have had."

Linke ended the season with a career-high 11 wins. Despite a record of 6-1 in 1937, he was out of the majors the next year.

## Pete Appleton
### Pitcher, 1936 - 1939; 1945

Pete Appleton chose a career in baseball over his first love, music. Born Peter Jablonowski, he was a classically trained pianist who changed his name to support a career in show business. For nine years, however, he made his living in baseball, bouncing between the minor and major leagues. After he won 23 games for Montreal at 31, Washington called him up.

Appleton went 14-9 in 1936, but joined the bullpen after an 8-15 record in 1937. He pitched in relief for two years and then was traded to the White Sox in 1940. Two years later, he enlisted in the Navy and briefly returned to Washington after the war ended. Appleton later managed in the minors and scouted 15 years for the Senators and Minnesota Twins.

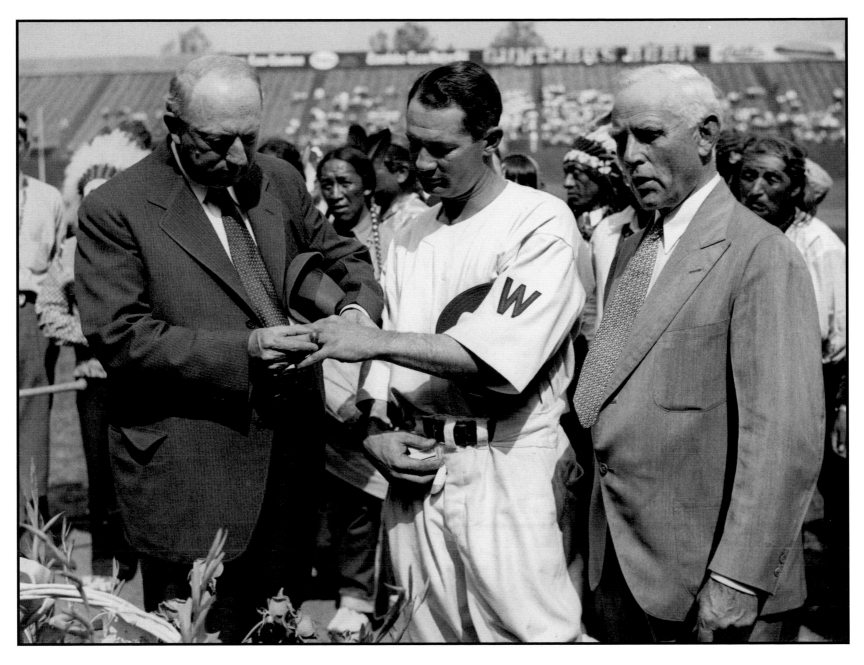

**Buddy Myer Day**
**Griffith Stadium, 1936**

Washington honored Buddy Myer for winning the 1935 American League batting title before a game against the Boston Red Sox on May 9. Myer is seen here accepting a $500 diamond ring from U.S. Senator Pat Harrison of Mississippi, Myer's home state.

The Sporting News reported that as part of the ceremony, Myer was made an honorary Indian chief by the Navajo Indians seen behind him. Washington coach and chief clown, Al Schacht, joined in a ceremonial war dance.

## Jimmie DeShong
### Pitcher, 1936 - 1939

Jimmie DeShong had one great season in the majors, winning 18 games for Washington in 1936. DeShong had won 19 games for Sacramento in the Pacific Coast League in 1932 and was bought by the New York Yankees. Used almost exclusively in relief, DeShong got a rare start in 1934 and made the most of it. On July 28, he held the Philadelphia Athletics to a single hit, a home run by Jimmie Foxx, in defeating the A's 2-1. In 1935, DeShong was 4-1 for the Yankees, but two of those wins came against Washington.

Clark Griffith and manager Bucky Harris thought they saw something in DeShong that everyone else had missed and so acquired him from the Yankees. His first year, he led the Senators pitching staff with 18 wins, but he couldn't sustain his success. The next year, even though he threw 20 complete games and 264 innings, his record slipped to 14-15. At age 28, his major-league career was all but over. His final two seasons with Washington, he went a combined 5-11 before being released. He pitched for a short time in the minors and then retired to his hometown of Harrisburg, Pennsylvania.

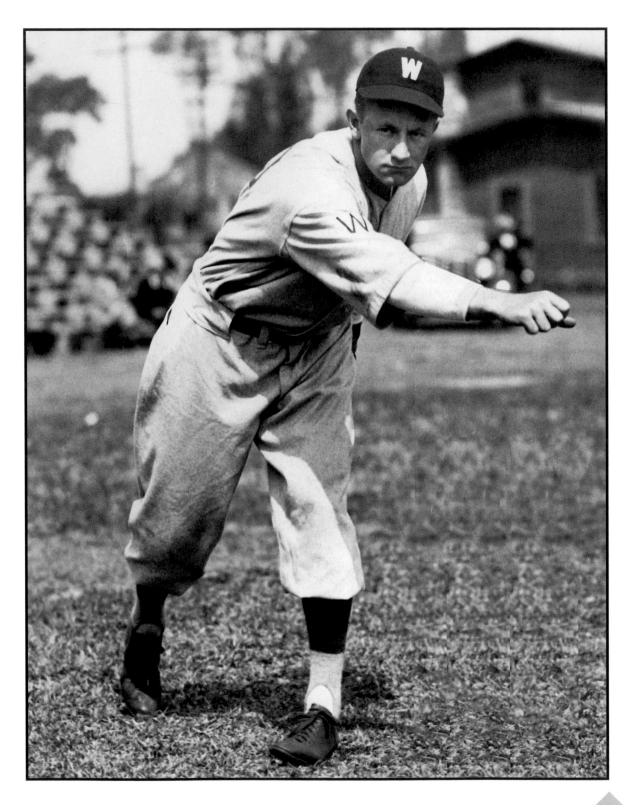

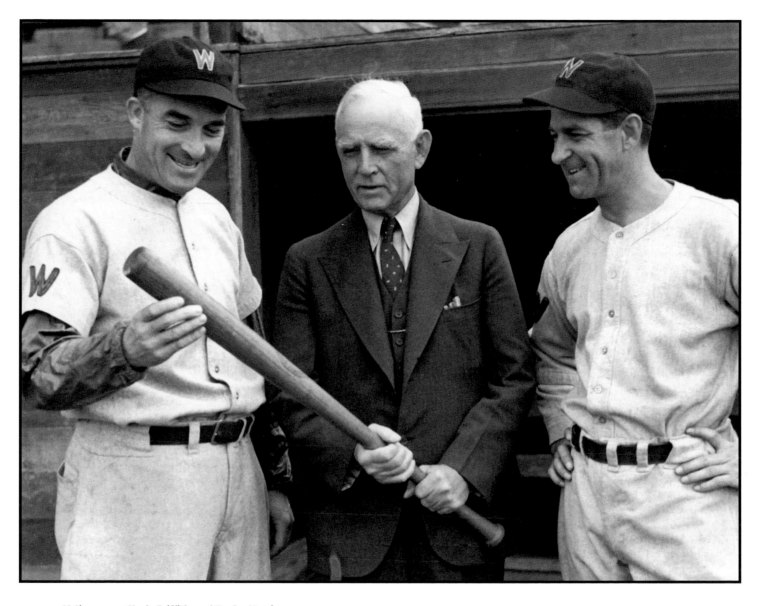

**Al Simmons, Clark Griffith and Bucky Harris**
**Spring Training, 1937**

A year after their great success, the 1934 Senators sank to seventh place, so owner Clark Griffith decided to shake things up. He brought Bucky Harris back to replace Joe Cronin as manager and began acquiring veteran players, such as outfielder Al Simmons in 1937.

With the Philadelphia Athletics, Simmons had won two batting titles and was one of the league's most feared sluggers. Griffith spent $15,000 for his contract, hoping some magic remained in the 35-year-old's bat. Simmons drove in 83 runs his first year in Washington, but his average slipped to .279. He did better the next year, hitting 21 home runs and producing 95 RBI.

Things ended badly for Simmons in Washington. The last day of the season, fans taunted him near the dugout. The outfielder let loose with a string of profanities and was immediately fined by team owner Clark Griffith. Their relationship deteriorated and Simmons was soon sold to the Boston Braves.

He played parts of another five seasons with four different teams, all as a reserve, trying to reach 3,000 hits. He fell just short, ending his career with 2,927. He was elected to the Hall of Fame in 1953.

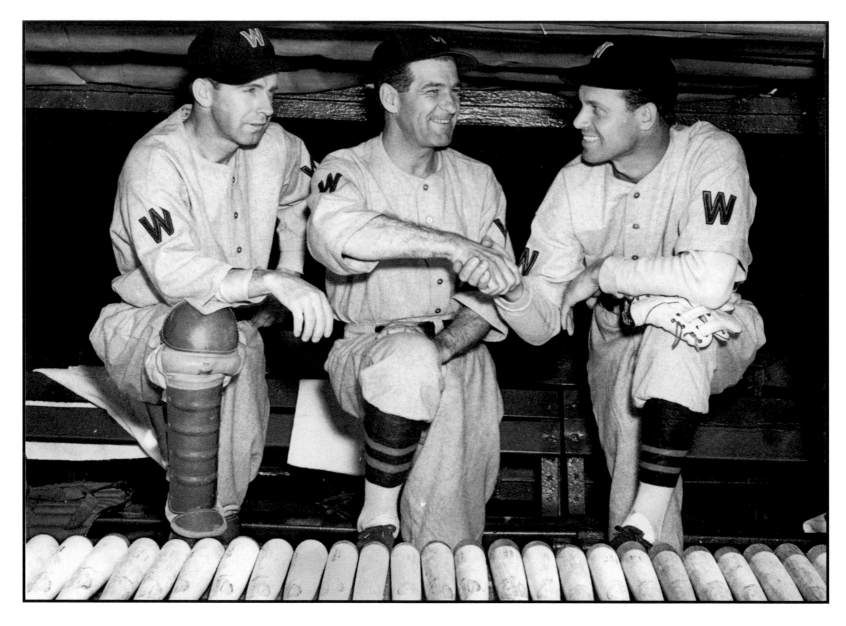

**Rick Ferrell, Bucky Harris and Wes Ferrell**
**Comiskey Park, 1937**

In his quest for veteran talent, Clark Griffith acquired Rick and Wes Ferrell in June 1937 by trading pitcher Bobo Newsom and outfielder Ben Chapman to the Boston Red Sox.

Rick Ferrell, 31, was a catcher and one of the league's finest defensive signal-callers. He would spend the next three-plus seasons as Washington's everyday backstop.

Wes Ferrell, 28, was a pitcher who could hit. He came to town having won 20 games in a season six times. He also was a hothead who picked fights with teammates and managers. He went 11-13 in the second half of the season and led the league in innings pitched for the third straight year.

The next year, with Ferrell sporting a 13-8 record, Griffith shocked fans by releasing him midway through the season. The owner's hunch proved correct because at age 30, Ferrell's arm was shot. He pitched another 40 innings over the next three years before calling it quits.

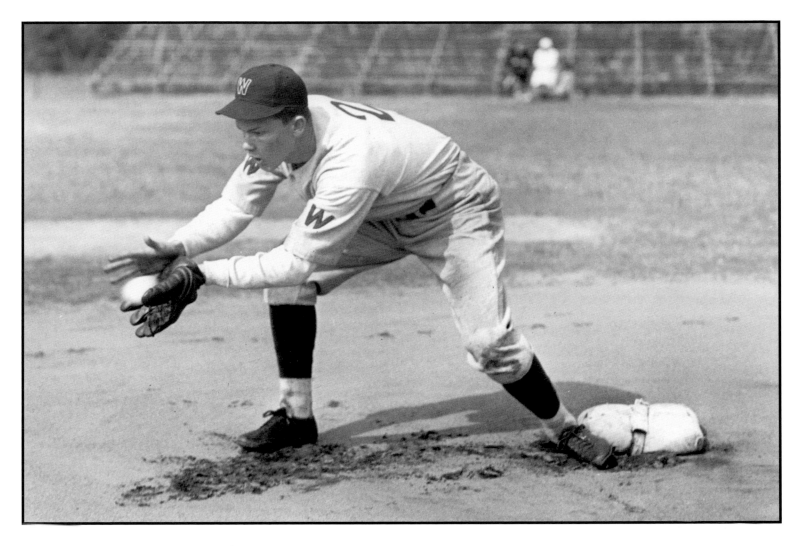

**John "Buddy" Lewis**
**Third Baseman/Outfielder, 1935 - 1941; 1945 - 1947; 1949**

For four seasons, Buddy Lewis held down the hot corner in Washington, but World War II interrupted his superb career.

Lewis joined the Senators at 19 and the next spring training, he led the team in hitting. The Senators moved veteran Cecil Travis from third base to shortstop to make room for Lewis, who hit .291 his first season. His second year, he collected 210 hits and batted .314.

"I was just an ordinary third baseman," Lewis recalled late in life. "Hitting always came easy to me. I was a left-handed hitter in a Senators lineup that had seven left-handed hitters in it, so we always saw a lot of left-handers throwing against us. I hated left-handed pitchers. I hit to all fields, there was no advantage to pulling the ball to right field at Griffith Stadium because you had a 40-foot fence in right field."

In 1938, Lewis was selected for the All-Star game and his 19 triples the next year

led the American League. He was moved to the outfield beginning in 1940. But after the 1941 bombing of Pearl Harbor, Lewis enlisted in the Air Corps. Upon completing his pilot training, and about to be shipped to the Pacific, Lewis honored his teammates by flying his C-47 transport plane low over Griffith Stadium and tipping his wings to the cheering Nationals dugout. Over the next three years, Lewis flew more than 350 missions in the Far East and was awarded the Distinguished Flying Cross.

When he returned midway through the 1945 season, Lewis quickly regained his batting stroke with a .333 average. He made the 1947 All-Star team, but retired at the end of the season because of an aversion to playing too many night games. Lewis went home to North Carolina to run his car dealership, although he attempted a brief comeback in 1949.

**John Stone, Ben Chapman and Al Simmons**
**Spring Training, 1937**

The powerful outfield of the 1937 Senators was no youth league. John Stone, who hit .341 the previous year, was 31. Seven-year veteran Ben Chapman, who had hit .332 for Washington in the second half of 1936, was 28. And Al Simmons, who knocked in 112 runs and batted .327 for Detroit the year before, was almost 35. But given their experience and combined offensive records, optimism ran high when Washington broke training camp.

But Chapman got off to a poor start and was traded to Boston in June in the deal for the Ferrell brothers. Simmons played only 104 games and his power numbers fell dramatically. Stone batted .330 and drove in 88 runs, but it was his last full season in the majors. He caught tuberculosis early in 1938 and had to retire from the game. He died at 50.

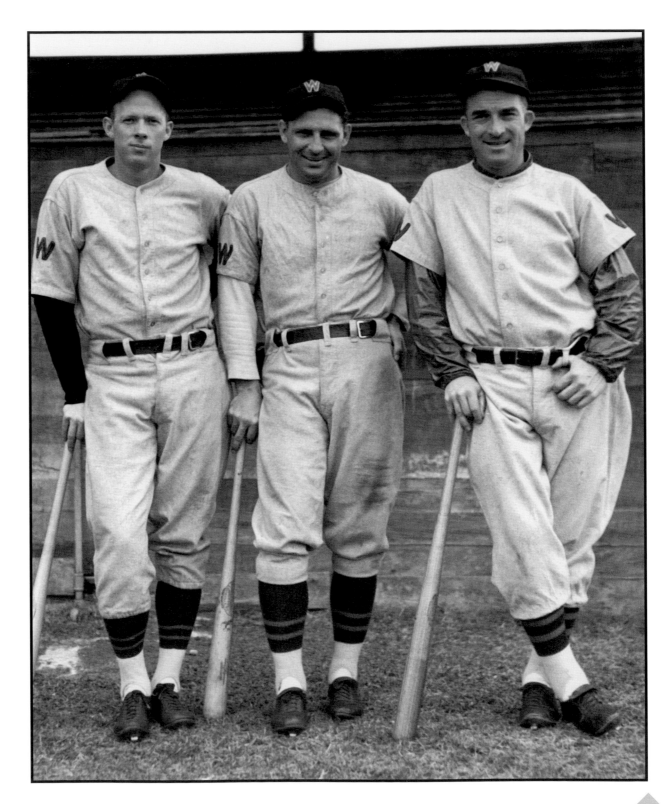

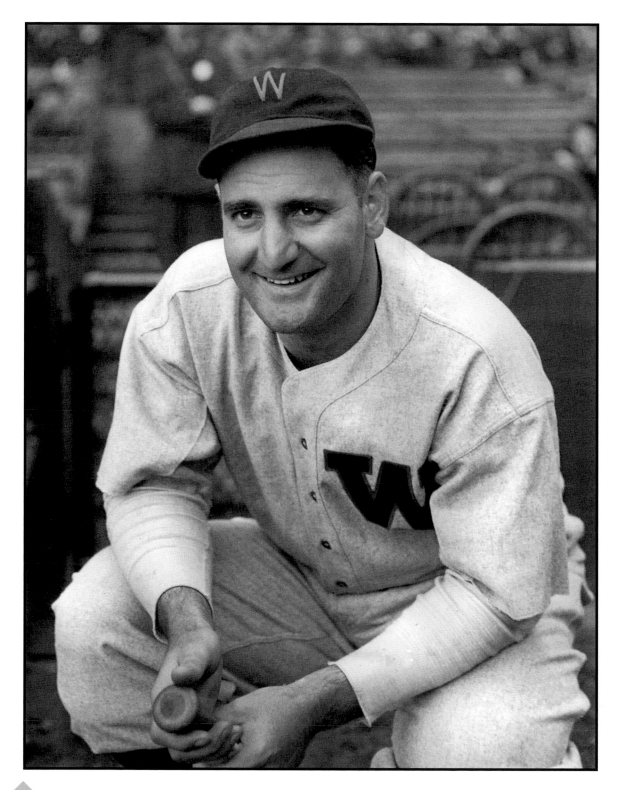

### Henry "Zeke" Bonura
### First Baseman, 1938, 1940

Zeke Bonura could hit a baseball a country mile, but couldn't play defense well enough to last in Washington.

Bonura got his nickname in 1925, when he won the AAU national championship in the javelin throw. A sportswriter who saw him compete remarked, "What a physique!"

His rookie season with the Chicago White Sox, Bonura hit 27 home runs and drove in 110 runs. In 1938, he produced 138 RBI, a franchise record that stood until Albert Belle's 152 in 1998.

In Washington, owner Clark Griffith needed offense and decided to trade first baseman Joe Kuhel to Chicago for Bonura, who was holding out for another $2,000 in a salary dispute. Griffith regretted the trade almost instantly. Washington fans were accustomed to athletic first basemen, such as Joe Judge and Joe Kuhel, who could snare anything that came their way. Bonura kept slugging but was a disaster in the field. Despite his 22 home runs and 114 RBI, Griffith shipped him to the New York Giants after one season, but two years later, needed him back for his bat. A few months after his return to Washington, Griffith sold Bonura to the Chicago Cubs to make a quick buck.

Bonura spent the war years in North Africa, Italy and France, organizing baseball programs on military installations. Starting in 1945, he played and managed in the minor leagues for 11 years before returning to New Orleans and working in the commercial real estate business.

## Ken Chase
### Pitcher, 1936 - 1941

Ken Chase battled control problems during his five seasons with the Senators. He threw hard, just didn't always find home plate. In 1937, he won four games, but pitched his best against the toughest opponents. For example, he defeated the Yankees' 20-game winner Red Ruffing twice that season and the Indians' Bob Feller once. In 1938 he threw all 12 innings in besting Cleveland's Earl Whitehill. Chase's best year was 1940, when he won 15 games but also led the league in walks.

His lack of control doomed him to four straight losing seasons. When Chase went 6-18 in 1941, Washington traded him to the Boston Red Sox. He retired after 1943 and returned to run the family dairy farm in upstate New York.

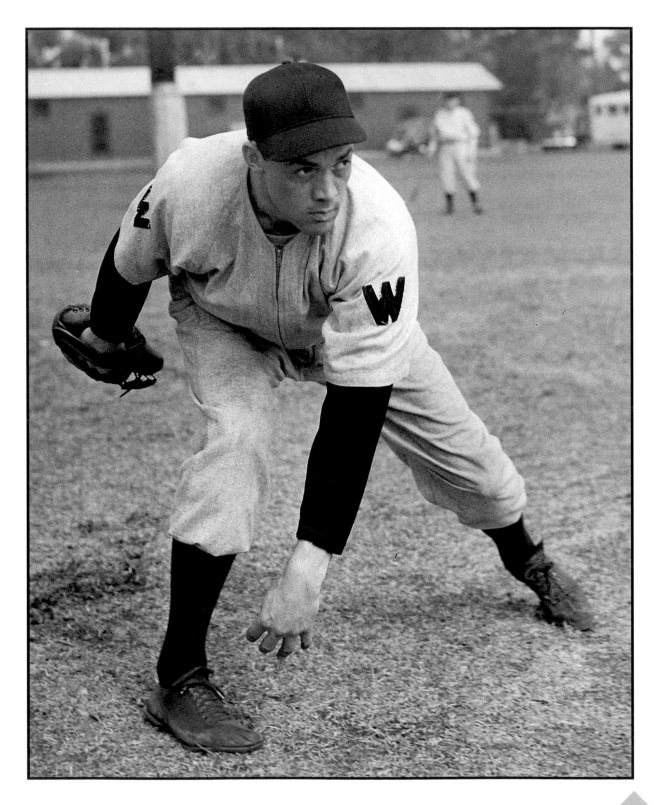

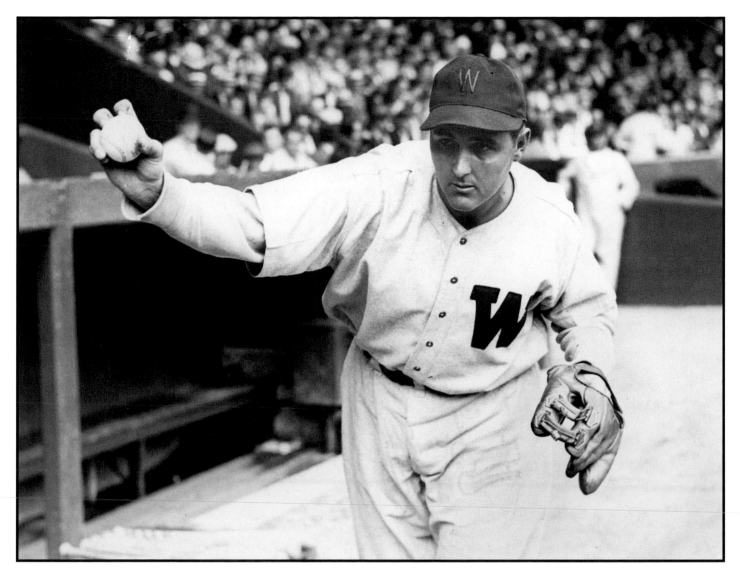

**Emil "Dutch" Leonard**
**Pitcher, 1938 - 1946**

Dutch Leonard was a knuckleball pitcher who won 20 games for Washington in 1939. The Senators found him in Atlanta, where he had learned to throw the knuckleball following an arm injury playing basketball. With Washington, Leonard won 12 games his first year and 20 the next. The 1939 highlight was a 13-inning, 1-0 shutout of Bob Feller and the Cleveland Indians. In 1941, Leonard won another 18 games as Washington finished tied for sixth place.

Leonard possessed uncommon control for a knuckleball pitcher, averaging only two walks per nine innings. His problem was having to pitch for some really bad teams. Although Leonard pitched on a winning team only three times in his 20-year career, he was selected to five All-Star teams. He also recorded 30 career shutouts.

On the final day of the 1944 season, someone tried to bribe Leonard to throw a critical game against the Detroit Tigers, who were battling the St. Louis Browns for the American League pennant. He received a call at the team hotel before the game and was offered nearly $20,000 to lose the game. Leonard told his manger about the offer, then went out and beat Detroit, 4-1.

Leonard was traded to the Phillies after the 1946 season. He spent another five years with the Chicago Cubs, mostly in relief. He retired at 44.

## Arch McDonald
### Broadcaster, 1934 - 1938; 1940 - 1956

Southerner Arch McDonald spent more than 20 years regaling Senators fans with his down-home style of broadcasting. He came from rural Arkansas, where he'd tried his hand at being a butcher, an oil rigger, a soda jerk, an appliance salesman and a boxing referee. He even spent some time in the corner of heavyweight champion Jack Dempsey.

McDonald's experiences served him well when he took over the microphone in Chattanooga in 1932. He was voted the most popular minor-league announcer in a reader poll by *The Sporting News*. Two years later, he made his debut in Washington, recreating games for listeners using the Western Union teletype. In 1937, station WJSV sent him to spring training for the first time.

McDonald briefly left Washington in 1939 to broadcast Yankees games and so Walter Johnson filled his seat. But the next season, McDonald was back to stay. In 1942, he was voted the outstanding announcer in the majors by *The Sporting News*.

McDonalds's theme song was "They Cut Down the Old Pine Tree" which he insisted on singing during every game. At the stadium, he banged a gong in the radio booth every time the Senators got a base hit. And when the weather got too hot in the summer, he sometimes worked in his underwear. Still, his cornpone humor and over-the-top delivery endeared him to listeners.

Even after his final season in 1956, McDonald continued hosting a radio sports show on WTOP. He died in 1960 while traveling by train back from New York, where he had just broadcast the Redskins-Giants football game.

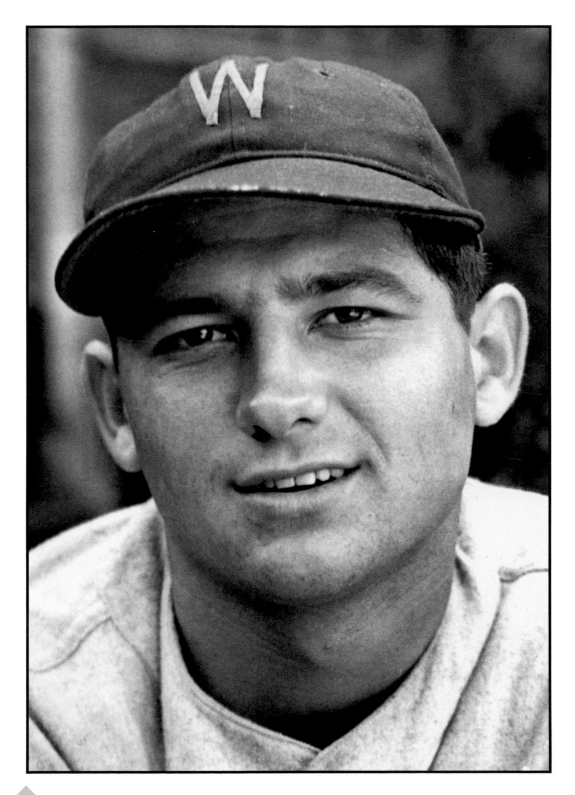

### Early Wynn
### 1939

Early Wynn was a big strong farm kid from rural Alabama who became one of the game's most-feared pitchers.

Joe Engel spotted Wynn, 17, at his Florida baseball camp in 1937 and the Senators signed him to a contract for $100 a month. He spent the next three seasons in the low minors, throwing nothing but fastballs. At the end of the 1939 season, he saw action in Washington, but was sent back after giving up 15 runs and 10 walks in 20 innings. In 1941, Wynn's 16 wins for Springfield in the Eastern League got him a second chance. He made the most of it. Wynn pitched five games for Washington at the end of the 1941 season and won three. His only defeat was a 1-0 loss to the A.L. champion Yankees.

In the starting rotation by 1942, Wynn was still trying to get by on nothing but his blazing speed. He soon discovered he needed more than a fastball to win in the majors. Wynn gradually learned to throw a variety of off-speed pitches and when he won 18 games in 1943, the press hailed him as the savior of Washington's aging pitching staff. But the last-place club won only 60 games the next year, and Wynn went 8-17. With World War II still raging, Wynn joined the Navy.

**Jake Early**
**Catcher, 1939 - 1943; 1946, 1948 - 1949**

Jake Early spent eight seasons behind the plate distracting hitters with constant chatter. Like a radio announcer, he would call the play-by-play with each pitch and pepper his narrative with a song, such as "Turkey in the Straw." His constant banter once caused Boston's Ted Williams to drop his bat in laughter. Early's favorite target was George McQuinn of the Browns. When Washington's pitcher released the ball, he'd start: "McQuinn takes the pitch for strike two with the bat on his shoulder."

Early's real value was his strong throwing arm. Never a power hitter, Early's 10 home runs and .287 average in 1941 were career highs. He was traded to the St. Louis Browns in 1947, but soon returned to Washington where he finished his major-league career.

Early spent several seasons catching and managing in the minors before returning to North Carolina and working briefly as a police officer.

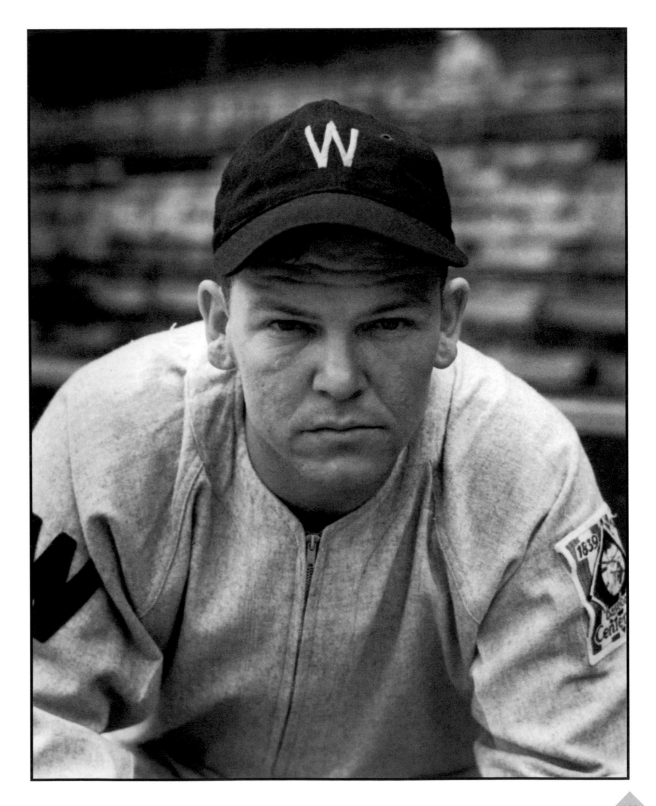

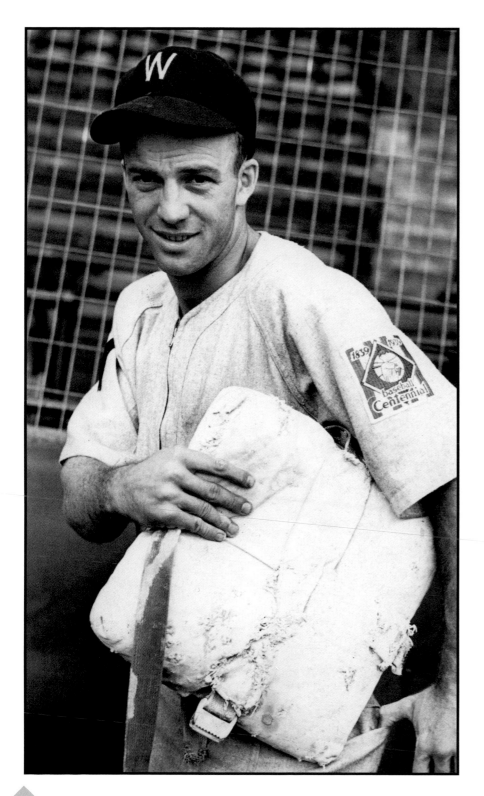

## George Case
### Outfielder, 1937 - 1945; 1947

George Washington Case led the American League in stolen bases six times. Case was tutored by Washington's veteran coach Clyde Milan, the club's all-time leader in stolen bases.

Case's streak started in 1939 when he stole 51 bases, and it peaked in 1943 with 61 steals. His raw speed and ability to read pitchers and catchers made him the most feared base-stealer in either league. Case later recalled: "You just can't run on a sign and be a good base stealer. All the time I played in Washington under Bucky Harris and Ossie Bluege, I never was given a sign."

Case also performed at the plate. During a 1940 doubleheader against the Philadelphia Athletics, for example, he collected nine hits. But a separated shoulder hampered his hitting and his back eventually gave out from the pounding that comes from hitting the dirt. He had his last big year with Cleveland in 1946 when his 28 steals led the league for the sixth and final time.

Case returned to Washington in 1947, but saw limited action. He retired at the end of the season because of his continuing back problems. In 1951, he became the baseball coach at Rutgers University, a position he held for 10 years. He later managed in the minors and coached with the Senators and Twins.

## Cecil Travis
### Infielder, 1933 - 1941; 1945 - 1947

Cecil Travis was a superb hitter who played in the shadow of the game's greatest stars. And like many men of his era, his career was interrupted by World War II.

Travis made the starting lineup his second year in Washington. Manager Joe Cronin moved veteran Ossie Bluege to shortstop to free up third base for him. Two years later, Travis was moved to shortstop to take the departed Joe Cronin's place. No matter where he played, he kept hitting.

Travis never hit below .317 his first five full seasons with the Senators. In 1941, he had his greatest season. His 218 hits made Travis the only player in either league with more than 200 safeties. His 101 RBI were the most by any Washington hitter in four years. Travis' .359 batting average was second only to Ted Williams. Still, his accomplishments were overshadowed by Joe DiMaggios's 56-game hitting streak that season and Ted Williams' .406 batting average.

At the start of the 1942 season, Travis was in Europe serving in the Army. He would return to baseball late in 1945.

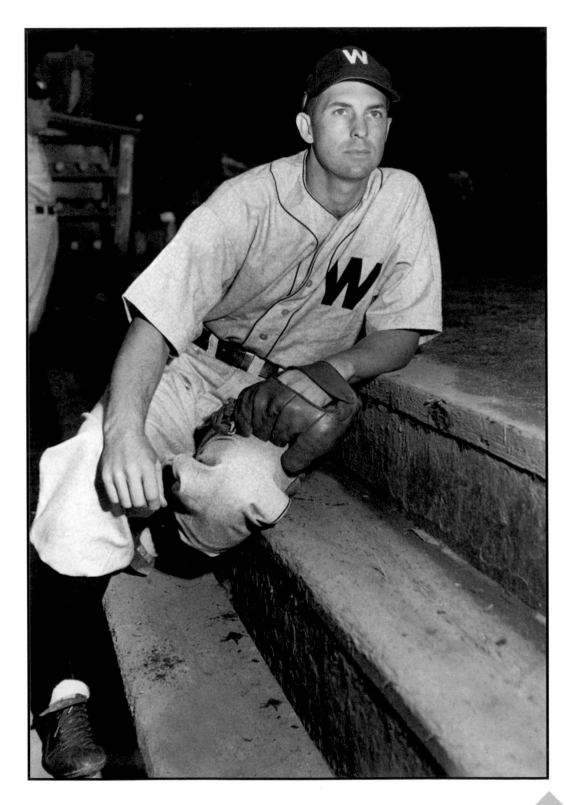

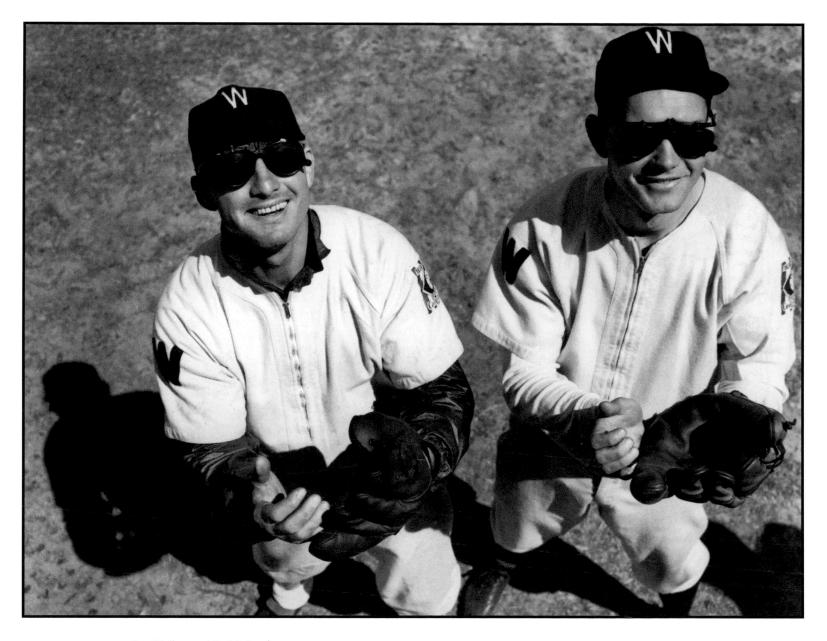

**Gee Walker and Buddy Lewis**
**Spring Training, 1940**

Hope springs eternal at spring training and in 1940, Washington fans pinned their hopes on the bats of outfielder Gerald "Gee" Walker and third baseman Buddy Lewis.

Walker had twice produced more than 110 RBI and had consistently hit well over .300. Buddy Lewis was coming off a year when he hit .319 and led the league in triples.

The pair proved powerful at the plate. Walker hit 13 home runs and drove in 96 runs to lead the team in both categories. Lewis hit .317, banged out 38 doubles and scored 101 runs. Still, the Senators ended the year in seventh place. Worse, they placed last in the league in homers and runs scored.

It was a sign of things to come. Starting in 1937, Senators fans saw only four winning seasons during the next 35 years.

### Walt Masterson
### Pitcher, 1939 - 1942; 1945 - 1948; 1952 - 1953

Walt Masterson pitched 14 years in the majors and posted a winning record only four times.

Early on, Masterson had control problems, but occasional displays of brilliance made the front office believe he had star potential. His first start for Washington, he notched a complete game victory against Detroit Tigers ace Bobo Newsom.

Masterson had an uncanny knack for getting hit by batted balls and so altered his delivery to protect himself. But the changes affected his control. He was also eventually persuaded to begin wearing glasses to correct his poor eyesight. The dark colored lenses aided him during night games and soon became his trademark.

Masterson missed three seasons after joining the Navy in 1943. When he returned late in 1945, he won a career-high 12 games, including four shutouts. His first game back, he pitched a two-hitter that blanked Bob Feller and the Cleveland Indians, 4-0. On June 8, 1947, Masterson shut out the Chicago White Sox for 16 innings until his teammates punched across a single run in the 18th inning to win the game for reliever Early Wynn 1-0. He was selected to the two consecutive All Star teams.

Masterson was traded to Boston in 1949, but returned to Washington for two more seasons starting in 1952. There, he won 10 games in 1953 including four shutouts, before retiring. In 1956, he returned to throw 49 innings for the Detroit Tigers, then hung up his glove for good.

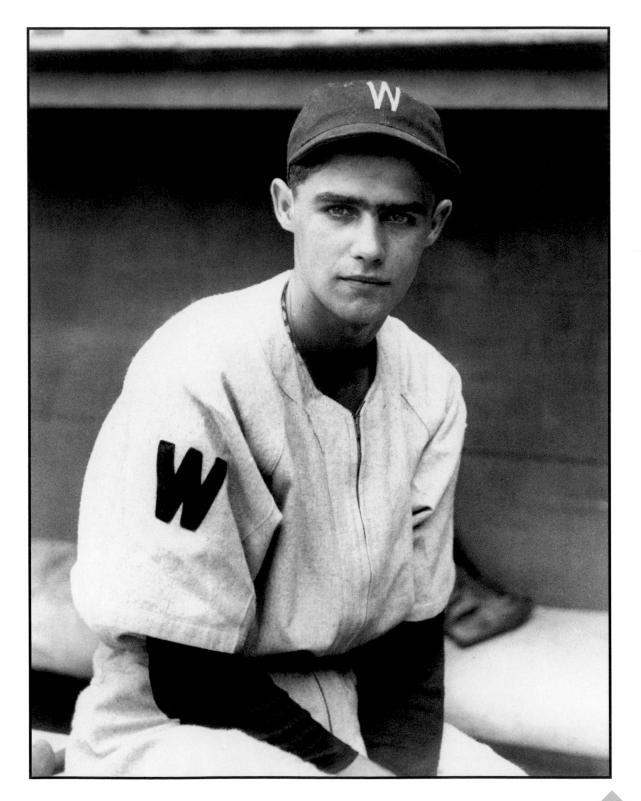

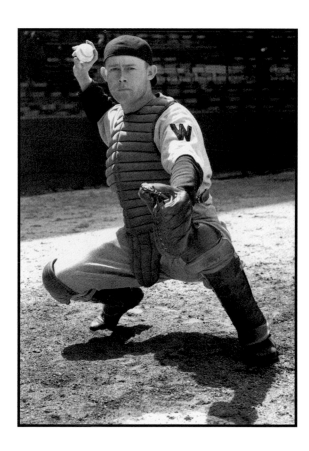

**Al Evans**
**Catcher, 1939 - 1942; 1944 - 1950**

Al Evans spent nearly his entire major-league career as a back-up catcher with the Senators, splitting duties with Rick Ferrell and then Jake Early.

Like teammate Early Wynn, Evans was signed by Washington after attending a Florida baseball school. He had a strong throwing arm, but lacked punch at the plate. He was traded to the Red Sox in 1951 and retired that same year. He managed and scouted in Washington's minor league system for many years.

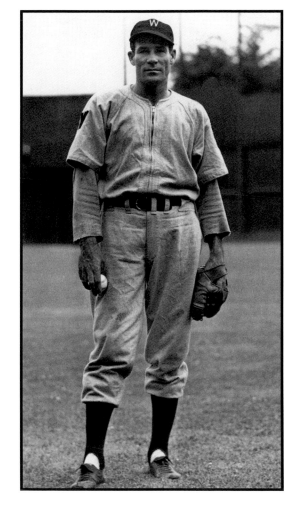

**Alex Carrasquel**
**Pitcher, 1939 - 1945**

Alex Carrasquel is believed to be the first South American player in the major leagues. Venezuelan by birth, he was pitching in Cuba in 1939 when Washington scout Joe Cambria signed him. The big right-hander spoke no English and his age was a mystery, but his fluid motion on the mound impressed Manager Bucky Harris.

During his seven years in Washington, Carrasquel pitched primarily out of the bullpen, although he made an occasional start when needed. Because of the language barrier, he needed an interpreter to communicate, usually a Latin teammate. Because of this, he was initially shunned by his teammates and treated disrespectfully in the clubhouse. Latin players were a novelty in this era and even the press wrote about them in stereotypical ways.

When Washington waived Carrasquel late in 1945, he jumped to the outlaw Mexican League for three seasons. In 1949, he threw a final three innings for the Chicago White Sox before retiring.

## Bucky Harris and Sid Hudson
### Griffith Stadium, 1940

Bucky Harris had returned to manage the Senators in 1935. For the next eight years, Harris would be saddled with a second-division club that enjoyed only one winning season(1936). Occasionally, though, a talented rookie would burst onto the scene and give fans hope. Such was the case with Sid Hudson, a string-bean pitcher from Chattanooga.

Hudson had only two seasons of minor league ball under his belt when he took the majors by storm during the second half of the 1940 season. Hudson threw a pair of one-hitters and won 17 games for the seventh-place Senators. Although Hudson was 13-14 for Washington in 1941, it was really World War II which put a halt to his success.

Hudson enlisted in the Army in 1942 and spent three years directing young recruits through conditioning drills. He developed arm problems from a bone spur in his shoulder, and doctors later recommended a new pitching style.

When Hudson returned to the mound in 1946, he was throwing sidearm. He remained with Washington for six-plus seasons, but never had another winning record.

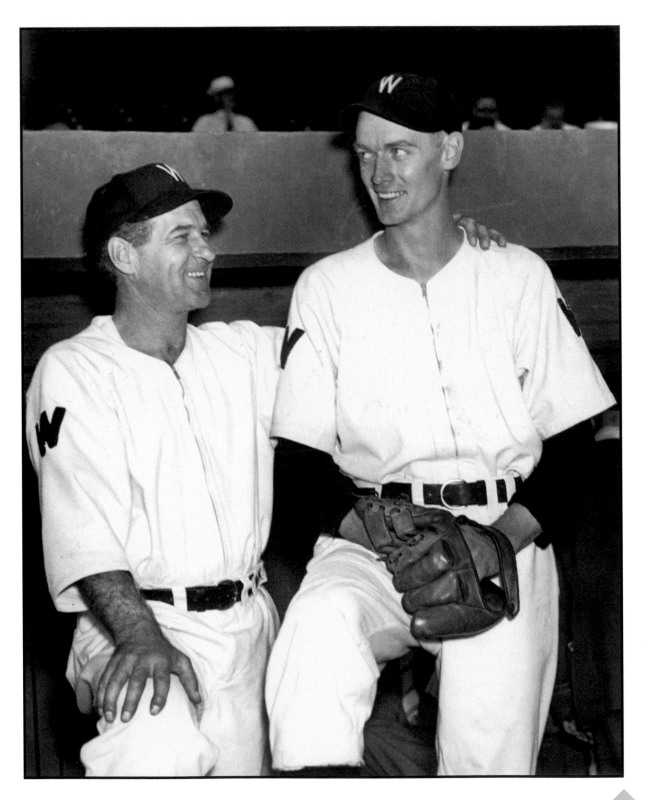

## Clark Griffith
## 1943

The Cincinnati Reds ushered in a new era of baseball in 1935 by installing lights and playing night games, but other clubs were slow to follow suit. Clark Griffith initially spoke against the idea because of the expense. But after watching a 1939 game under the lights at Philadelphia's Shibe Park, he became a champion of night games and urged the American League to allow them as quickly as possible.

On May 28, 1941, the Griffith Stadium lighting system - 740 high-watt bulbs on eight steel towers - was unveiled before a crowd of 25,000 who saw the Senators lose their 10th straight game to the Yankees. In the end, the size of the crowd became more important than the score of the game, given that weekday games were drawing fewer than 3,000 people.

Citing the huge surge in attendance, Griffith twice petitioned Commissioner Landis to allow Washington to increase the number of night games. Several influential club owners, the Yankees among them, wanted the number of night games strictly limited to seven per season. For two years, Landis refused to budge.

Finally, in July 1943, citing the needs of wartime shift workers, Landis made an exception for Washington. Griffith immediately re-worked the remainder of the schedule to include a total of 35 night games. For a cash-strapped ball club like the Senators, the crowds proved a financial windfall.

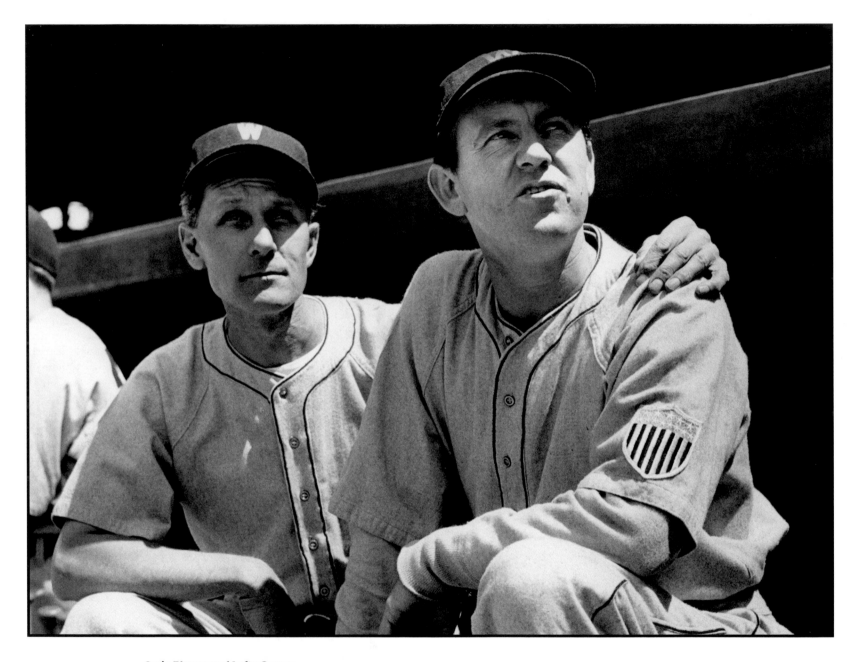

**Ossie Bluege and Lefty Gomez**
**Comiskey Park, 1943**

Vernon "Lefty" Gomez put up big numbers with the Yankees. During 13 seasons in New York, he won two ERA crowns, won 20-or-more games four times and led the league in strikeouts and shutouts three times. But when Gomez came to the Senators at age 33, his arm was shot.

In his only start, he pulled a shoulder muscle after throwing 4 2/3 innings, but not before allowing the White Sox four runs on four hits. Gomez knew it was over a week later when he struggled in an exhibition game against a minor league club. He never pitched in the majors again.

Gomez later went to work for the Wilson sporting goods company and in 1972, he was elected to the Hall of Fame.

## Harlond Clift
### Third baseman, 1943 - 1945

Washington acquired Harlond Clift a little too late in his career. With the St. Louis Browns, he had twice driven in 118 runs in a season and his 34 home runs in 1938 had set a new record for third baseman, since broken.

After playing just eight games with the Senators, however, Clift caught the mumps. Later, he injured his shoulder in a fall from a horse. He missed all but 12 games of the 1944 season and could only watch as his former team, the Browns, won their only American League pennant.

Never able to regain his batting stroke, Clift retired after the 1945 season. He managed and coached briefly in the minors.

### Rick Ferrell
### Catcher, 1944 - 1945; 1947

World War II roster shortages gave older players the chance to play a few extra years, which is how catcher Rick Ferrell, 38, came to return to the Senators. Ferrell came back to catch Washington's three knuckleball pitchers. He caught more than 90 games for two straight years and helped Washington to a second-place finish in 1945. He retired in 1947, after attempting a final comeback.

Rick Ferrell was elected to the Hall of Fame in 1984.

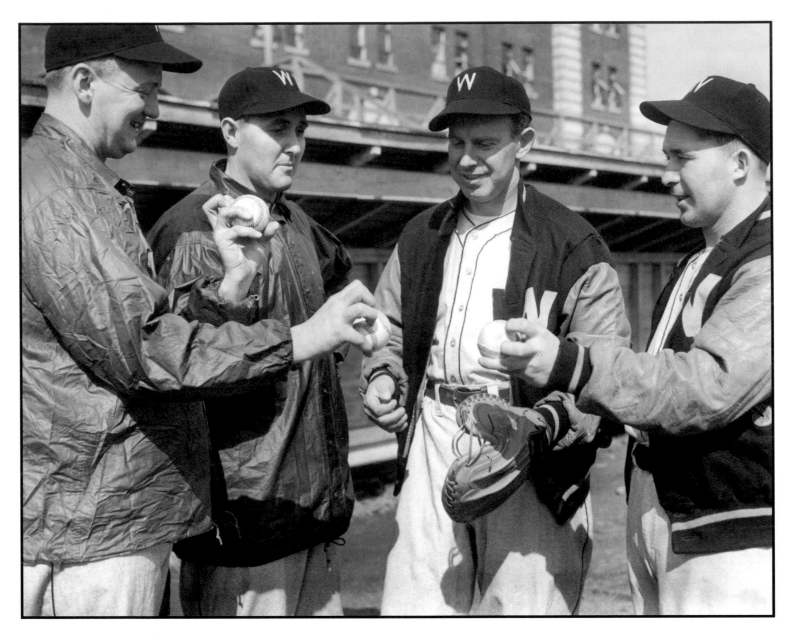

**Roger Wolff, Dutch Leonard, Rick Ferrell and Mickey Haefner**
**Spring training, 1944**

Because of government-imposed travel restrictions during the war, the 1944 Senators held spring training on the University of Maryland campus in College Park. This is where the team's three knuckleball pitchers were photographed with catcher Rick Ferrell.

Despite throwing a notoriously hard pitch to control, the Washington pitching staff allowed the fewest walks in the American League that season.

Roger Wolff won 20 games and had the lowest ERA on the team. Dutch Leonard went 17-7 and threw four shutouts. Mickey Haefner won 16.

The trio won the American League's ERA crown and their 19 shutouts tied with Detroit's for first. In their first real pennant race since 1933, the Senators came up only 1 ½ games short of the Tigers.

**Mickey Vernon**
**First baseman, 1939 - 1943; 1946 -1948**

James "Mickey" Vernon played parts of four decades in the majors, starting with the Senators in 1939 and finishing with Pittsburgh in 1960. In between, he collected 2,495 hits and won two American League batting titles.

Vernon was one of the most popular players ever to wear a Washington uniform. His left-handed swing produced a steady stream of runs. He knocked in at least 80 runs in nine of his 11 full seasons with Washington and led the league in doubles three times. At first base, his long reach and graceful glove work saved many an errant throw. And he excelled at double plays, once collecting two unassisted double plays in a single game and 10 in a doubleheader.

Vernon missed two years to service in World War II, but when he returned in 1946, he won the first of two batting titles. Before the 1949 season, owner Clark Griffith made the worst trade in franchise history, sending Vernon and pitcher Early Wynn to Cleveland for three players. Vernon returned to Washington midway through 1950 and spent another five years anchoring the Senators infield. Wynn, meanwhile, spent a Hall-of-Fame career with the Indians. Vernon later managed the expansion Senators for two-plus seasons.

## George Myatt
### Infielder, 1943 - 1947

George Myatt was an everyday player for only two of five seasons with the Senators. He alternated between shortstop and second base, but was best on the base paths. Given a chance to play every day, Myatt stole 30 bases in 1945 and hit a career-high .296.

His greatest achievement came on May 1, 1944, in a game at Boston's Fenway Park. He connected for six consecutive hits and drove in four runs, helping Washington win, 11-4.

Myatt retired from playing after the 1947 season, but managed in the Senators farm system for two seasons before returning to Washington to coach for another five years. He spent another 17 years in the majors, coaching with five other teams.

## Milo Candini
### Pitcher, 1943 - 1944; 1946 - 1949

Milo Candini's best major-league season was his first. He spent six years in the Yankees farm system, but was traded to Washington because of chronic arm problems. There, trainer Mike Martin made Candini his personal reclamation project, betting Clark Griffith a new suit that he could improve the right hander's arm. He did.

By June, Candini had won seven straight games for the Senators. A complete-game, 1-0 victory over Boston was followed by an 11-inning victory over Philadelphia. During his streak, he allowed only four earned runs in almost 50 innings of work. He was the talk of the American League.

Candini spent 1945 in the Army infantry, but never regained his form after returning to Washington late in 1946. He began pitching almost exclusively out of the bullpen and went 7-7 his final five years in the majors. He spent most of 1949 in the Pacific Coast League, where he won 15 games for Oakland. In 1952, he set a new PCL record by appearing in 69 games.

**Joe Kuhel**
**First baseman**, 1944 - 1946
**Manager**, 1948 -1949

At 38, Joe Kuhel returned to Washington after six years in Chicago to man first base while Mickey Vernon served in the military. When Vernon returned in 1946, Kuhel was traded back to the White Sox, where he finished his playing days the next year.

In the fall of 1947, Kuhel was named Washington's new manager and took over a club that had lost 90 games and finished seventh the year before. Though no one thought it could get any worse, it did. By Kuhel's second season, Washington's record was 50-104. It was the most losses by the Senators in 40 years. He was replaced in 1950 by Bucky Harris, who returned for a third stint as Washington manager.

## President Roosevelt and Clark Griffith
## 1945

When World War II threatened to shut down the national pastime, baseball owners pleaded with the White House to keep baseball up and running. As baseball's local representative, owner Clark Griffith hand delivered the request to President Franklin Delano Roosevelt. Early in 1942, FDR wrote a letter assuring club owners that baseball was an "essential industry" to the war effort. The games would continue.

Just prior to the start of the 1945 season, Griffith returned to the White House to present President Roosevelt with two season passes and, for the First Lady, a leather handbag with her initials embossed in gold.

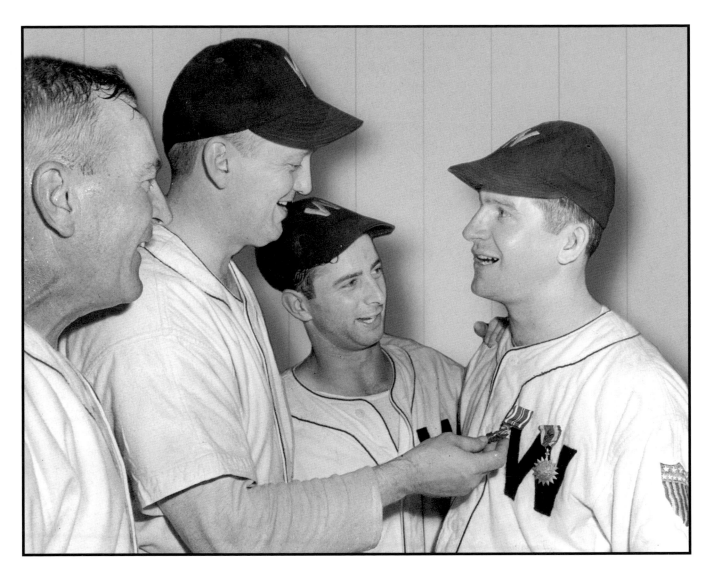

**Joe Judge, Roger Wolff, Marino Pieretti and Bert Shepard**
**Griffith Stadium, 1945.**

Bert Shepard was a minor league pitcher in 1942 when he was drafted into the Army Air Corps. Two years later, he lost his right foot in a bombing raid over Berlin. He was fitted for an artificial leg at Walter Reed Hospital, where he met Under-Secretary of War Robert Patterson and spoke of his dream to pitch again. Patterson called Clark Griffith, who arranged a tryout during spring training of 1945.

In camp, Shepard proved he could pitch effectively and field bunts with ease. He was signed as a coach and put on the team's active roster. He threw three innings in an exhibition game against Brooklyn, convincing Griffith that he could face major league hitters. But in the heat of a pennant race, Manager Ossie Bluege refused to pitch him.

In the second game of an August 4 doubleheader, Shepard finally got his chance. The Senators were losing to Boston, 12-0, in the fourth inning. Shepard entered the game with two outs in the fourth. He struck out the final batter and retired the side. More impressively, he pitched the remaining five innings, allowing only three hits and a single run.

Eleven days later, World War II ended. Shepard was awarded the Distinguished Flying Cross in a pre-game ceremony at Griffith Stadium that September, but he never again pitched in the major leagues.

**Ossie Bluege and Cecil Travis**
**Griffith Stadium, 1945**

Infielder Cecil Travis spent almost four years in the military and suffered frostbite on his feet during the infamous "Battle of the Bulge." He returned to baseball in late 1945, but his injuries and the long layoff had eroded his skills. He played in just 15 games. A lifetime .314 hitter, Travis batted just .250 in 1946. He retired midway through the next season at age 33.

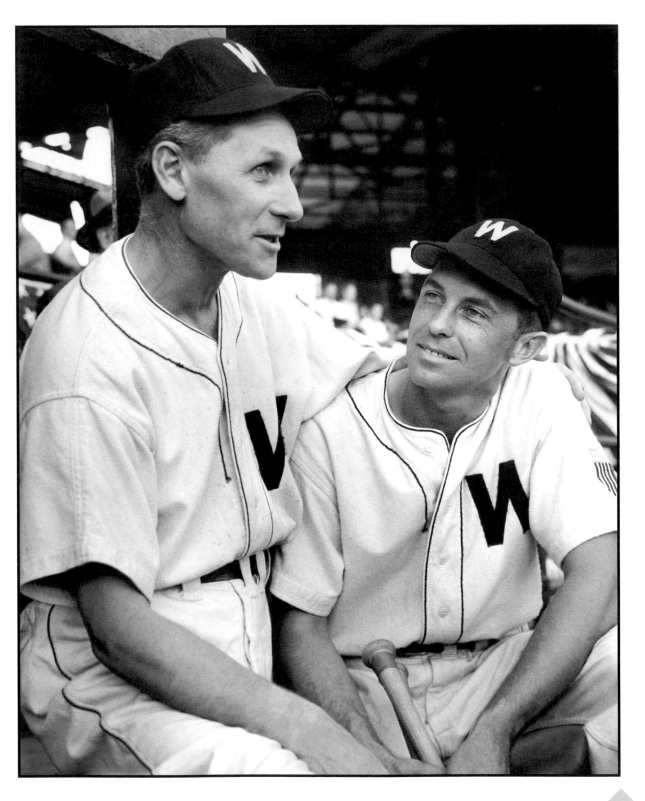

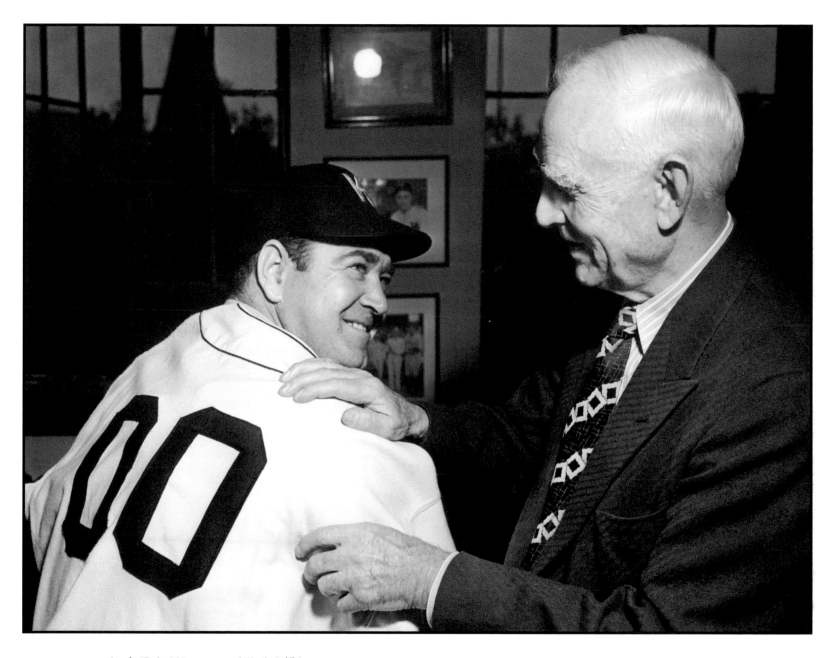

**Louis "Bobo" Newsom and Clark Grifith**
**Griffith Stadium, 1946**

During his 20-year career in the majors, Bobo Newsom changed teams 16 times and pitched for Washington on five different occasions. He is shown here in 1946 after joining the Senators for the fourth time. Newsom is in Clark Griffith's office, showing off his double-zero jersey. Newsom began wearing "00" with Washington in 1943, and was the first major-league player to wear that number.

Newsom was a superb pitcher who won 20 games for three straight years with the Browns and Tigers. He was unusually durable and led the league in starts for four straight seasons. He could also be wild, twice leading the league in walks. Newsom ended his major-league career in 1953 at age 46.

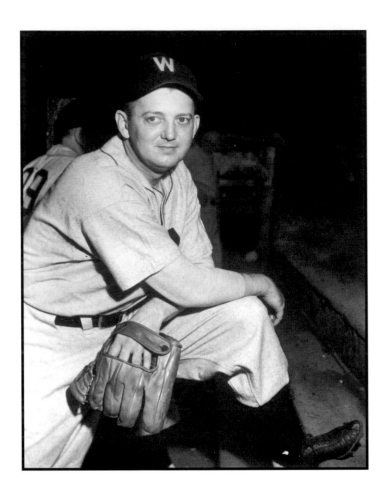

## Roger Wolff
### Pitcher, 1944 -1946

Knuckleballer Roger Wolff was acquired from the Athletics in a trade for Bobo Newsom after the 1943 season. Wolff went only 4-15 as the Nationals finished last in 1944, but won 20 the following year as Washington contended for the American League flag. It was to be his finest year in the majors as his 2.12 ERA was third-best in the American League.

But, when the better players returned from the war in 1946, Wolff's record dropped to 5-8. He was traded to Cleveland in 1947 when George Case was re-acquired, but failed to win a game for the Indians. It was his last season in the big leagues.

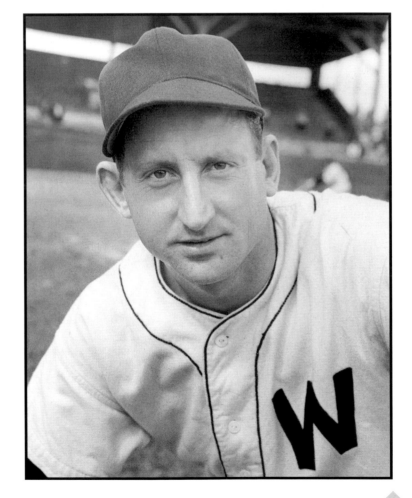

### Ray Scarborough
### Pitcher, 1942 - 1950

Right-hander Ray Scarborough was a native North Carolinian who broke in with the wartime Senators of 1942. He spent parts of seven seasons in Washington, predominantly as a starter. He peaked statistically with the 1948 Nats, winning 15 against only eight losses for a 7th place team. He also finished second to Cleveland's Gene Bearden in the ERA race at 2.82. Scarborough had perhaps an even more impressive year in 1949, going 13-11 for a last place team that finished 50-104.

He was traded to the White Sox in a six-player deal in 1950, and later saw World Series action with the 1952 Yankees.

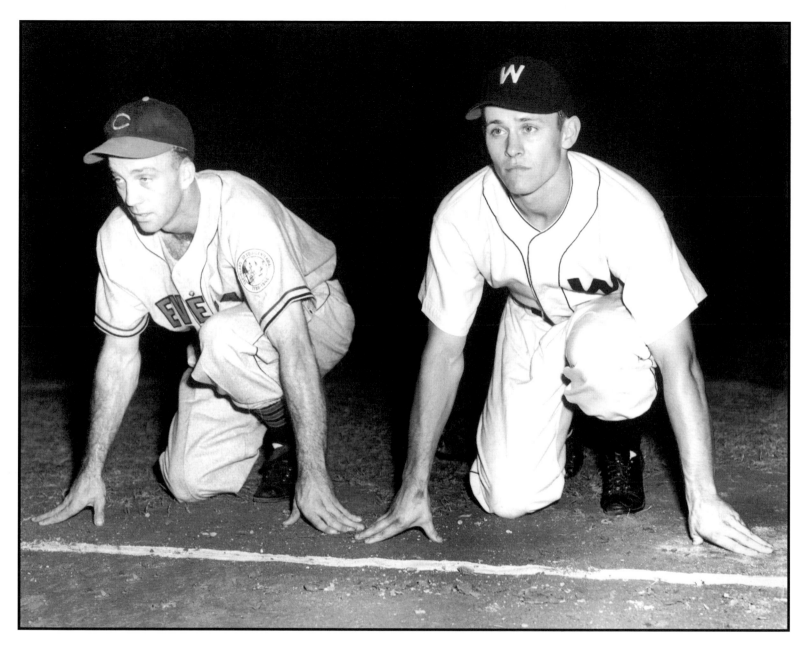

**George Case and Gil Coan**
**Griffith Stadium, 1946**

Gil Coan's foot speed was just one reason why he was so highly touted as a prospect in the Washington farm system in the 1940's. It also prompted the club to trade former AL stolen base leader George Case to Cleveland to make room for Coan on the roster.

When Case returned to Washington in an Indians uniform in 1946, the promotion-conscious Clark Griffith scheduled a match race between the two. It was a 100-yard dash between the rookie and the veteran, and Coan came up short.

Coan started off well behind Case, caught up at 60 yards, then broke stride and lost by a couple of yards. Case was clocked at 10 seconds flat, Coan at 10.1.

**Stan Spence and Buddy Lewis**
**Cleveland Stadium**, 1947

After serving in World War II, Stan Spence and Buddy Lewis formed two-thirds of the 1947 Senators' outfield. Spence was a five-year starter named to four All-Star teams. Base runners feared his strong, accurate throwing arm and pitchers respected his performance at the plate. His best season was 1944, when he hit .316, drove in 100 runs and went 6 for 6 in a game against the Browns.

Spence spent 1945 in the Navy, but returned the next year and eventually slugged 66 home runs in a Washington uniform. He was traded to the Red Sox in 1948 and finished his career with the Browns in 1949.

Lewis missed three and a half seasons because of the war. When he returned late in 1945, he was 28. He put up two solid seasons, but retired after the 1947 season. He attempted a comeback in 1949 and then retired for good.

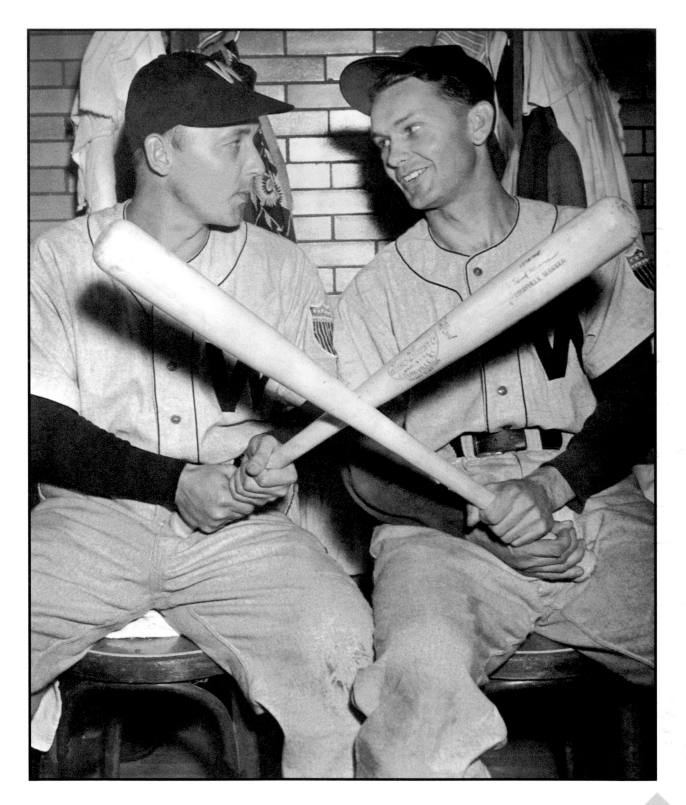

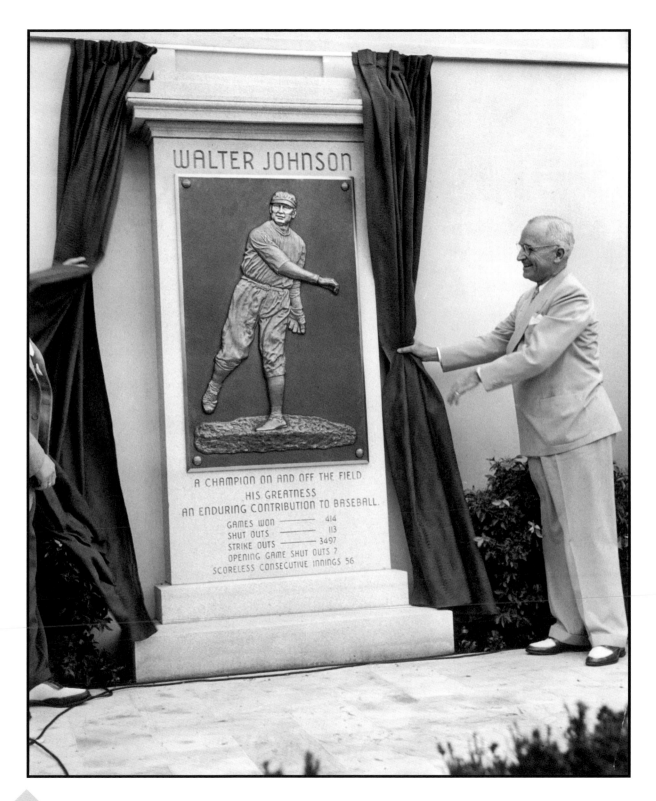

**President Truman**
**Griffith Stadium, 1947**

Walter Johnson, the greatest player in the history of professional baseball in Washington, died on December 10, 1946, after an eight-month battle with brain cancer. The following season, President Harry S. Truman unveiled a memorial to Johnson at Griffith Stadium before a June 21 game with the Browns.

In his remarks, the President called Johnson "the greatest ballplayer who ever lived...a great American, and great citizen of the United States." The memorial was later moved to Walter Johnson High School in Bethesda, Maryland in 1962 where it remains today.

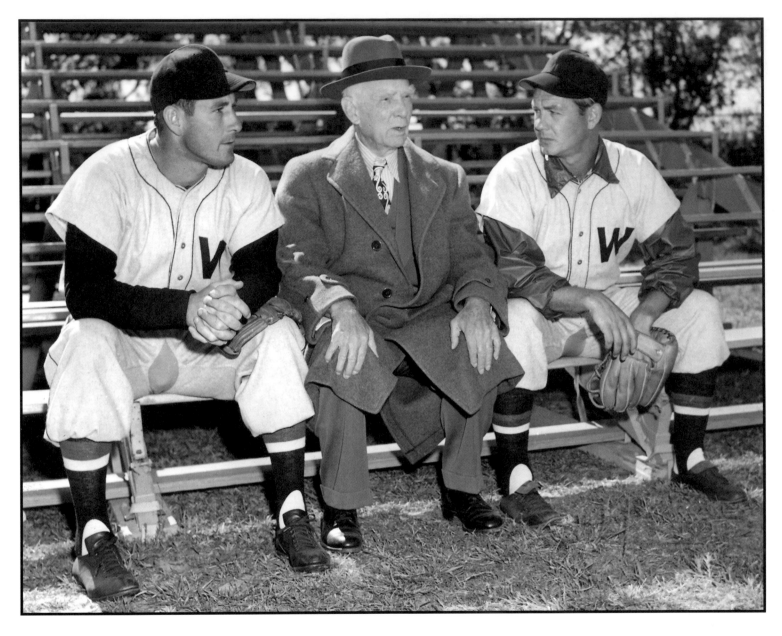

**Joe Haynes, Clark Griffith and Sherry Robertson**
**Spring Training, 1949**

Clark Griffith's two nieces, who were raised like daughters, both married ballplayers named Joe. Mildred married Senators shortstop Joe Cronin and Thelma married Chicago White Sox pitcher Joe Haynes, whose career began with the Nationals in 1939.

Because Thelma enjoyed living in Washington, the Old Fox reacquired Haynes in the winter of 1948-49 in perhaps his worst deal ever. He gave up future Hall of Famer Early Wynn and former AL batting champion Mickey Vernon in the multi-player deal. Haynes went on to win 10 games for Washington over the next four years before moving into the front office.

Sherry Robertson, Thelma's and Mildred's brother, spent all but 43 games of a 10-year career with Washington, playing both the outfield and infield. Like Haynes, he ended up in the front office.

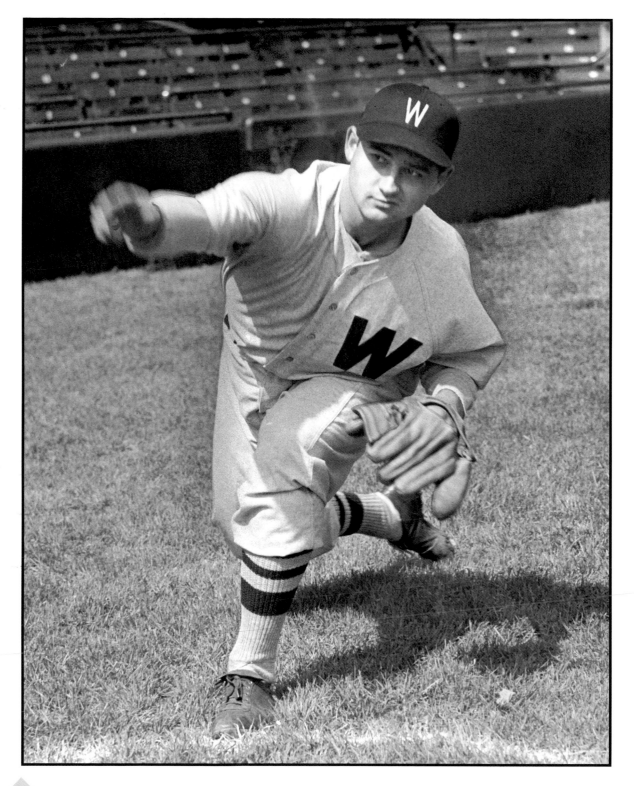

**Early Wynn**
**1947**

Early Wynn won 18 games for Washington in 1943, but joined the Army after posting a losing record the next year. He spent the entire 1945 season in the tank corps, but returned midway through the following season, going 8-5.

After Washington finished in seventh place in 1947, with Wynn winning 17 games, team owner Clark Griffith openly questioned his pitcher's weight and conditioning. He offered Wynn $100 to lose 30 pounds. Wynn lost 35 and won the bet, but also told reporters it had taken the zip off his fastball. He went 8-19 the next season.

His patience lost, Griffith traded the big right-hander and Mickey Vernon to Cleveland in 1948, one of the worst trades in franchise history. Wynn became a consistent winner in Cleveland, developing an arsenal of off-speed pitches to go with his trademark fastball. He won 20 or more games five times and ended his career with exactly 300 victories. Wynn was elected to the Hall of Fame in 1971.

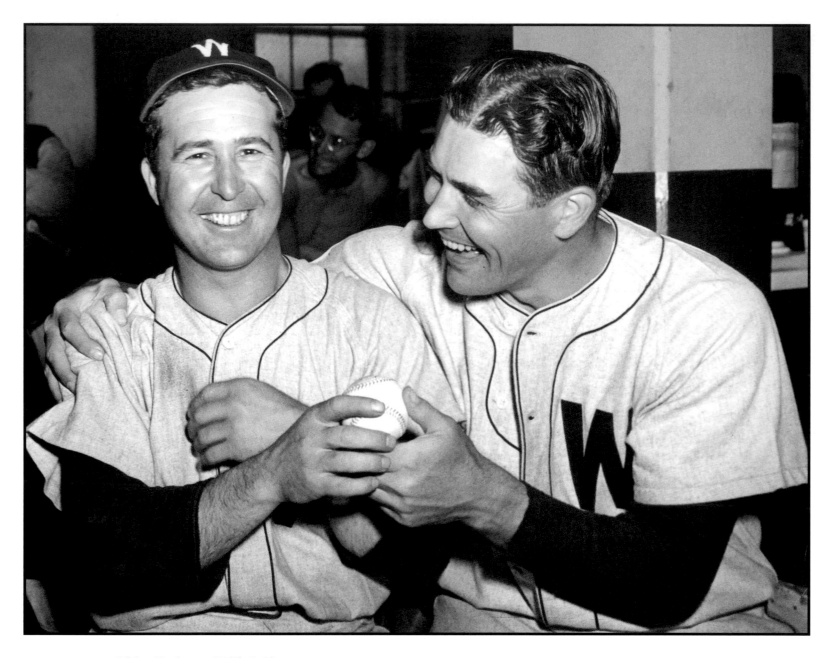

**Mickey Haefner and Eddie Robinson**
**Cleveland Stadium, 1949**

The 1949 Senators won their season opener, then lost seven straight. It looked like another dismal season until they went on their first western road swing May 3-10 through Chicago, St. Louis and Cleveland. Joe Kuhel's club swept the White Sox, the Browns, and the Indians to earn nine straight victories, their longest winning streak since 1912.

Win number eight of the streak was a one-hitter by knuckleballer Milton "Mickey" Haefner against the defending World Champion Tribe, the only hit a first inning single by Larry Doby. Robinson had the game's lone run batted in.

The streak's euphoria would be short-lived, however, and Haefner would be sold to the White Sox that July.

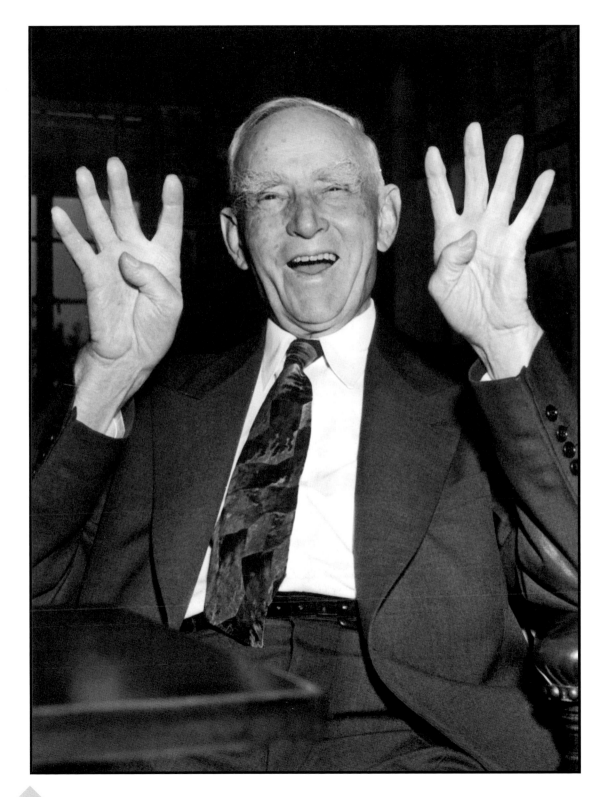

**Clark Griffith**
**Griffith Stadium, 1949**

The nine-game winning streak of early May 1949 brought joy to owner Clark Griffith and the approximately 5,000 fans that greeted the club's return to Washington at Union Station. A motorcade down Pennsylvania Avenue produced more crowds, waving signs reading "We'll Win Plenty with Sam Dente," "Drink a Toast with Eddie Yost," and "No Raspberries for Our Boy Sherry."

The streaky nature of the 1949 club did them in, however. While they would enjoy additional winning streaks of seven and 11 games, they hit last place in August and stayed there. They won only 16 of their final 74 games, and finished 50-104, their worst record since 1909. Joe Kuhel was fired as manager and Bucky Harris returned for his third tour of duty as the Nationals' manager.

## Eddie Yost
### Third baseman, 1944; 1946 - 1958

Edward Fred Joseph Yost signed with the Senators as a 17-year-old Brooklyn schoolboy in 1944. He went straight to the major leagues, appearing in seven games that war-time season. He spent 1945-46 in the military, and when he returned, was slated for assignment to the minor leagues for additional seasoning. One problem: as a returning veteran, he was guaranteed his old job back, so he stayed with the big club.

Yost never looked back, and spent the next four decades in the major leagues as either a player or a coach. His patience at the plate earned him the nickname "The Walking Man," as he led the American League in walks six times, and ranks in the top ten all-time with 1,614 free passes.

Yost was traded to Detroit for Reno Bertoia following the 1958 season, and returned to Washington as a coach with the expansion Senators in 1963.

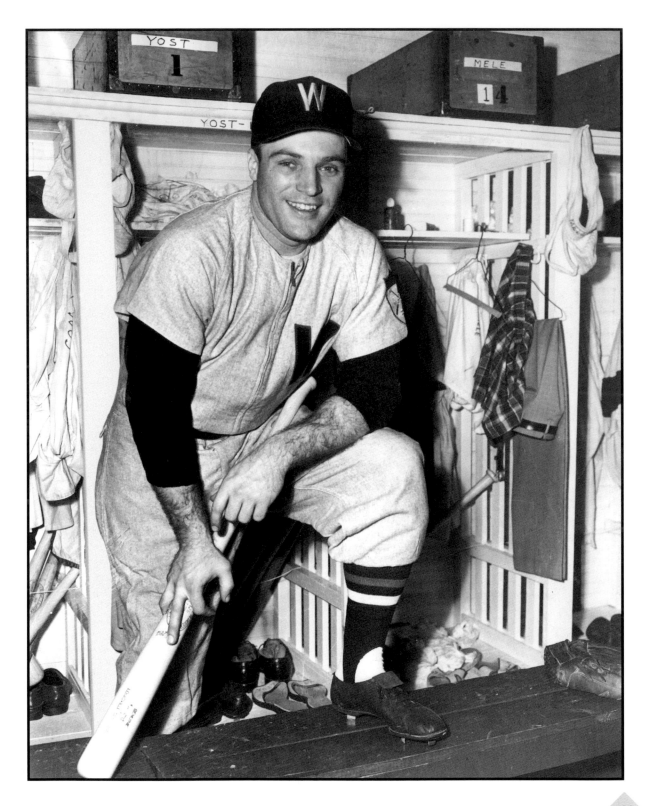

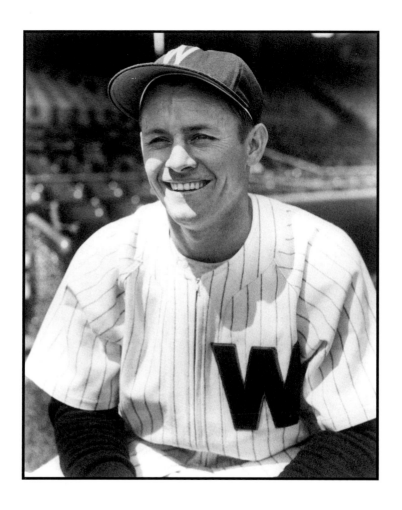

## Gil Coan
### Outfielder, 1946 - 1953

Gil Coan was signed by the Nationals out of Brevard Junior College in 1944. He was an immediate sensation in the minor leagues, batting .367 in Class D and .335 at Double A Chattanooga his freshman year in pro ball. With the Lookouts in 1945 Coan won *The Sporting News* Minor League Player of the Year award, batting .372 with 117 RBI.

Early promotions to Washington never paid off, as he struggled against big league pitching. He seemed to come of age in 1950-51, batting .303 both seasons. He dropped to .205 in 1952, and .196 in 1953, and was traded to the Orioles in 1954 for slugger Roy Sievers, proving that his early potential was still marketable.

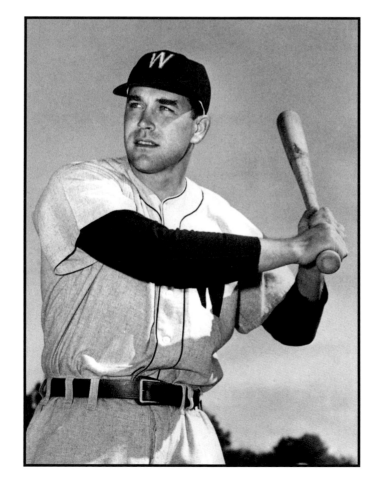

## Eddie Robinson
### First baseman, 1949 - 1950

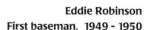

Eddie Robinson took over for Mickey Vernon at first base in 1949 when Clark Griffith traded Vernon and Early Wynn to Cleveland. Robinson was a consistent run producer everywhere he played. In 1949, he batted .294 with 18 homers and 78 RBI and made the All-Star team. His tenure in the capital was short-lived, however. After just 36 games - and a single home run - in 1950, he was dealt to the Chicago White Sox, where he would have the most productive years of his major league career.

Beginning in 1951, Robinson drove in over 100 runs for three straight years and was selected to to two consecutive All-Star teams. That same season, he became the first White Sox player to ever hit a ball over the roof of Comiskey Park.

Robinson retired after the 1957 season and later worked as the General Manager of the Atlanta Braves and the Texas Rangers in the 1970's.

### Connie Marrero
**Pitcher, 1950 - 1954**

Conrado Eugenio Marrero was a 39-year-old rookie with the 1950 Senators, another in the long line of scout Joe Cambria's Cuban recruits. Marrero was short in stature - just 5'5" tall - and threw an assortment of junk and off-speed pitches that baffled even the best hitters. Ted Williams hated to face Marrero - "He throws you everything but the ball" - and the diminutive right hander seemed unaffected by the aging process.

He twice was an 11-game winner for the Nats, and finished his big league career 39-40, with a respectable 3.67 ERA.

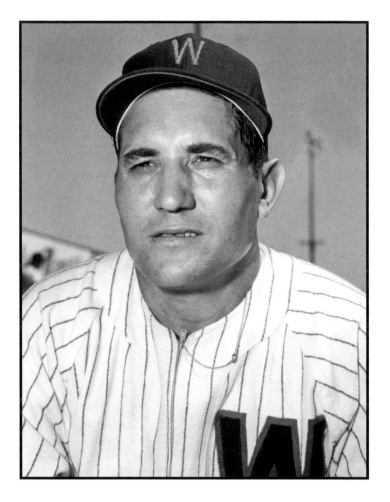

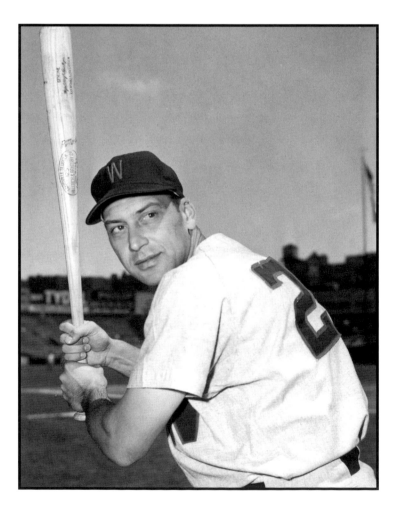

### Clyde Vollmer
**Outfielder, 1948 - 1950; 1953 - 1954**

Clyde Vollmer was a serviceable outfielder who represented the franchise's futility during two tours with the mediocre Nationals. Vollmer was playing for the Cincinnati Reds' farm team in Syracuse when the Nats bought his contract for $25,000 and put him in the starting lineup. It is a mark of how pathetic Washington's offense was that Vollmer's 14 home runs and 59 RBI were the second highest totals on the team in 1949.

Traded to Boston early in 1950, Vollmer caught fire and became the talk of the league during July 1951. Over a 19-game stretch, he hit 13 home runs and knocked in 40 runs.

One game into the 1953 season, Vollmer was sold back to Washington, where he finished his career as a part-timer in 1954.

**Clark Griffith**
**Griffith Stadium**, 1952

The 1952 season represented Clark Griffith's 40th anniversary with the Washington American League ball club.

Newspaper photographers were on hand to record Griffith, at age 82, displaying his pitching form, resplendent in a Nats uniform, complete with their new cap for 1952, with an all-red block "W".

## Jim Busby
### Outfielder, 1952 - 1955

Native Texan Jim Busby came to the Senators from the "Go Go" Chicago White Sox in a trade for Sam Mele in May 1952. The former Texas Christian quarterback brought a steady - and sometimes spectacular - glove to the Griffith Stadium outfield, and enjoyed his two finest offensive seasons in Washington livery, batting .312 with 82 RBI in 1953, and .298 - 80 in 1954. He was traded back to the Pale Hose for three players in June 1955.

## Jackie Jensen
### Outfielder, 1952 - 1953

Nicknamed "the Golden Boy" for his good looks and athleticism, Jackie Jensen came to Washington in the 1952 trade that sent Irv Noren to New York. The Yankees could never find a regular slot for Jensen after acquiring him from Oakland of the Pacific Coast League. The Nationals could, and did, playing Jensen daily in an outfield that included Gil Coan and Jim Busby.

His first year with the Nats, Jensen hit .286 and made the All-Star team. He had an equally strong year in 1953. But on a quest for pitching help, Clark Griffith traded Jensen to the Boston Red Sox after the 1953 season. It was a huge mistake. At Fenway Park, Jensen became one of the league's most consistent run producers. He led the American League in RBI three times and won the 1958 American League MVP award.

Jensen's fear of airplane travel led him to retire in 1959 at the age of 32. He attempted a comeback in 1961, but left after a single season. He died of a heart attack in 1982 at age 55.

**Joe Cambria, Carlos Paula, Roberto Zapata, Jose Valdivielso, Julio Becquer, Gonzalo Naranjo, and Camilo Pascual.
Spring Training, 1954**

Joe Cambria, a former Baltimore laundry owner, became Clark Griffith's most active talent scout when he owned the Albany, and later the Trenton franchises in the International League. Cambria was known to sell his players for a reasonable price, and frequently on a conditional basis.

The Senators acquired George Case and Mickey Vernon through Cambria's efforts prior to Joe discovering the talent market in Cuba. Cambria filtered a succession of low-cost Cubans through Washington, beginning with Bobby Estalella in 1935. By the wartime season of 1944, 12 Cubans dotted the Washington spring training roster.

By 1954, Griffith realized that the time had come to integrate his ball club, and entrusted Cambria to come up with an appropriate candidate. It turned out to be Carlos Paula, a big, muscular 27-year-old right-handed hitting outfielder. Paula wasn't promoted to the big club until the September call-ups, and didn't impress, batting just .167 in 9 games. The next year, in a semi-platoon, he hit .299, but fielded abysmally. He hit .188 in 1956 and was gone.

Of the players pictured, Zapata never appeared in a big league game, while Naranjo pitched briefly for the 1956 Pirates. Valdivielso, Becquer and Pascual all played significant roles for Washington.

**Pete Runnels**
**Infielder, 1951 - 1957**

James "Pete" Runnels, a left-handed hitter from Lufkin, Texas, joined the Nationals as a shortstop in 1951. A line drive hitter, Runnels played every infield position during his tenure with Washington, and hit as high as .310, in 1956.

Slumping to .230 in '57, he was traded to Boston in 1958 for Albie Pearson and Norm Zauchin. There, schooled by teammate Ted Williams on the finer points of hitting, Runnels topped the .300 mark for five straight years. He also won the American League batting title in 1960 and 1962.

Runnels finished his career close to home with the Houston Colt 45's in 1964.

## Roy Sievers
### Outfielder/First baseman, 1954 - 1959

Roy Sievers played 17 seasons in the major leagues, but spent his five greatest years with Washington. Sievers was the runaway winner of the 1949 American League Rookie-of-the-Year Award while playing for the St. Louis Browns. But his offensive and defensive skills suffered after he broke his collarbone in 1950. By the time the Browns moved to Baltimore in 1954, Orioles' manager Jimmie Dykes was convinced that Sievers was damaged goods and so he was willing to take whatever he could get for him. Enter the Senators, who traded the slumping Gil Coan to Baltimore for Sievers.

His first season in D.C., Sievers set a team record for home runs with 24, a mark he bettered every season for three straight years. He hit 159 home runs during his first five years with Washington and drove in 525 runs. For a team that continually finished near the bottom of the standings, Sievers was the team's lone gate attraction.

In 1957, Sievers led the league with 42 homers and 114 RBI, to go along with a .301 batting average. He finished third in MVP voting behind Mickey Mantle and Ted Williams. Sievers had another strong year in 1958, but was hurt in 1959, when he was spiked in a play at first base.

He was traded to the White Sox for Earl Battey and Don Mincher just prior to the 1960 season. He returned to play for the expansion Senators in 1964-65.

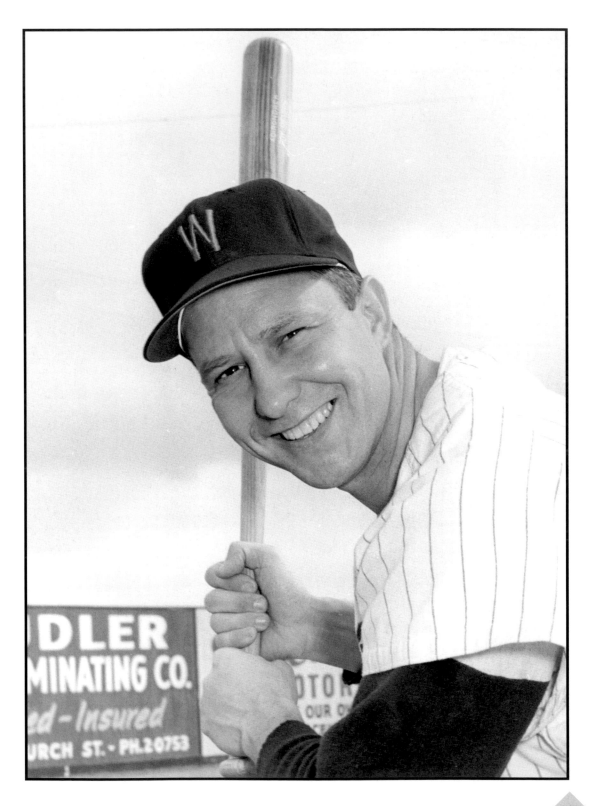

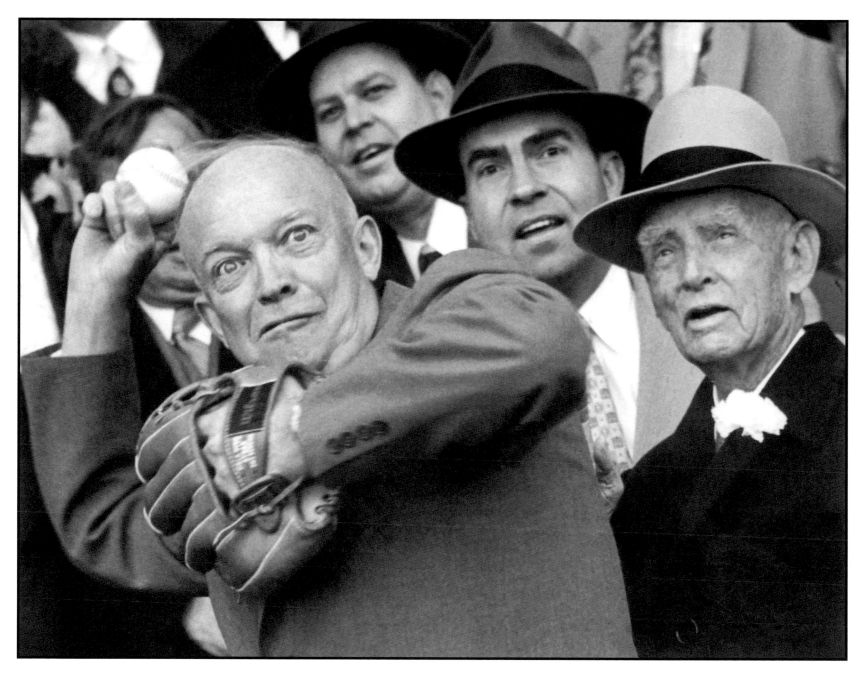

**President Eisenhower**
**Opening Day,  1954**

The tradition of U.S. Presidents throwing out the first ball of the season in Washington had started with President Taft, and President Eisenhower wasn't timid about taking his turn.

Looking on as Ike prepares to toss his two-seamer are Nationals' owner Clark Griffith, Vice President Richard Nixon and Griffith's nephew - and future Nats' owner - Calvin Griffith.

## Mickey Vernon
### Griffith Stadium, 1954

In 1953, Mickey Vernon had the best year of his long career and won the second of his two American League batting titles. In addition to his .337 batting average, Vernon led the A.L. with 43 doubles and drove in a career-high 115 runs.

On Opening Day, 1954 Vernon hit a tenth-inning home run to beat the New York Yankees 5-3. President Eisenhower became so excited that he tried to run onto the field to help celebrate. A Secret Service man held him back and made sure Vernon was escorted to the President's box to accept congratulations.

On May 27, 1954 Eisenhower returned to Griffith Stadium. This time, he presented Vernon with a silver bat in honor of his achievement. Vernon then took a few ceremonial swings for the assembled photographers.

Vernon played on seven A.L. All-Star teams, and was easily the most skilled and graceful first baseman of his era. At the time of his retirement, he had played more games at first base than anyone in major league history, a record later broken by Eddie Murray.

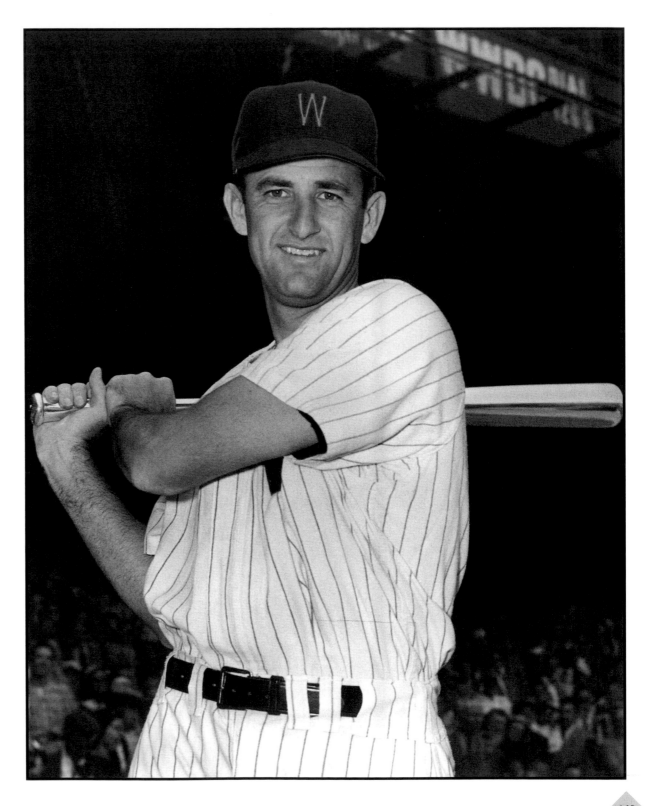

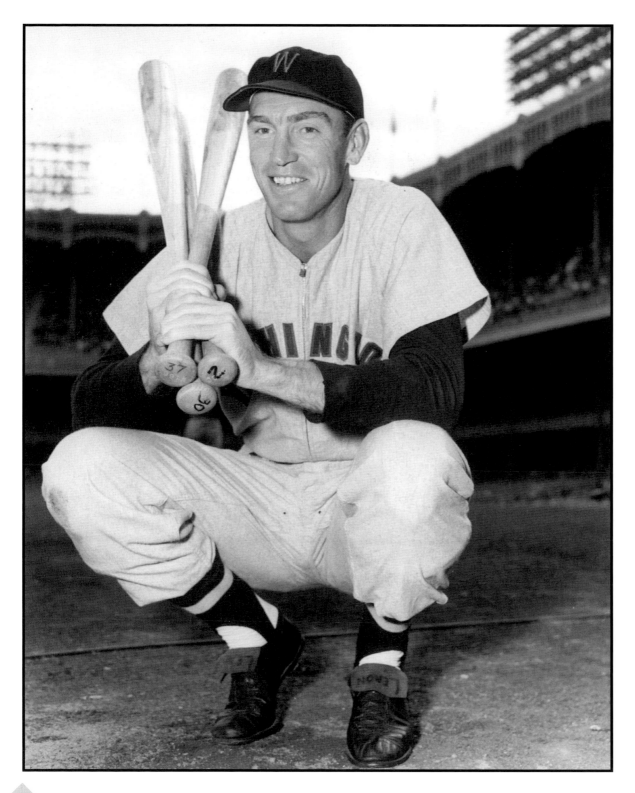

**Jim Lemon**
**Outfielder, 1954 - 1960**

Jim Lemon came to Washington in May 1954, a straight cash purchase from the Indians. The six-foot-four Virginia native was a legitimate power threat every time he stepped to the plate. Between 1956 and 1960 he reached double digits in home runs every year, and reached the century mark in RBI in both 1959 and 1960. Lemon finished with 164 big league homers, and 787 strikeouts, not unusual for a hitter with his kind of swing.

He retired as a player in 1964, and returned to Washington in 1968 as manager for one season.

## Harmon Killebrew
## Spring Training, 1955

It sounds like a storyline from a movie: a politician discovers raw baseball talent in his district and alerts the major-league club owner in Washington. Yet, that's exactly how Harmon Killebrew made it to the Washington Senators and ultimately, to the Hall of Fame. Idaho senator Herman Welker spotted Killebrew back home in Payette, and told Clark Griffith about the youngster who could "hit the ball a mile." Griffith sent a scout to take a look and sure enough, his talents were exactly as advertised. Killebrew signed a bonus contract - as a second baseman - which took him straight to the major leagues. But the "bonus baby" rules in place at the time dictated he spend the entire year in the majors.

Killebrew's progress was likely retarded by the bonus rule, but by the time he was an everyday player in 1959, the investment had paid off.

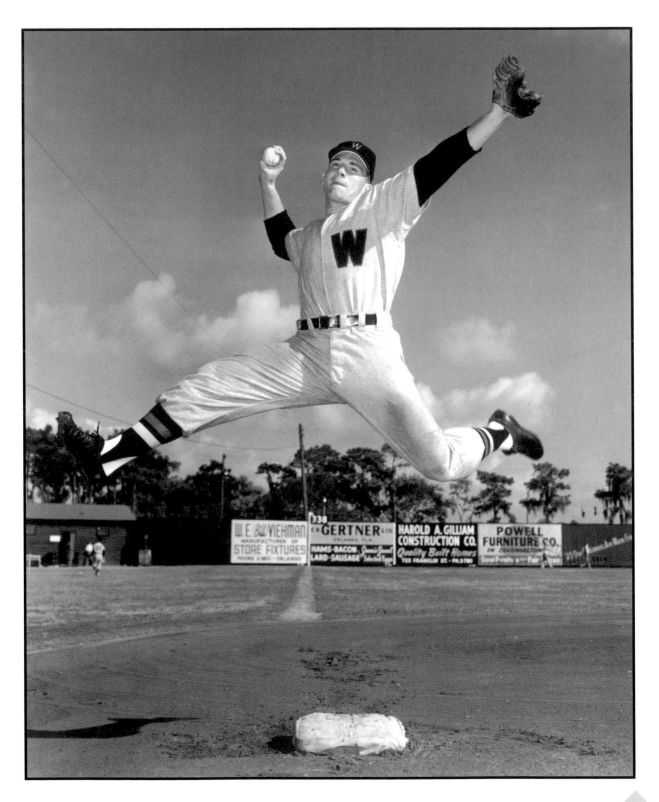

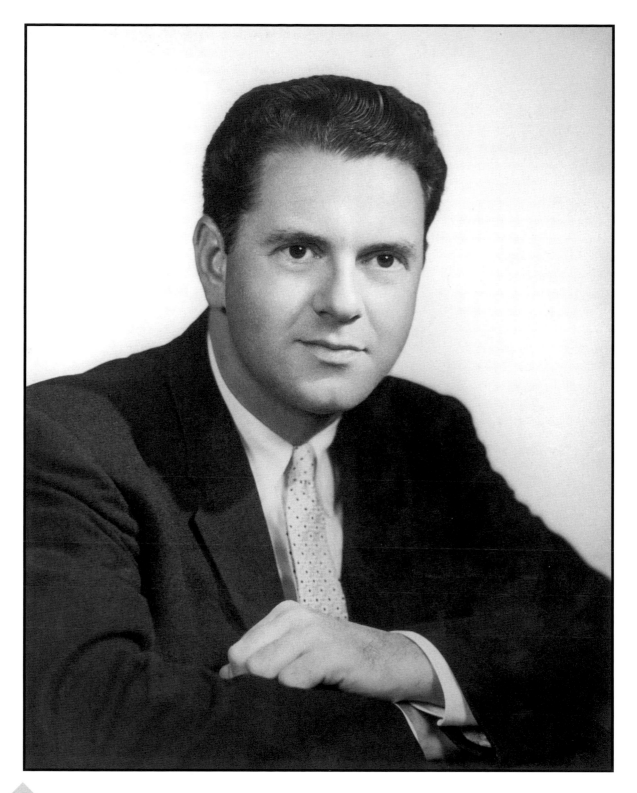

**Bob Wolff**
**Broadcaster, 1946 - 1960**

Native New Yorker Bob Wolff arrived in Washington in 1946 via the United States Navy, a Phi Beta Kappa graduate of Duke University. Wolff initially worked the Nationals' games on television, a medium which veteran radio man Arch McDonald considered a gimmick, and beneath him as a broadcaster.

There were only about 200 television sets in the greater Washington area at the time, so Wolff's audience was likely small at the beginning, many of whom were crowded into bars to watch the game.

However, his impact was immediate, and by 1950 he was doing radio and TV, as well as network assignments. When the Griffith family moved the team to Minnesota for the 1961 season, Wolff went along. Wolff was recognized for his contributions to baseball when he received the Ford Frick Award at the 1995 Hall of Fame Induction ceremonies in Cooperstown, New York.

## Ed Fitz Gerald
### Catcher, 1953 - 1959

Ed Fitz Gerald - that's correct, his last name is split in two - came to the Nationals from Pittsburgh, where he had spent parts of six seasons as a back-up catcher. He served the same role with Washington, establishing a reputation as a solid receiver and potent pinch hitter.

His biggest moment in a Nats' uniform came June 27, 1958 when he connected for a two-out pinch-hit double in the ninth inning off of Chicago's Billy Pierce, ending the southpaw's bid for a perfect game.

He was traded to Cleveland during the 1959 season for a pair of Hals: catcher Naragon and pitcher Woodeshick.

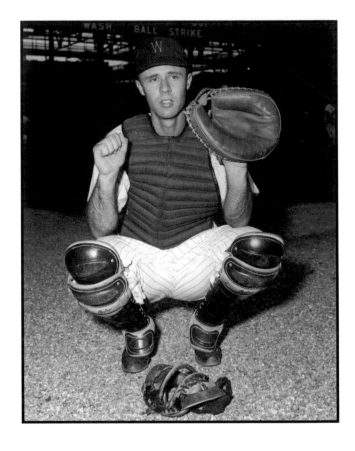

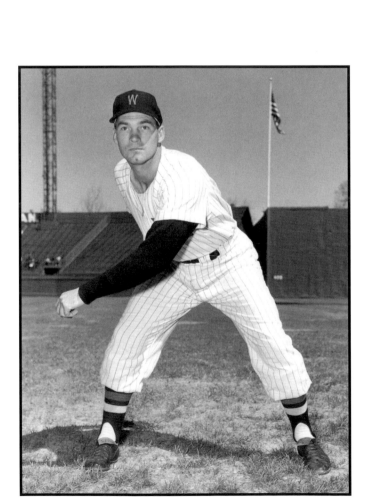

## Chuck Stobbs
### Pitcher, 1953 - 1960

One of the greatest athletes to emerge from the Tidewater region of Virginia, Chuck Stobbs broke into the majors with the 1947 Red Sox, and came to Washington in a trade with the White Sox for Mike Fornieles. The lefthander hit double figures in victories - and defeats - four times in D.C., but is probably best remembered as the pitcher who surrendered Mickey Mantle's 565 foot home run in 1953 at Griffith Stadium - the birth of the "tape measure" homer.

Stobbs spent part of the 1958 season with the Cardinals, but was back in a Washington uniform in '59. Stobbs won more than 100 games in the big leagues, and following his retirement was briefly a Senators' television analyst.

## Hal Griggs
### Pitcher, 1956 - 1959

Right-hander Hal Griggs won only six games for the Senators over all or parts of four seasons in the big leagues. He'd been a 21-game winner for the 1957 Chattanooga Lookouts, but was never able to translate that into major league success.

Griggs was considered the club humorist, a Will Rogers in flannel. He was married on the pitcher's mound in the minor leagues, because he "never hit well enough to be married at home plate." He claimed he never played baseball until he was 21, when he was a bellhop at a Miami hotel, and overheard a local coach says he was looking for players. Griggs volunteered, and by the following year was pitching professionally. His best game in the major leagues was a two-hit shutout of the Yankees in New York in May 1959.

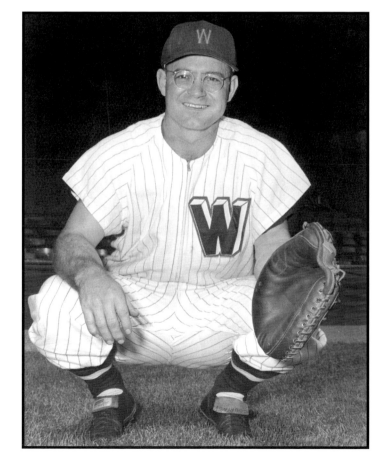

## Clint Courtney
### Catcher, 1955 - 1959

Veteran backstop Clint Courtney was known as "Scrap Iron," due largely to his aggressive, almost combative nature behind the plate. Courtney joined the Nats in a June 1955 trade that sent Jim Busby to the White Sox. Primarily a reserve, he was the everyday catcher in 1958, when he batted .251 with 8 home runs and 62 RBI, his best offensive season.

Originally a product of the Yankees farm system, Clint was the first major league catcher to wear glasses. He was traded to Baltimore for Billy Gardner just prior to the opening of the 1960 season.

**Camilo Pascual**
**Pitcher, 1954 - 1960**

Scout Joe Cambria's greatest pitching find was Havana's Camilo Pascual, possessor of perhaps the most impressive curveball in the American League. Pascual's older brother Carlos had preceded him with the Nats, appearing in two games in 1950.

Pascual struggled with his control in the early years, but was the club's undisputed ace by 1959. He twice won 20 or more after the move to Minnesota. Pascual returned to Washington with the expansion Senators in 1967 for three seasons.

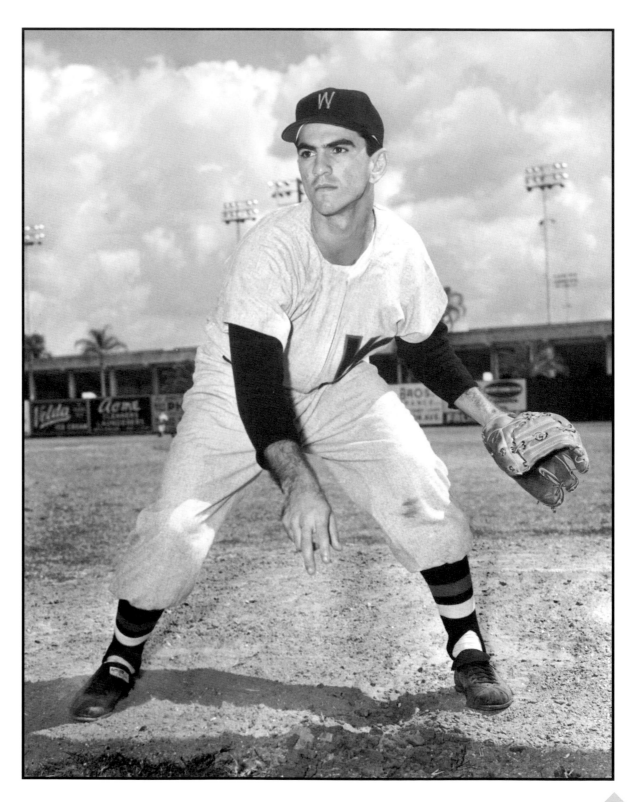

## Calvin Griffith
### Owner, 1956 - 1960

Calvin Robertson Griffith was the nephew of the venerable Clark Griffith. When the "Old Fox" passed away in 1955, control of the Washington franchise passed to Calvin. Several other Robertson family members were involved in the day-to-day operations, but Calvin ran the ballclub.

Calvin officially changed the team's nickname from Nationals to Senators in 1957. He also began offering season tickets for the first time in club history. Considered somewhat penurious, baseball was Griffith's only source of income, which left him open to overtures from other cities seeking a major league team.

Demonized by local fans after the move to Minnesota, Calvin Griffith remained a part of the Twins' franchise until 1984.

**Pedro Ramos**
**Pitcher, 1955 - 1960, 1970**

Pedro Ramos was still a teenager when he made his debut with the Nationals in 1955. Primarily a reliever his rookie year, Ramos was a full-time starter by 1957, and won in double figures every season from 1956 through 1960. He also led the AL in losses every season from 1958 to 1961.

Ramos was the swiftest afoot on the Washington roster, and was frequently employed as a pinch runner. On one occasion, catcher Clint Courtney arranged a 100-yard match race with Mickey Mantle. Ramos won the event, though later it was revealed that Courtney had actually laid out the course at 110 yards.

Ramos moved with the club to Minnesota, and later pitched for the Indians, Yankees, Phillies, Pirates and Reds. He finished up with the expansion Senators in 1970.

## Tex Clevenger
### Pitcher, 1956 - 1960

"Tex" Clevenger came to the Senators from the Red Sox in the November 1955 swap that sent Mickey Vernon and Bob Porterfield to Boston for five players. Of the five, only Clevenger made an impact with the Nats, going 29-31, mostly in relief, during his stay. Tex - a native Californian, by the way - made only 32 starts during his five seasons, but one stands out: a 1959 shutout over Cleveland that snapped an 18-game Washington losing streak.

Clevenger went to the Angels in 1961, and finished his career by winning World Series' rings with the 1961 and 1962 Yankees.

## Chuck Dressen
### Manager, 1955 - 1957

Chuck Dressen was a scrappy big league third baseman for eight seasons, and played fullback in the early NFL for the Decatur Staleys (later to become the Chicago Bears). He became a manager in 1934 in Cincinnati, and in 1951 succeeded Burt Shotton with the Brooklyn Dodgers. After taking Brooklyn to consecutive NL Pennants in 1952-53, he issued boss Walter O'Malley an ultimatum: give me a multi-year contract, or I'm going to look elsewhere. With Walt Alston in the wings, O'Malley sent Dressen on his way.

After Dressen won the PCL flag with Oakland in 1954, Clark Griffith came calling. It was a bad club, but it was a multi-year contract, and Dressen was back in the big leagues. He took a sixth-place club that had won 66 games in 1954, and headed south, finishing last in 1955, at 53-101. The following year wasn't much better, seventh place and 59 wins, and after a 4-16 start in 1957, he was replaced by Cookie Lavagetto.

Dressen would survive to manage again, with the Milwaukee Braves and the Detroit Tigers.

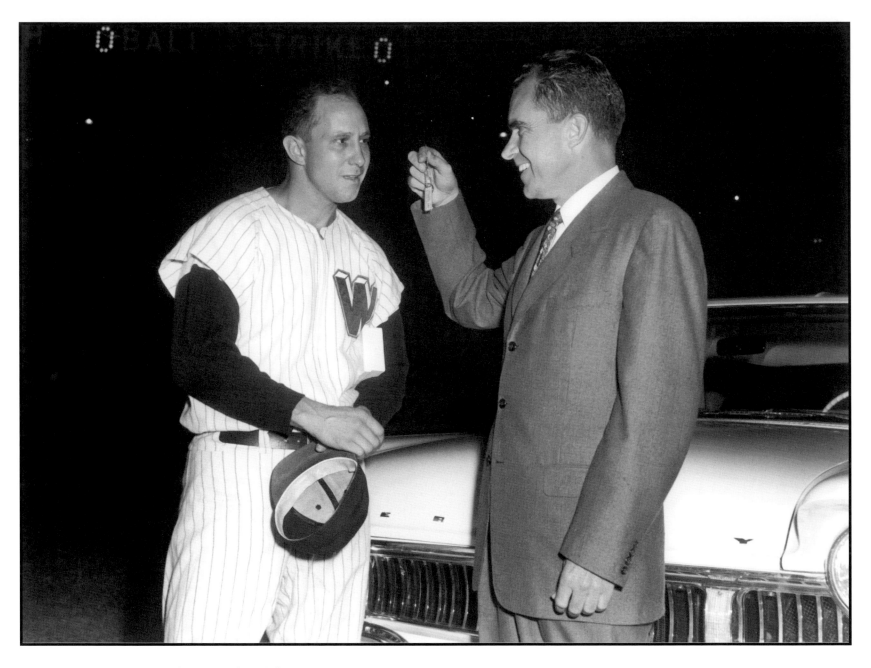

**Roy Sievers and Richard Nixon**
**Griffith Stadium, 1957**

Roy Sievers' 1957 season was spectacular. His 42 home runs made him Washington's very first home run champion. Sievers also produced 114 RBI, a .301 average, and 331 total bases, which also led the league.

On September 23 of that year, the club held a "night" for Roy, featuring remarks by Vice President Nixon, who also presented Roy with the keys to a new car. Sievers finished third in the AL MVP voting that year, behind Mickey Mantle and Ted Williams. He had another fine year in 1958, hitting 39 home runs, to go along with 108 RBI and a .296 average - and was asked to take a pay cut by Calvin Griffith!

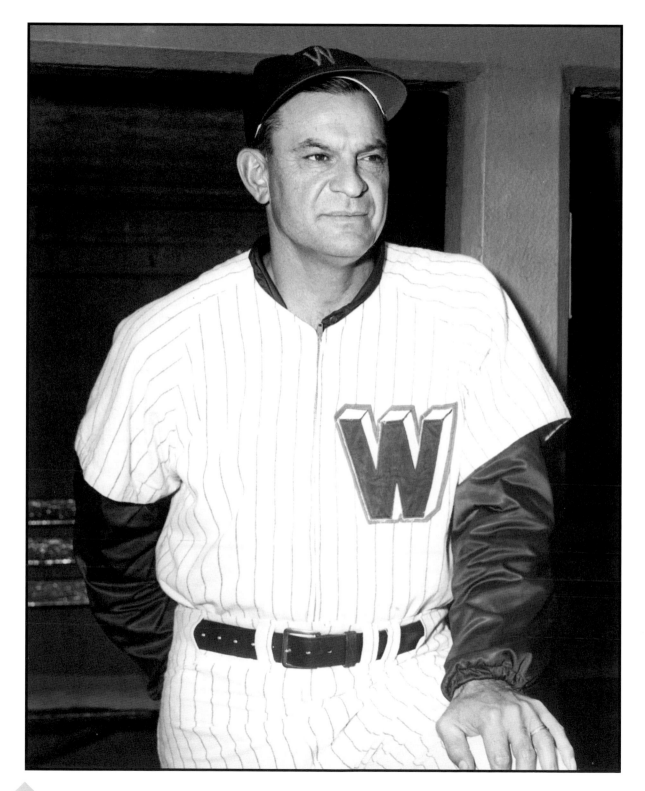

**Cookie Lavagetto**
**Manager, 1957 - 1960**

Harry "Cookie" Lavagetto was best known as the Dodger pinch-hitter who broke up Yankee pitcher Bill Bevens' no-hit bid in Game 4 of the 1947 World Series. Lavagetto's two-out, two-run double gave Brooklyn a 3-2 victory, though the Yanks eventually won the series.

In 1955, Lavagetto was hired by Washington as a coach under Chuck Dressen, and took the reins when Dressen was fired in May 1957. Under Lavagetto, Washington's win total inched upward year after year, from 51 to 61 to 63 to 73, their final year in Washington. Lavagetto was given credit for changing Brooklyn slugger Gil Hodges' stance at the plate, and did the same thing with Roy Sievers in Washington.

### Whitey Herzog
### Outfielder, 1956 - 1958

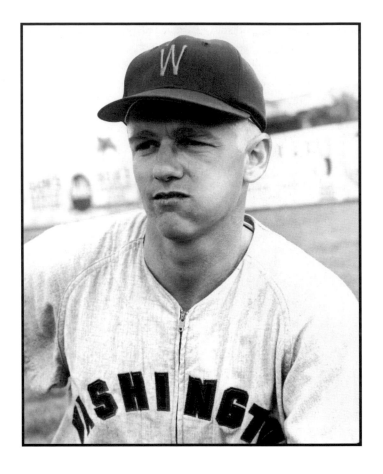

Better known as a big league manager, Dorrel Norman Elvert Herzog -"Whitey," thanks to his hair color - was a product of the Yankee farm system. He came to the Nationals in a seven-player deal that sent Pitcher Mickey McDermott and shortstop Bobby Kline to New York. Herzog played semi-regularly his rookie year, batting .245, with 4 homers and 35 RBI, but was relegated to part-time (or minor league) status thereafter. He was sold to Kansas City early in 1958.

Long after his playing days were over, Herzog managed the Kansas City Royals to three straight divisional titles in the 1970's and the St. Louis Cardinals to three World Series appearances in the 1980's.

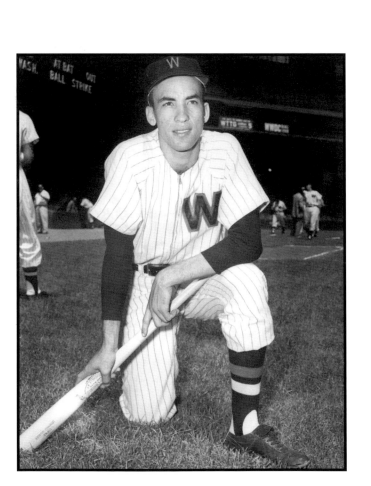

### Jose Valdivielso
### Infielder, 1955 - 1956; 1959 - 1960

Another Joe Cambria find, Jose Valdivielso was your classic slick fielding, weak hitting middle infielder. Brought to the big leagues in 1956 after a strong start at Charlotte, he responded with a .221 average with 32 runs scored and 28 RBI in 94 games. He put up similar numbers the following year, but was soon back in the minors.

He returned to the Senators as a defensive specialist in 1959, and moved with the club to Minnesota, where he finished his major league career in 1961.

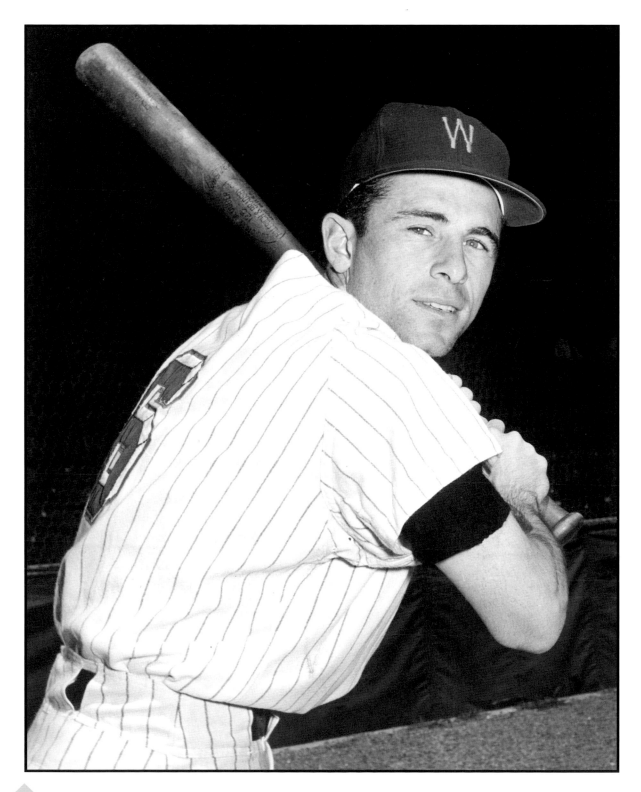

**Albie Pearson**
**Outfielder, 1958 - 1959**

Many fans assumed that Pearson's real first name was "Little," inasmuch as that's how he was usually described: Little Albie Pearson. The five-foot-five flychaser had been acquired from Boston in the deal that sent Pete Runnels to the Red Sox. Albie made the Senators' starting lineup in centerfield, and finished as the American League's Rookie-of-the-Year, batting .275 with 25 doubles and 63 runs scored for a last-place club.

Pearson started off slowly in 1959, and after just 25 games was traded to the Orioles for Lenny Green. Pearson played nine years in the major leagues, the last six with the California Angels, before retiring in 1966.

**Julio Becquer**
**First baseman,  1955, 1957 - 1960**

The versatile Cuban was Washington's principal left-handed pinch-hitter and defensive replacement at first. Becquer led the majors with 18 pinch hits in 1957, setting a new club record. His versatility even earned him a shot on the mound with the Senators in 1960, throwing a single inning of work.

He was taken by the Angels in the December 1960 expansion draft, but returned to the Minnesota Twins after only 11 games and retired in 1963.

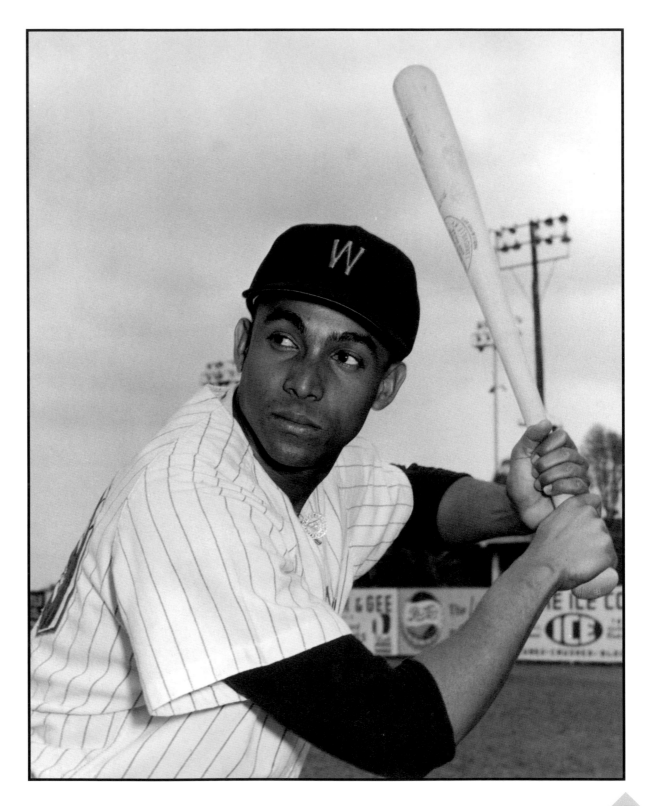

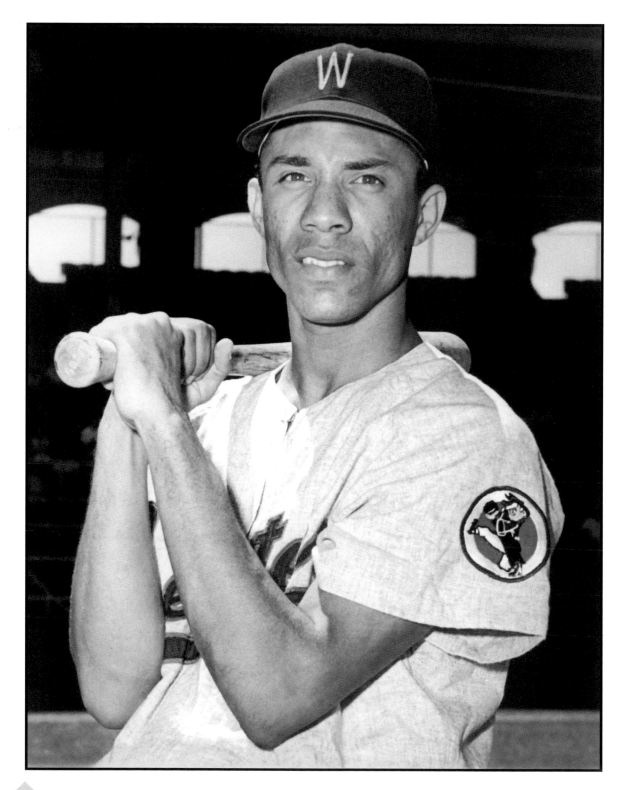

**Zoilo Versalles**
**Shortstop, 1959 - 1960, 1969**

Zoilo Versalles made it to the big leagues in just his second season of professional baseball, getting called up to Washington in 1959 at the age of 19. It was not an auspicious beginning, as the youngster - nicknamed "Zorro" after the legendary caballero - batted only .153 in 29 games. He got another look-see in 1960, and hit only .133 in 15 games.

In Minnesota, however, Versalles became a frontline shortstop and timely hitter, the offensive catalyst of the 1965 American League champions. For his efforts he was awarded the AL MVP Award. He returned to Washington as a part-timer with the 1969 Senators, and finished his career with a .242 average in 12 seasons. He died in 1995 at age 56.

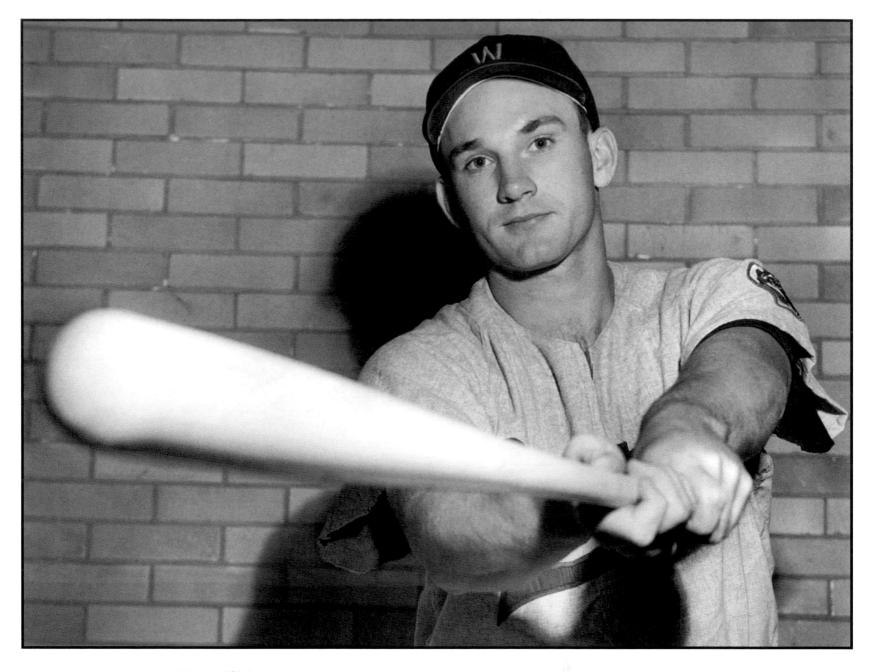

**Harmon Killebrew**
**Yankee Stadium, 1959**

Although he made his major league debut in 1954 and appeared in the Washington lineup sporadically for the next five years, 1959 was Harmon Killebrew's first season as an everyday player.

Installed at third base by manager Cookie Lavagetto, the 22-year-old

Killebrew responded with his first big power year, slugging 42 home runs to tie for the American League lead with Cleveland's Rocky Colavito. Killebrew also knocked in a team-high 105 runs and made his first All-Star appearance.

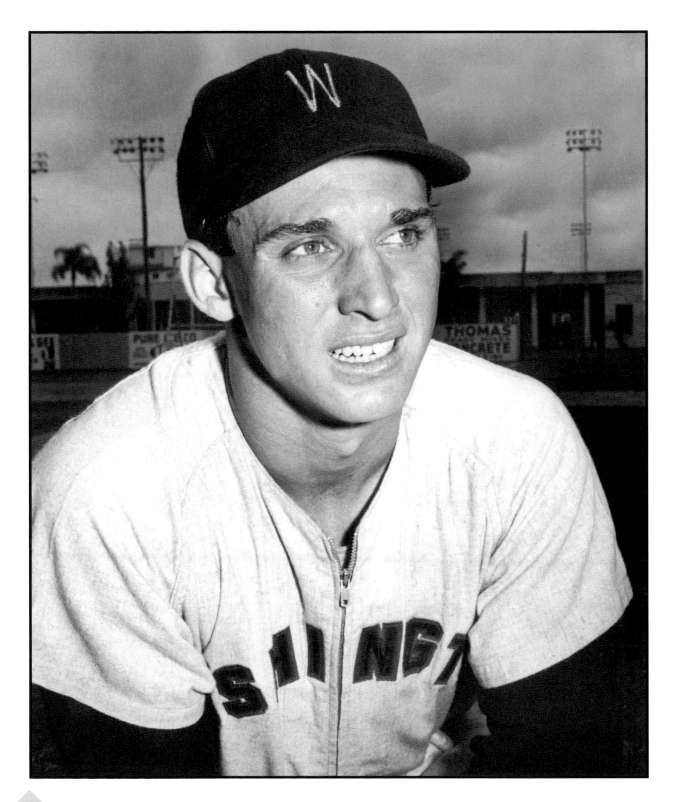

**Bob Allison**
**Outfielder, 1958 - 1960**

Former Kansas University fullback Bob Allison was the runaway winner of the 1959 AL Rookie of the Year Award, slugging 30 home runs and driving in 85 runs. For a team that had produced only one winning season in its last 14 years, Washington now had its second consecutive rookie honoree.

Allison's matinee idol looks gave local female fans a reason to go the game, and his powerful bat allowed the Nationals to finish second in the American League in home runs that year. He struggled in 1960, hitting only 15 homers, but hit 22 or more home runs in 7 of the next 8 seasons in Minnesota. Bob retired at 36 in 1970 with 256 career home runs.

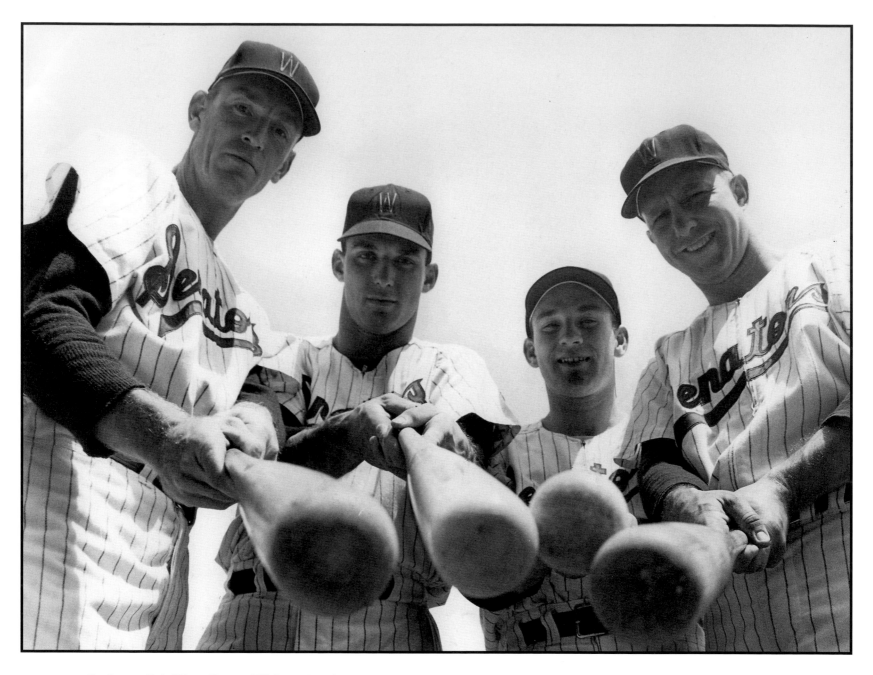

**Jim Lemon, Bob Allison, Harmon Killebrew, Roy Sievers**
**1959**

The Senators' version of the "Fearsome Foursome" connected for a total of 126 home runs in 1959: Lemon's 33, Allison's 30, Killebrew's 42 and Sievers' 21. Washington's total of 163 long balls that season would be the most in franchise history. The total would have been higher if not for Sievers missing 29 games with various ailments, including shoulder miseries and a severe spike wound to his heel. Unfortunately, all that power couldn't prevent the Senators from 91 losses and another last-place finish.

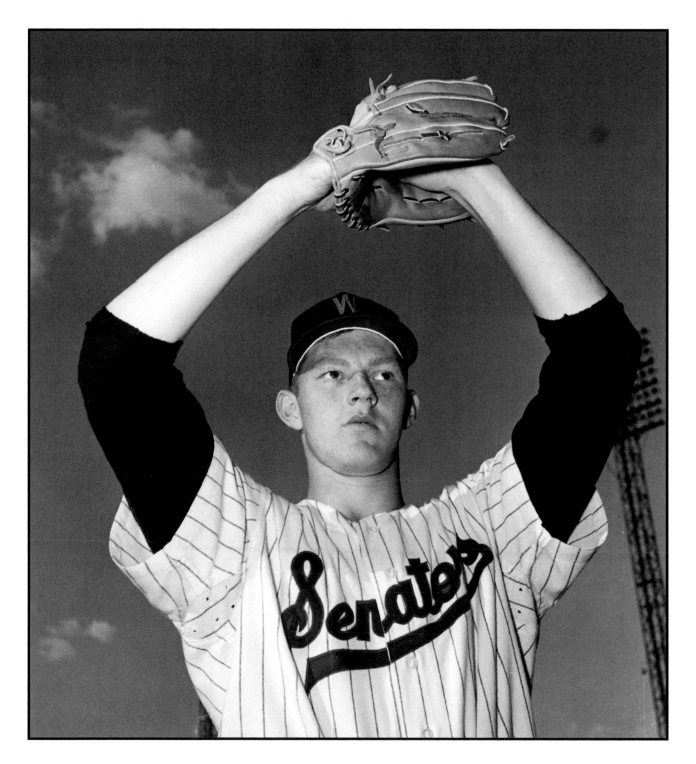

### Jim Kaat
### Pitcher, 1959 - 1960

Lefthander Jim Kaat was leading the Southern Association in strikeouts when the Senators called him up in August 1959. In fact, on May 16, Kaat had struck out a record-tying 19 Nashville batters while hurling for Chattanooga.

With Washington, however, he struggled at the major league level, going only 1-7 in 16 appearances between '59 and '60.

But Kaat soon hit his stride once the club moved to Minnesota, leading the American League with 25 victories in 1966. He went on to play all or part of 25 big-league seasons, including twice winning 20 games for the Chicago White Sox. Considered one of the best fielding pitchers of all time, Kaat won 16 consecutive Gold Glove awards.

His 283 career wins are the second-most of any pitcher not in the Hall of Fame. Kaat has been a Yankee broadcaster for years.

## Reno Bertoia
### Third baseman, 1959 - 1960

Native Italian Reno Bertoia came to Washington from Detroit in a December 1958 trade for Eddie Yost. A product of the University of Michigan, Bertoia had been a bonus baby with the Tigers who never quite justified the investment. He took over third base in 1960 when Harmon Killebrew moved to first, and hit .265 in his only year as a regular. He finished his big league career with the Tigers in 1962, and later became a scout.

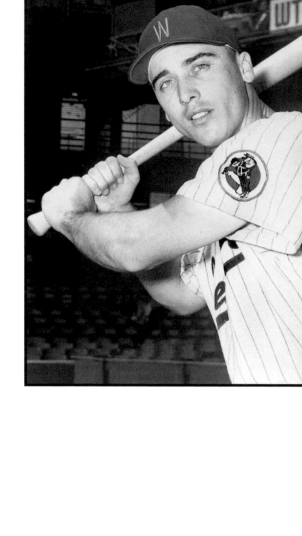

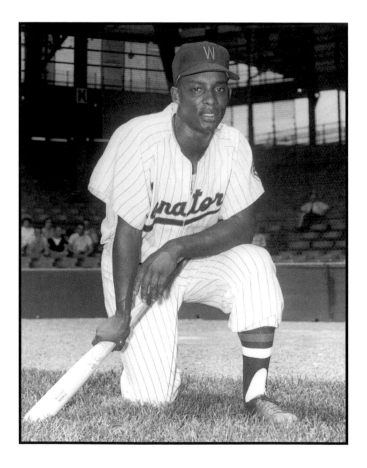

## Lenny Green
### Outfielder, 1959 - 1960

Lenny Green was a spare outfielder in Baltimore when he was traded to the Senators during a series in Baltimore in 1959. With Washington, Green got a chance to play every day, and in 1960, had his best year in the majors to that point, batting .294 with 21 steals, both career highs.

Green stuck around the big leagues for all or part of 12 seasons, playing mostly centerfield for the Twins, Angels, Red Sox and Tigers in addition to the Orioles and Senators. Lenny hit .267 for his career, and retired in 1968.

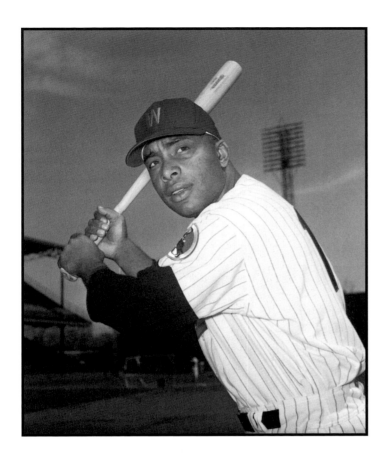

## Earl Battey
### Catcher, 1960

White Sox owner Bill Veeck had had Roy Sievers with the St. Louis Browns, and wanted his bat in the Chicago lineup. Finally, the week before the 1960 season got underway, Veeck sent Earl Battey, along with rookie first baseman Don Mincher and $150,000 to Washington for the 33-year old Sievers. Battey, who had sat behind veteran Sherm Lollar in Chicago, was an immediate hit in Washington, batting .270 with 15 home runs and 60 RBI, and doing a rock-solid job behind the plate.

The California native became a four-time All-Star with the Minnesota Twins, and retired in 1967.

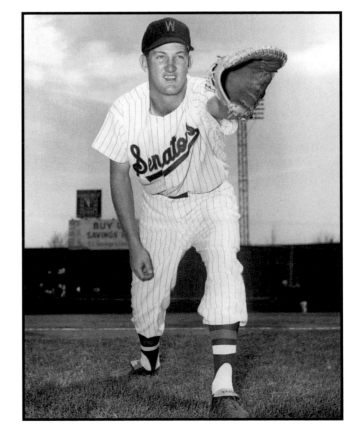

### Don Mincher
### First baseman, 1960, 1971

Don Mincher hit 200 career homers in the major leagues, but only 12 of them while wearing a Senators uniform. Acquired from the White Sox, along with Earl Battery, for veteran slugger Roy Sievers, Don Mincher was a big (6'3", 215 pounds) right-handed hitter who retired with an unusual distinction: he moved with both Washington American League franchises. He spent time with the Twins, Angels, Pilots, A's and Rangers.

Mincher retired in 1972 after winning a World Series ring with Oakland.

**Calvin Griffith**
**Griffith Stadium, 1960**

Calvin Griffith wanted a new stadium built in upper northwest Washington, where real estate prices were the highest in town. He didn't care for the site selected and dragged his feet on discussing a lease. Rumors persisted that he was going to move the team out of town, most likely to the Minneapolis-St. Paul area.

To clear the air, he met with local baseball scribes and assured them that the Senators wouldn't leave Washington "as long as I'm alive." On October 26, 1960, Griffith declared himself deceased and announced that the Senators would become the Minnesota Twins, ending 48 years of Griffith family ownership in Washington.

That same day, the American League owners voted to expand the league to 10 teams, allowing Griffith to play a small role in putting a replacement team in Washington for the 1961 season. Griffith left behind team records and old uniforms for the expansion Senators to use in spring training.

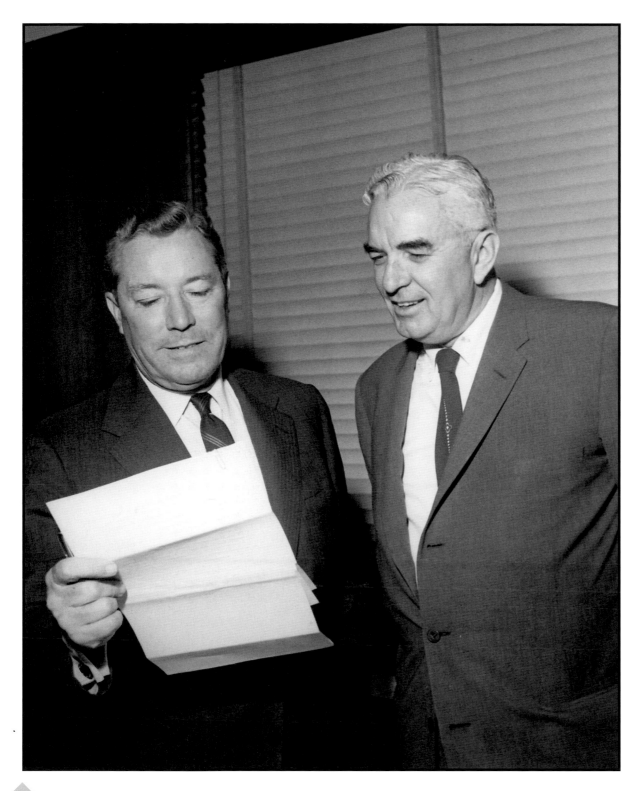

**Elwood Quesada and Ed Doherty
Owner and General Manager, 1961**

Elwood R. "Pete" Quesada was
selected by American League owners to
head the new Washington expansion
franchise. Quesada, a career military
man who had risen from the rank of
private to lieutenant general, and later
headed the Federal Aviation
Administration, beat out the favorite,
attorney Edward Bennett Williams, for
the team. Quesada was a fan, but knew
very little about the business of
baseball. He was shocked to learn that
he'd have to pay the players in the farm
system as well as the big club.

Ed Doherty had been around
baseball since 1914, when he was
batboy for Providence in the
International League, and carried bats
for a rookie pitcher named Babe Ruth.
Doherty left his position as president of
the American Association to take the
GM's position with the new Senators.

Both Quesada and Doherty were
gone by 1963.

## Dick Donovan
### Pitcher, 1961

The expansion Senators (and Los Angeles Angels) were allowed to select players left unprotected by the other eight American League teams. GM Ed Doherty and manager Mickey Vernon went largely with experience, and came away with a legitimate staff ace in Dick Donovan from the Chicago White Sox.

Donovan had spent six years in the White Sox rotation, going 73-50. With the first-year Nats, Donovan went 10-10, and won the league ERA title at 2.40. The numbers made the likeable New Englander a desirable commodity in the off-season, and he was sent to Cleveland for outfielder Jimmy Piersall four days after the season ended.

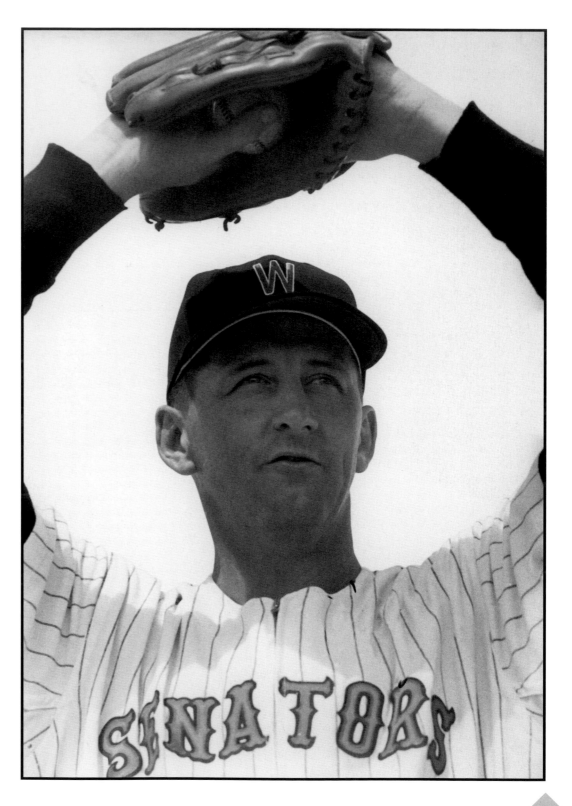

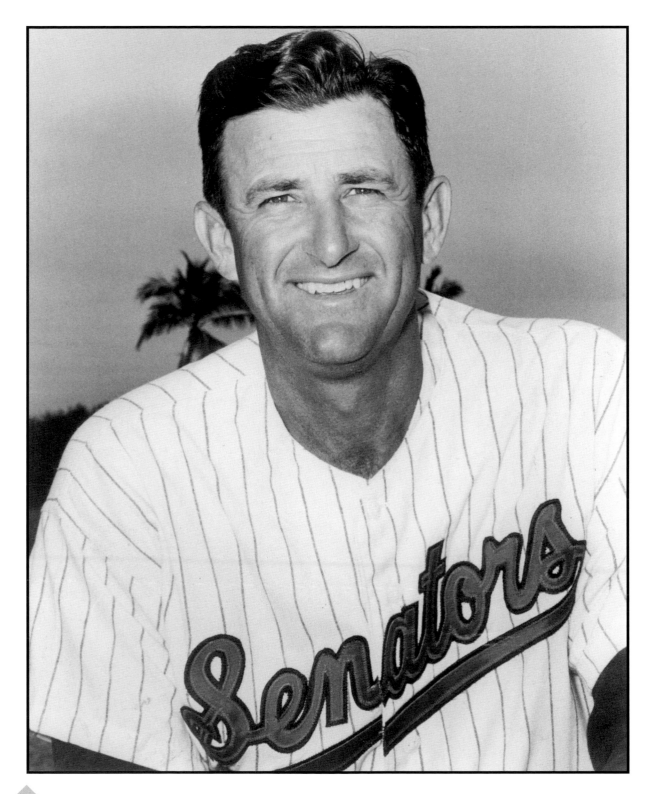

**Mickey Vernon**
**Manager, 1961 - 1963**

Mickey Vernon seemed an obvious choice to manage the expansion Senators. He had coached under manager Danny Murtaugh with the champion 1960 Pirates.

A longtime fan favorite, Vernon brought a style and dignity to the dugout, as well as the ability to coach hitting in the days before clubs routinely had hitting coaches.

Saddled with second-tier veterans taken in the expansion draft and youngsters clearly not ready for the majors, Vernon struggled to keep the fans' hopes high. The club played .500 ball into June, but a 12-46 record after August 1 soon spelled another wretched season. In the end, Vernon was probably too kind to succeed as a big league manager, and was replaced by Gil Hodges in May 1963.

He went on to manage in the minor leagues for many years, and was a big league hitting coach for the Pirates, Cardinals and Expos. While serving as a minor league instructor for the Yankees he tutored a young Don Mattingly.

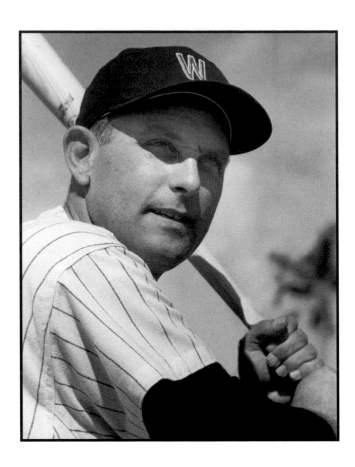

### Gene Woodling
### Outfielder, 1961 - 1962

Veteran Gene Woodling could flat out hit. Taken from the Orioles in the expansion draft, the Buckeye hit .313 for the Senators in 1961, and was batting a respectable .280 when he was sold to the Mets in June 1962. The transaction reunited him with Casey Stengel, his manager with the Yankees, where he had earned five World Series rings from 1949 to 1953. Woodling bowed out of the game with the Amazing Mets, hitting .274 as a 40-year-old semi-regular.

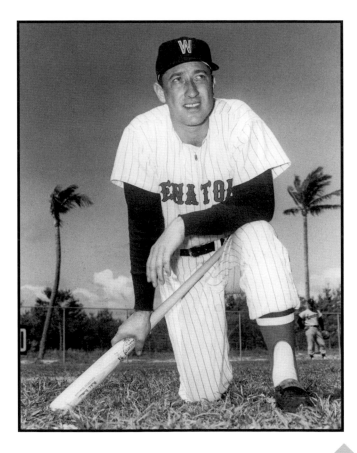

### Harry Bright
### Infielder, 1961 - 1962

Harry Bright was obtained from the World Champion Pirates by the expansion Senators, along with pitcher Bennie Daniels and first baseman R C Stevens, for pitcher Bobby Shantz a few days after the expansion draft. Bright was already past 30, and had managed in the minor leagues in the 1950's.

In Washington, Bright played first, second and third, and even caught 11 games along the way. In 1962, Bright connected for 17 home runs and 67 RBI, easily his best season in the major leagues. He was traded to Cincinnati for a minor league slugger named Rogelio Alvarez, who never played a game for Washington.

Bright only played one game for the Reds before he was sold to the Yankees, with whom he played in the 1963 World Series.

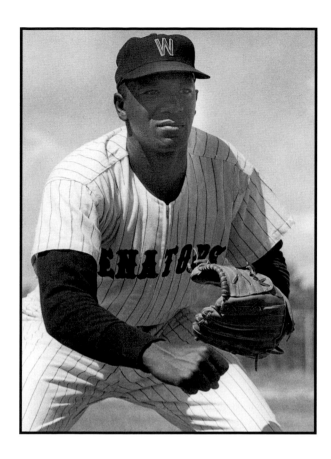

**Bennie Daniels**
**Pitcher, 1961 - 1965**

Part of the Pirates deal that also netted Harry Bright, Daniels produced his finest season as a major leaguer in 1961, going 12-11 with a 3.44 ERA. He remained part of the rotation through 1965, though he never won more than eight games in any one season.

Daniels was released after going 5-13 in 1965, partly because GM George Selkirk was convinced he was older than the 33 he claimed to be. Career-wise, Daniels went 45-76 in 230 games.

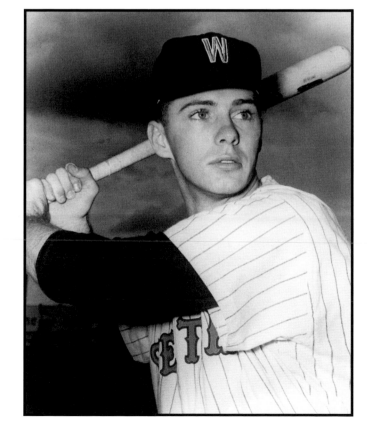

**Chuck Cottier**
**Infielder, 1961 - 1965**

Smooth fielding, light hitting Chuck Cottier was acquired from Detroit for pitcher Hal Woodeshick in June 1961. Chuck had few peers with the glove, but offensively, he struggled. He was the primary second baseman for the Senators through 1962, and posted a creditable .242 with six homers, 40 RBI and 14 stolen bases that year.

His biggest day with the bat was August 6, 1963 at D.C. Stadium, when he homered twice off of New York's Whitey Ford, handing the Yankee lefthander his first loss to the expansion Senators after 12 wins.

**Claude Osteen**
**Pitcher, 1961 - 1964**

Lefty Claude Osteen came to the
Senators in a September 1961 trade with
the Cincinnati Reds. Osteen had been up
and down with the Reds since 1957, but
got his first big league win in a Senators
uniform. He soon became the mainstay
of the Washington rotation, winning 15
games in 1964.

He was traded to the Dodgers at the
winter meetings that year in the deal
that brought slugger Frank Howard to
Washington. It was a deal that
benefited both teams. Over the next
nine seasons, Osteen won 147 games for
Los Angeles, twice winning 20.

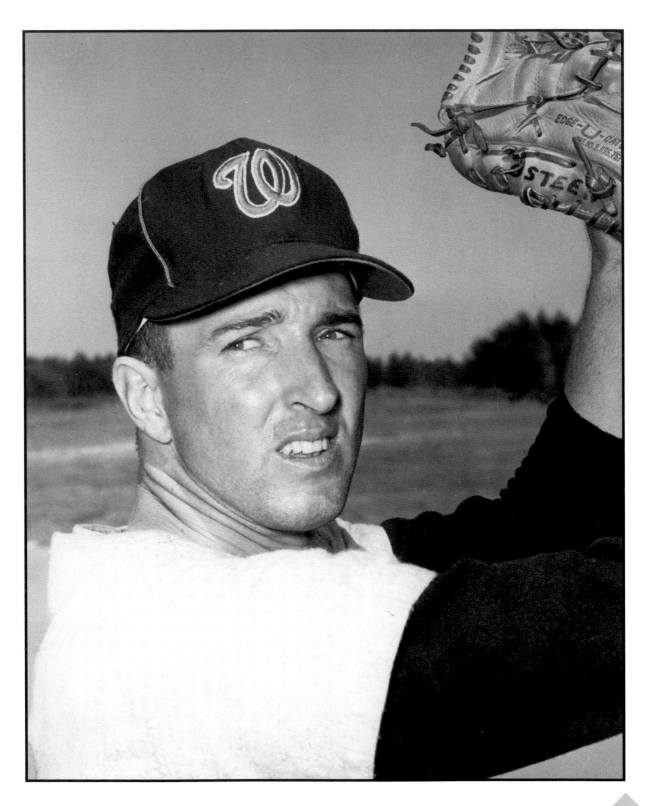

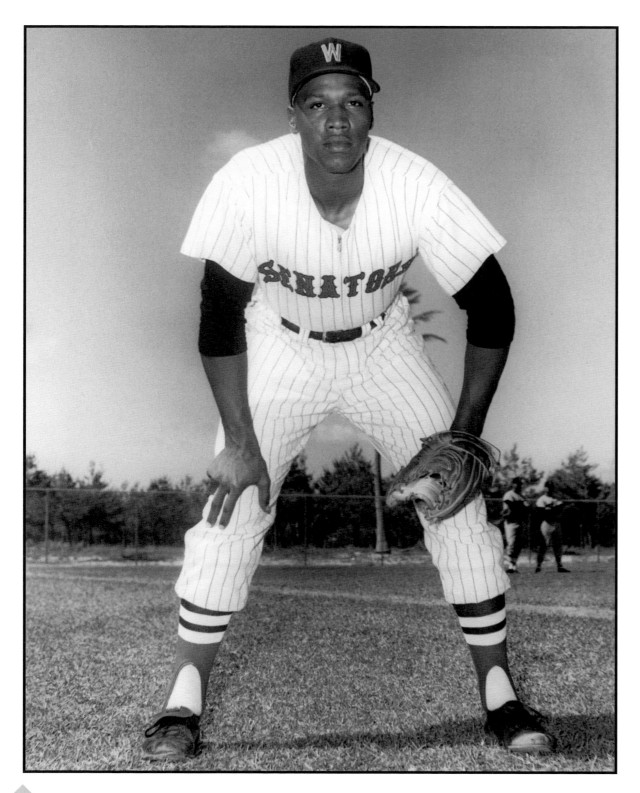

**Chuck Hinton**
**Outfielder, 1961 - 1964**

Chuck Hinton was a budding star in the Orioles' farm system, having twice batted over .358 in the minors. Baltimore opted not to protect Hinton in the expansion draft, and spread the story that he was damaged goods, having broken a bone in his leg. Washington drafted him nonetheless, and he made his debut in May 1961. Chuck had an immediate impact, and was an everyday player for Washington until his trade to Cleveland in December 1964.

Hinton was the last Senator to bat .300, finishing 1962 at .310. Hinton stayed in the D.C. area after he retired as a player in 1971, coaching baseball at Howard University for 20+ years.

**Tom Cheney**
**Pitcher, 1961 - 1964; 1966**

Right-hander Tom Cheney was another ex-Pirate brought to the Senators by Mickey Vernon in 1961. Cheney had a great assortment of pitches, but rarely great command of his stuff. He only won 17 games with the Senators, but will always be remembered for his 16-inning, 21-strikeout effort against the Orioles on September 12, 1962. Cheney, nicknamed "Skin" by teammates for his premature balding, threw over 200 pitches in defeating the Orioles 2-1.

Miraculously, he also made his next start with no problem.

In 1963, Cheney started 4-0 with an 0.25 ERA, and was reportedly headed for the Yankees in a trade when he blew out his elbow in a game at Baltimore. He was never quite the same and retired following the 1964 season. He tried a comeback in 1966, but after three appearances, hung up his cleats for good.

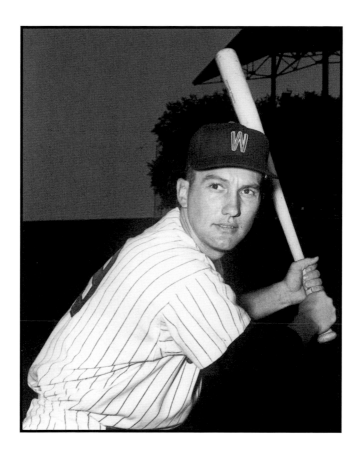

## Ken Retzer
### Catcher, 1961 - 1964

Ken Retzer arrived in Washington from San Diego of the Pacific Coast League in September 1961, and was installed behind the plate. His performance that month seemed to justify the purchase, as he hit .340 in 16 games. Platooned with Bob Schmidt in 1962, Retzer hit .285 with eight home runs and 37 RBI.

But his batting average soon dropped off dramatically and by 1964, he found himself back in the minors. Traded to Minnesota in October of that year, he never played another game in the majors.

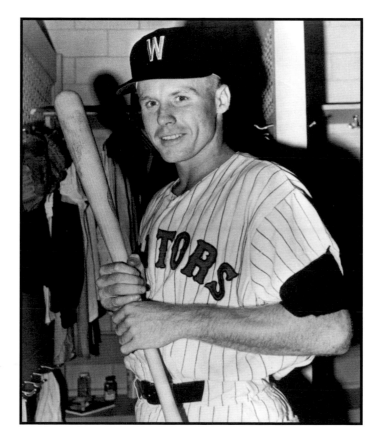

## John Kennedy
### Infielder, 1962 - 1964

John Kennedy shared the president's name and birthday, and came to Washington amid some fanfare: he was the first amateur player ever signed by the expansion Senators. Kennedy made his debut a memorable one, hitting a home run in his first at-bat on September 5, 1962 at D.C. Stadium. The blast came off Minnesota's Dick Stigman in the 6th inning, and was the first hit of the game for the Senators. Kennedy was a regular in 1964, batting .230 with seven home runs and 35 RBI, though he struck out 119 times.

Traded with Claude Osteen to the Dodgers in the Frank Howard deal, Kennedy played 12 seasons in the majors, mostly as a defensive specialist, and batted .225 for his career.

**Jimmy Piersall**
**Outfielder, 1962 - 1963**

Jimmy Piersall batted a career-high .322 for the Indians in 1961. His reward was a trade to the Senators, in the deal that sent Dick Donovan to Cleveland. Donovan won 20 games for Cleveland in 1962, while Piersall's average dropped to .244 in Washington.

A flawless defensive centerfielder, Piersall nonetheless called his time in Washington the "worst experience" of his career. Jimmy's earlier emotional problems were well documented in the book and movie "Fear Strikes Out," and he was fond of telling people that he was "crazy and had the papers to prove it".

After starting 1963 at .245, he was traded to the Mets for Gil Hodges, who was named manager of the Senators.

**Jim Hannan**
**Pitcher, 1962 - 1970**

Armed with a graduate degree in finance, Jim Hannan was likely the best-educated player in a Senator uniform during the expansion years. He was with the club for nine seasons after his acquisition from Boston in the 1961 minor league draft, and won 39 games in a Washington uniform.

Hannan's finest year was 1968, when he paced the staff with a 10-6 record and 3.01 ERA. He was a member of the Senators rotation in 1969, finishing at 7-6, and went 9-11 as a swingman in 1970.

He was traded to Detroit as part of the disastrous Denny McLain deal, and split 1971 between the Tigers and Brewers, before retiring.

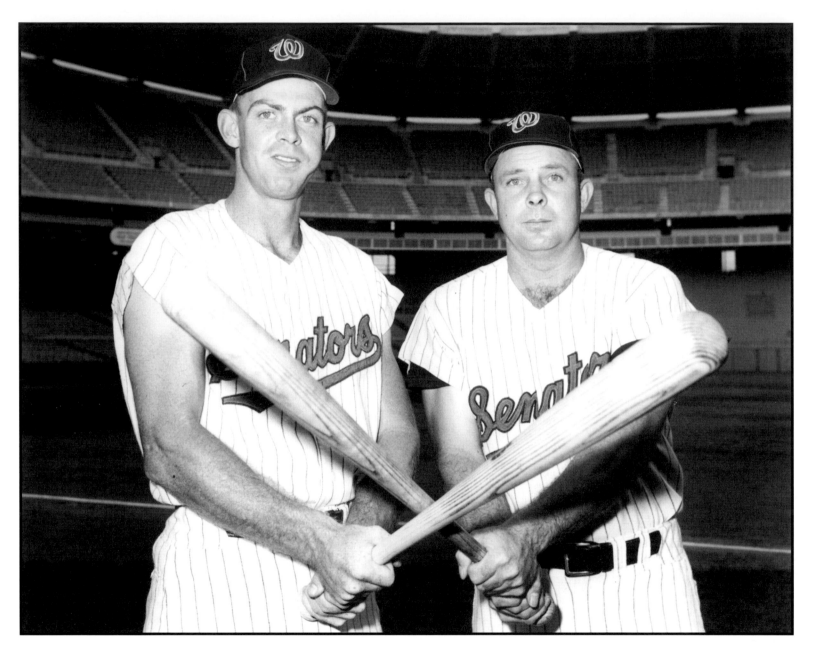

**Don Lock and Jim King**
**D.C. Stadium, c. 1964**

For three seasons prior to the arrival of slugger Frank Howard, the Washington offense was powered by two outfielders, Don Lock and Jim King.

Beginning in 1963, Don Lock's 80-plus RBI were tops on the Senators for two straight seasons. He and King ranked 1-2 in both home runs and RBI in both 1963 and 1964.

King was a left-handed hitter with power, an above-average throwing arm from right field, and a temperament consistent with his Arkansas upbringing. King set a Washington home run record, since broken, for lefty swingers with 24 in 1963. However, both players were gone by early in the 1967 season.

177

## Ed Brinkman
### Shortstop, 1961 - 1970

No one played more seasons in an expansion Senators uniform than Ed Brinkman, who signed with Washington as a pitcher-third baseman out of Western Hills High School in Cincinnati, where he was a high school teammate of Pete Rose. Brinkman was rushed to the major leagues after just 60 games in the minors. Arguably the best fielding shortstop in the American League, Brinkman's bat never kept pace with his glove. His two best offensive seasons were 1969-70, when he hit .266 and .262 under the tutelage of Ted Williams.

Part of the infamous Denny McLain trade, Brinkman spent four years in Detroit, and finished his career in 1975 with the Cardinals, Rangers and Yankees. "Steady Eddie" hit .224 for his career, and was a fan favorite for years.

**Bill Skowron**
**First baseman, 1964**

Bill "Moose" Skowron knew what it was like to play in the post-season; he did so in eight of his first 10 seasons in the major leagues, seven of those with the Yankees. After a dismal 1963 campaign with the World Champion Dodgers - his only year in the National League - Bill was sold to the Senators. Back in more familiar surroundings, Skowron had 13 homers and 41 RBI in 73 games, both team highs at the time, when he was traded to his hometown Chicago White Sox. Skowron finished his career with the California Angels in 1967.

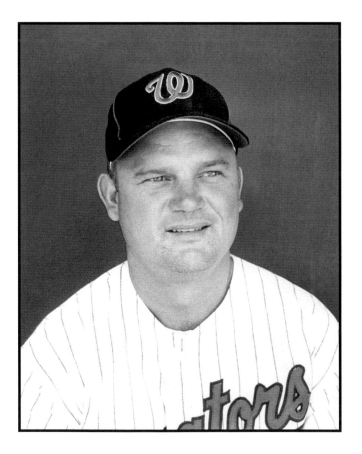

**Don Zimmer**
**Utility, 1963 - 1965**

When Gil Hodges was named manager in 1963, he seemed to want to surround himself with as many ex-Dodgers as he could. One of his first acquisitions along those lines was Don Zimmer, who arrived from Los Angeles in June. Primarily an infielder, Zim played second, short, third, outfield, and even caught 35 games. Another product of Western Hills High in Cincinnati, Don hit 27 home runs in a Senators uniform, three with the bases loaded.

Zimmer finished his playing days in Japan before embarking on a managerial career featuring stops in San Diego, Boston, Texas and the Cubs. He later coached with the Yankees and Devil Rays.

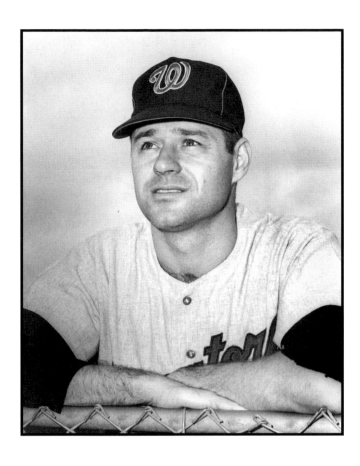

**Don Blasingame**
**Second baseman, 1963 - 1966**

Don Blasingame was an eight-year veteran of the National League when the Senators acquired him from the Reds, where he'd lost his job to Pete Rose. An All-Star with the Cardinals in 1958, "Blazer" had been a regular in St. Louis, San Francisco and Cincinnati, and was immediately installed as the everyday second baseman by Gil Hodges. He held that job until 1966 when declining stats sent him first to the bench, and then to Kansas City, who purchased his contract.

The following year he went to Japan, where he became extremely popular as both a player, and later, a coach. He retired as a career .258 major league hitter.

**Orestes "Minnie" Minoso**
**Outfielder, 1963**

Saturnino Orestes Minoso was 40 years old when Washington acquired him from St. Louis to be the Senators' everyday left fielder in 1963. Injuries prevented Minoso from playing in more than 74 games in the field, and he hit only .229, with four home runs and 30 RBI. By 1964, everyone thought he was done, but he saw action as the White Sox' primary pinch-hitter and made token comebacks in 1976 and 1980, allowing him to become a five-decade major leaguer.

If Minoso's really through playing, his career average is .298 with 186 home runs and 205 stolen bases.

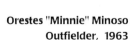

### Shirley Povich and Gil Hodges
### D.C. Stadium, 1964

Sportwriter Shirley Povich had covered the Senators' 1924 World Series victory over the Giants for *The Washington Post*, and a mere 40 years later, was still on the job, albeit as one of the nation's top sports columnists.

Gil Hodges was named manager of the Senators on May 22, 1963, a move that ended his playing career, although he was a part-timer with the Mets at the time. As a player, Hodges knew both highs and lows, having played in seven World Series with the Dodgers, and suffering through a 40-120 season with the 1962 Mets.

Under Hodges, the expansion Senators inched up the AL standings year-by-year, from last in '63, to 9th in 1964, 8th in 1965-66, and finally 6th in 1967. Given the opportunity to return to his baseball roots as Mets' manager in 1968, Hodges arranged for Washington to send his rights to New York for pitcher Bill Denehy.

In 1969, the move paid off with the Miracle Mets' dramatic World Series victory over Baltimore in five games.

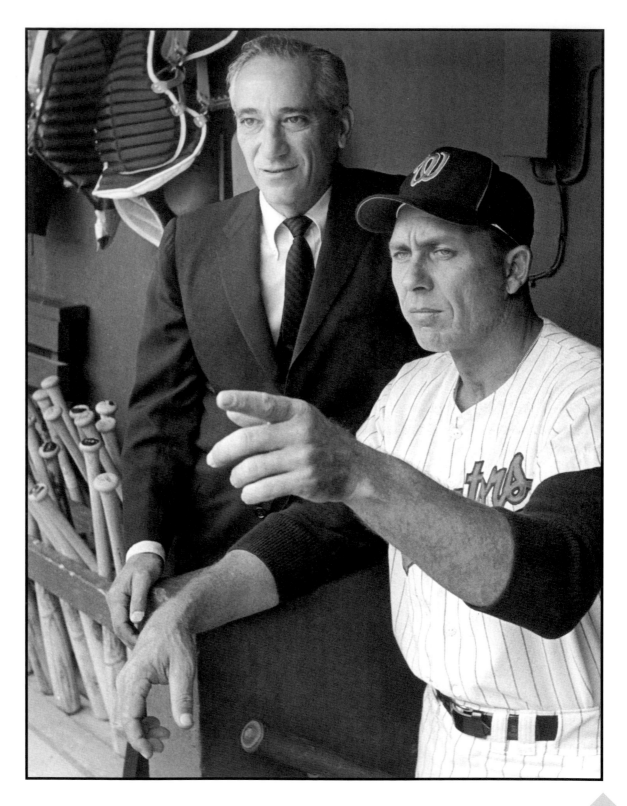

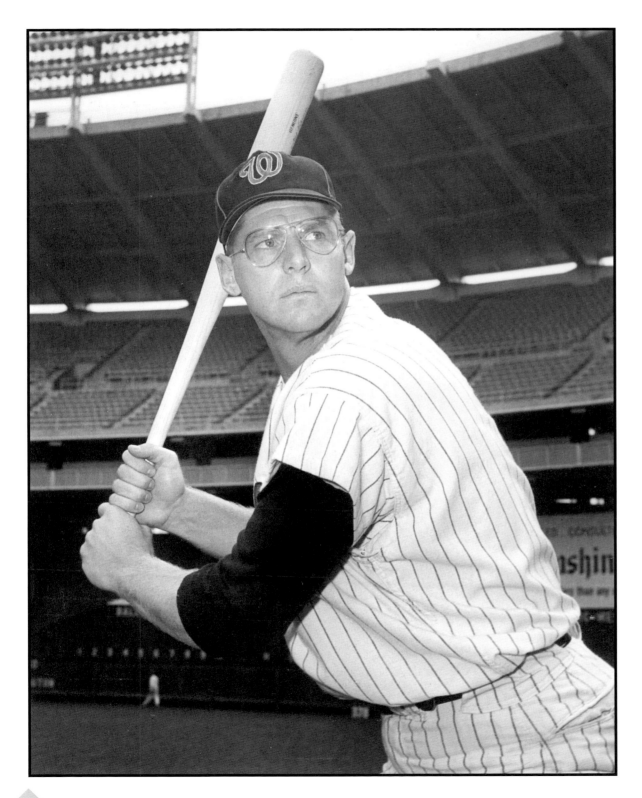

**Frank Howard**
**Outfielder/First baseman, 1965 - 1971**

Frank Howard personified the expansion Senators after Washington acquired him in a multi-player trade with Los Angeles at the 1964 winter meetings.

The 6-foot-7 slugger was the 1960 National League Rookie of the Year, but saw his average dip nearly 50 points in 1964. The Dodgers needed pitching depth and so agreed to a deal that sent Howard to the Senators. "Hondo" hit 237 home runs in seven seasons, leading the American League in 1968 and 1970. His tape-measure shots into the far reaches of the second deck at RFK Stadium were legendary.

Howard soon became the most popular player to wear a Washington uniform since Walter Johnson.

## Don Lock
## Outfielder, 1962 - 1966

Don Lock was a power-hitting Yankee outfield prospect in Richmond, Virginia when he was traded to Washington for veteran first baseman Dale Long in July 1962. He hit a home run in his first game for the Senators, and would go on to hit 98 more for Washington over the next four-plus seasons. Lock succeeded Jim Piersall in centerfield, and did a more-than-adequate job defensively, with the occasional spectacular grab.

Never a high average hitter, Lock was traded to the Phillies in 1967. His final season came with the 1969 Boston Red Sox.

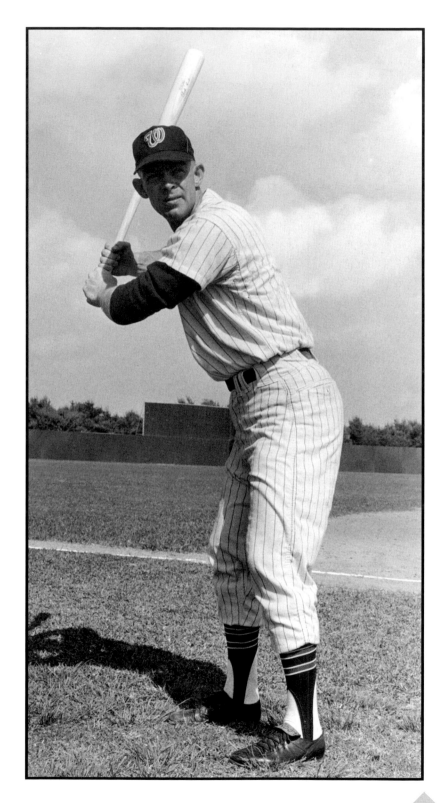

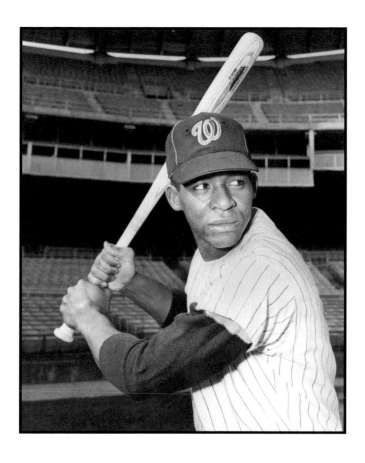

**Hank Allen**
**Utility, 1966 - 1970**

The Allen household in Wampum, Pennsylvania, specialized in raising ballplayers. Best known was Dick Allen, the slugging first baseman for the Phillies and White Sox. The Senators had Dick's older brother Harold, known to one and all as Hank. Hank lacked his younger brother's power, but showed great versatility on the field, playing all three outfield positions, as well as second and third base. Hank's bat skills peaked under Ted Williams in 1969, when he batted .277 as a spare outfielder.

Allen was traded to the Milwaukee Brewers in 1970. The Brewers insisted he wear number 44, after another notable Hank (Aaron), who had labored at County Stadium. Allen finished up in 1973 as a teammate of his brother in Chicago.

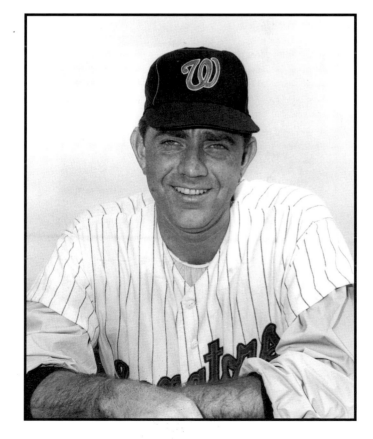

**Ron Kline**
**Pitcher, 1963 - 1966**

Ron Kline had been a successful starter and long reliever in the National League for the Pirates and Cardinals between 1952 and 1960. When the Senators acquired him from Detroit in 1963 for cash, he started once, but the rest of his career was spent in the bullpen. Kline was rumored to throw a spitter; whatever it was, it got people out, and "ol' Bear Tracks" led the league in saves in 1965. He had another strong year in 1966, after which he was traded to Minnesota for Bernie Allen and Camilo Pascual.

Kline had a 17-year career, notching 114 wins and 108 saves.

**Phil Ortega**
**Pitcher, 1965 - 1968**

Right-hander Phil Ortega came to the Senators from Los Angeles in the Frank Howard deal. The Chief had been up and down with the Dodgers since 1960, but Washington presented him with a regular slot in the starting rotation.

He responded with win totals of 12, 12 and 10 his first three seasons, but fell to 5-12 in 1968, including eight straight losses.

Ortega had occasional moments of brilliance in the big leagues: during one game in 1966 he struck out seven straight Red Sox hitters, and in 1967, he put together a stretch of eight straight wins.

Ortega finished his career with the California Angels in 1969.

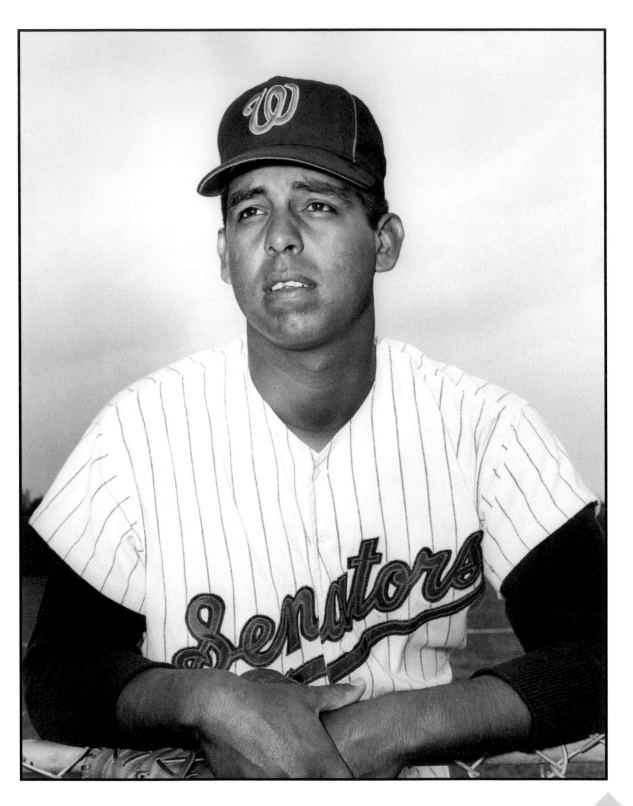

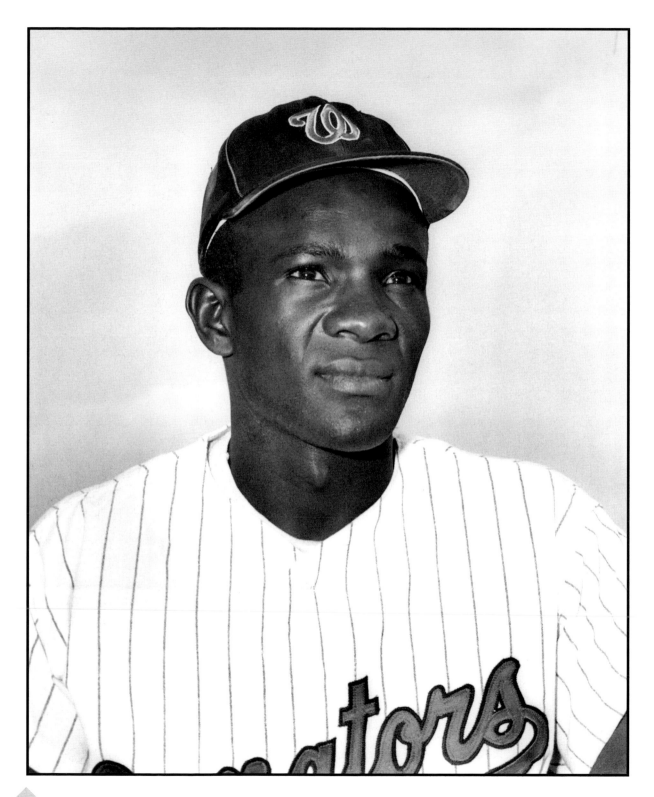

**Fred Valentine**
**Outfielder, 1964 - 1968**

Former Tennessee A&I football star Fred Valentine was a product of the Baltimore farm system. He was purchased from the Orioles in 1963, and in 1964 was Washington's fourth outfielder, batting .226. Valentine spent most of 1965 in the PCL, where he led the league in runs and stolen bases at Hawaii, batting .324.

Back with the big club to stay in '66, Valentine batted .276 with 16 homers and 59 RBI. A regular again in 1967, he slumped to .234 and was traded back to Baltimore the following year.

## Pete Richert
### Pitcher, 1965 - 1967

Lefty Pete Richert was another ex-Dodger, and part of the Frank Howard deal. A spare cog in Los Angeles, Richert emerged as the ace of the 1965 Senators' rotation, winning 15 games, and more than compensating for the loss of Claude Osteen. Richert won 14 games in 1966, and after a 2-6 start in '67, was sent to Baltimore for Mike Epstein and Frank Bertaina. With the Orioles, Richert left the rotation behind and became an extremely successful reliever.

He later returned to the Dodgers, before finishing up with the Cards and Phils in 1974.

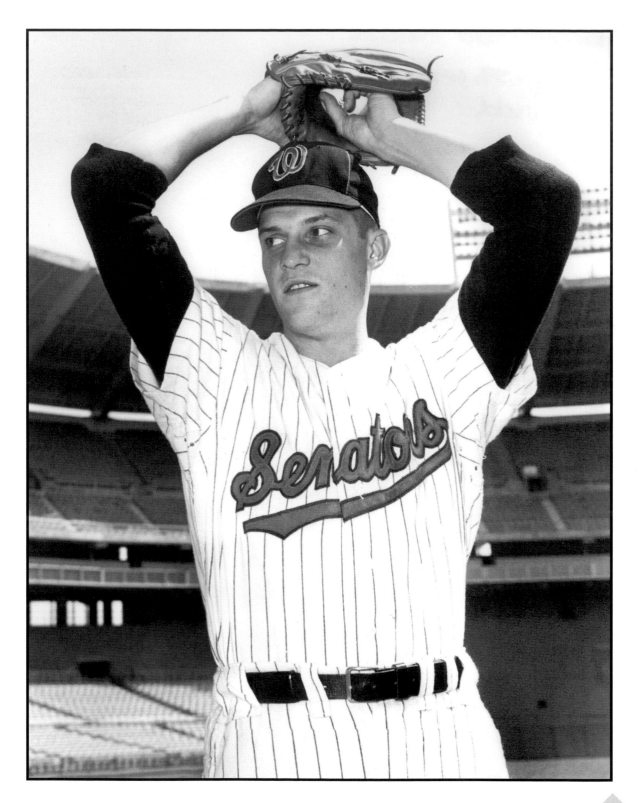

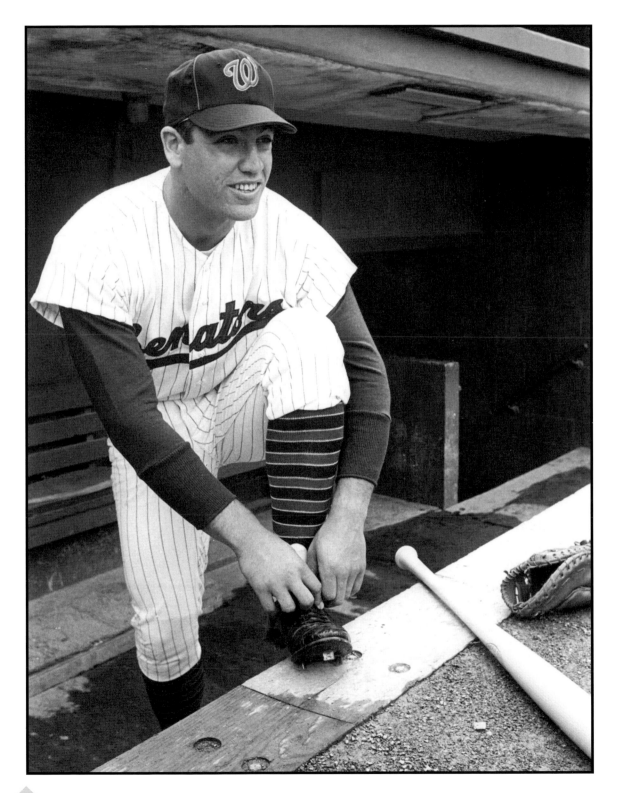

## Mike Epstein
### First baseman, 1967 - 1971

Mike Epstein had two spectacular years in the Orioles' farm system, but still couldn't dislodge Boog Powell at first base. He threatened to retire rather than report to the minors in 1967, and was swapped to Washington, along with lefty Frank Bertaina, for Pete Richert.

His rookie year was nothing special: nine home runs, 29 RBI and a .226 average in about 300 at-bats. He improved slightly in 1968 with 13 home runs, but came into his own under Ted Williams in 1969: 30 home runs - a new Senators record for lefty hitters, 85 RBI and a .278 average. He slumped to 20 homers in 1970, and after hitting just one homer in his first 24 games in 1971, was swapped to Oakland, where he won a World Series ring in 1972.

His career ended in 1974 when the Angels released him.

## Tim Cullen
### Infielder, 1966 - 1971

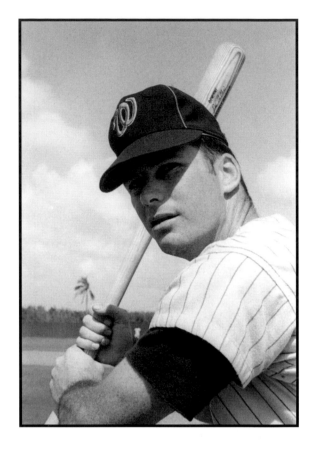

Tim Cullen was signed by Boston and drafted by the Senators in 1964. A versatile fielder, Cullen played second, short and third for Washington, and led all AL second basemen in fielding in 1970. The Worm made only 10 errors over the 1969-70 seasons, but three of them came in the same innings against the A's on August 30, 1969, an 11-0 Senators' win.

Cullen earned a degree in accounting at Santa Clara University, which he rarely needed to figure out his own batting average. A .220 career hitter, Cullen was traded to the White Sox for shortstop Ron Hansen in 1968, and then traded back to Washington for Hansen, a few days after the latter's unassisted triple play. Cullen earned a World Series ring with the 1972 Athletics.

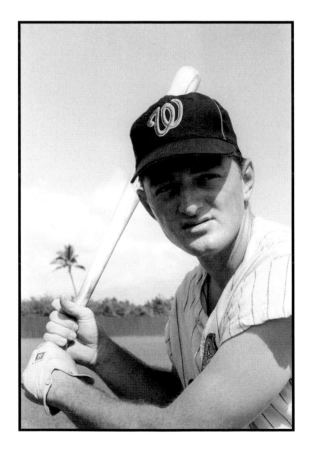

## Ken Harrelson
### First baseman, 1966 - 1967

Kansas City's colorful, free-swinging Ken Harrelson was swapped to the Senators for pitcher Jim Duckworth in June 1966. Harrelson and manager Gil Hodges rarely saw eye-to-eye on anything, and in 97 games over two seasons, the Hawk managed only 10 home runs and 38 RBI before he was sold back to the A's in June 1967.

He returned to K.C. in time for a player revolt against owner Charlie Finley, resulting in Harrelson's release. As a free agent, he signed with the Red Sox and ended up in the World Series. He led the league in RBI in 1968, was traded to Cleveland in 1969, and retired in 1971. Harrelson tried to make a go of it in pro golf, but later turned to baseball broadcasting in Chicago.

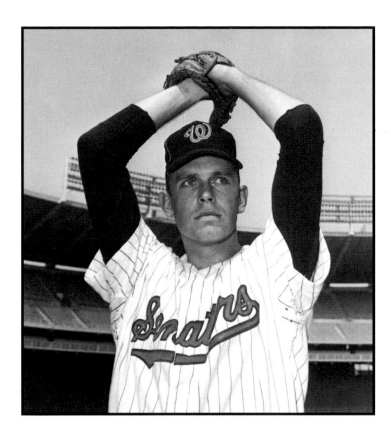

## Casey Cox
### Pitcher, 1966 - 1971

Casey Cox was a career reliever until Ted Williams put him into the starting rotation in 1969. Casey went 12-7 with four complete games, and seemed to have found his niche. The Red Sox offered slugger Reggie Smith for Cox that off-season, a deal Williams wanted to make, but owner Bob Short turned it down, saying he expected Cox to "win 20" in 1970. He didn't, going 8-12, followed by 5-7 in 1971, by which time he'd returned to the bullpen.

Cox was big - 6'5" and 200 pounds - but never a strikeout artist. He went to Texas and then the Yankees, and finished with a 39-42 record in eight seasons.

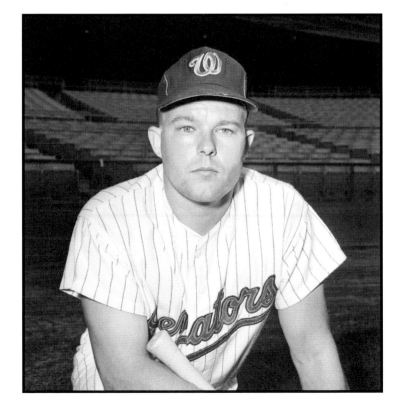

## Jim French
### Catcher, 1965 -1971

Jim French was a solid catch-and-throw receiver, but not much of a hitter. French made it to the big leagues on his defense, but for a guy with a lifetime .196 average, his career on-base percentage was .331. French had more career walks than hits, 121-119. At 5'7", his strike zone was on the small side, and he was incredibly patient at the plate. A favorite of Ted Williams, Frenchy had a master's degree in finance from the University of Indiana.

## Joe Coleman
### Pitcher, 1965 - 1970

Joe Coleman Jr. was the son of the former Philadelphia A's pitcher. He was signed by the Senators out of high school in 1965, and made his big league debut that year. He won his first three decisions for Washington, going the distance each time. Coleman won 12 games in both 1968 and '69, but dropped to 8-12 in 1970.

Included in the Denny McLain deal with the Detroit Tigers, he went 88-71 over the next six years. Coleman finished up in 1979 with the World Champion Pirates, a career mark of 142-135, with a solid 3.70 ERA.

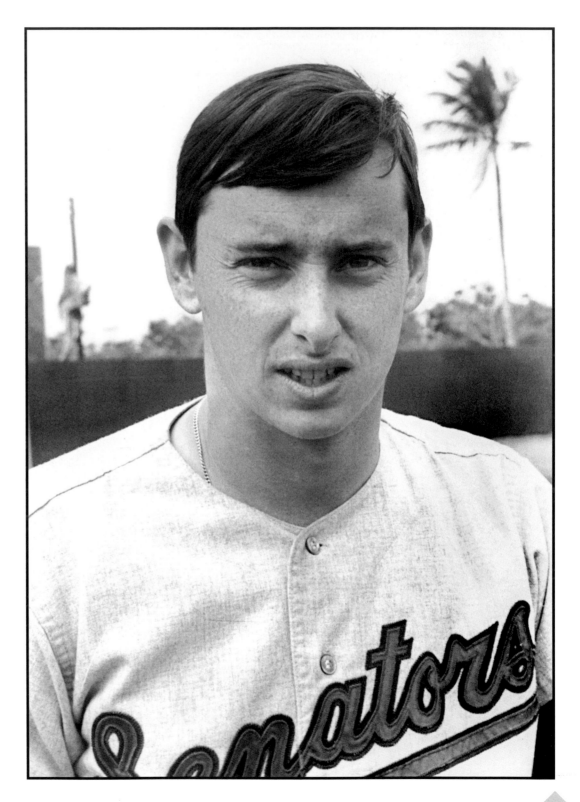

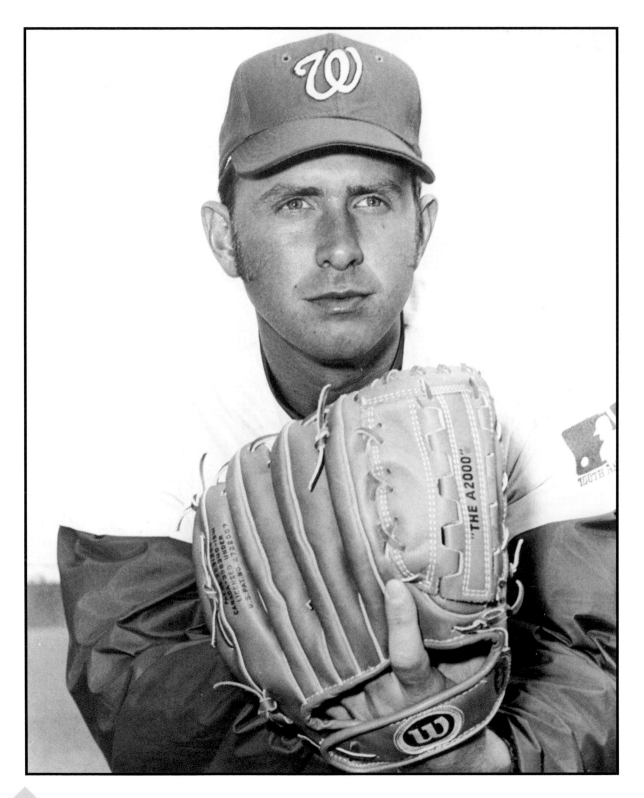

**Dick Bosman**
**Pitcher, 1966 - 1971**

Dick Bosman was originally signed by the Pirates, drafted by the Giants, and later drafted by the Senators. He made his debut in 1966, and was up to stay in 1968. Bozzie was the acknowledged staff ace 1969-71, winning 42 games, and leading the league in ERA in 1969. He threw a pair of one-hitters in Washington, against Cleveland in 1969 and Minnesota in 1970. It was a preview of things to come.

He moved with the club to Texas, and was traded to the Indians in 1973, where he tossed a no-hitter at the World Champion A's in 1974. Bosman found himself in an Oakland uniform 1975-76, and retired in 1977.

He returned to the game in the 1990's as a pitching coach for the Orioles and the Rangers.

**Camilo Pascual**
**D.C. Stadium**, **1968**

Cuban curve-baller Camilo Pascual
had returned to the Senators in 1967 in
a trade with the Twins. Pascual became a
regular winner with Minnesota after the
original franchise moved, but remained
a fan favorite in D.C.

Pascual led the staff in wins in 1967-
68, and in his second start in 1968,
reached the career 2,000-strikeout mark
in a 7-0 shutout of the Angels. His
2,000th victim was former Senator Chuck
Hinton.

At the time, Pascual was the only
active American Leaguer with 2,000 K's.
Pascual struggled under Ted Williams in
1969, going 2-5 before he was sold to
the Reds. He finished up with the
Dodgers and Indians, retiring in 1971
with 2,167 strikeouts and 174 victories.

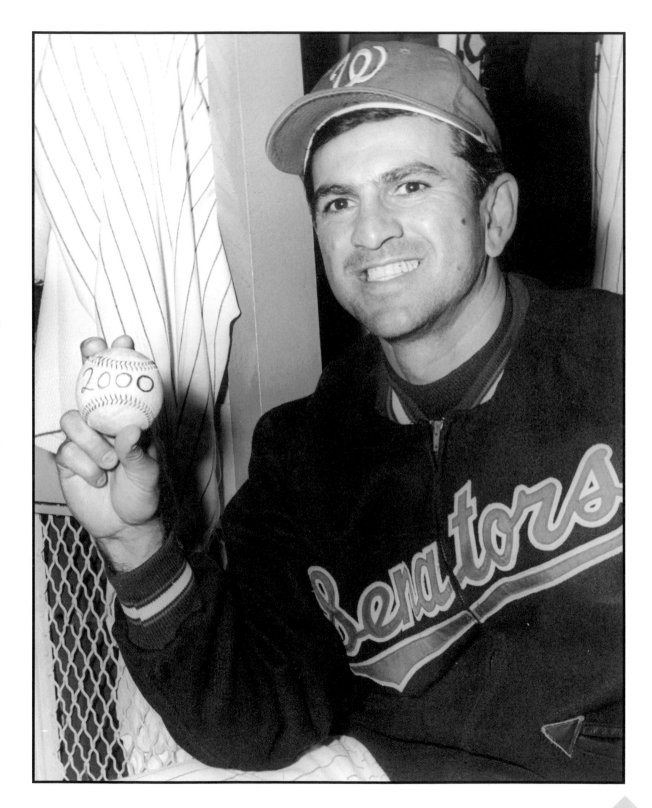

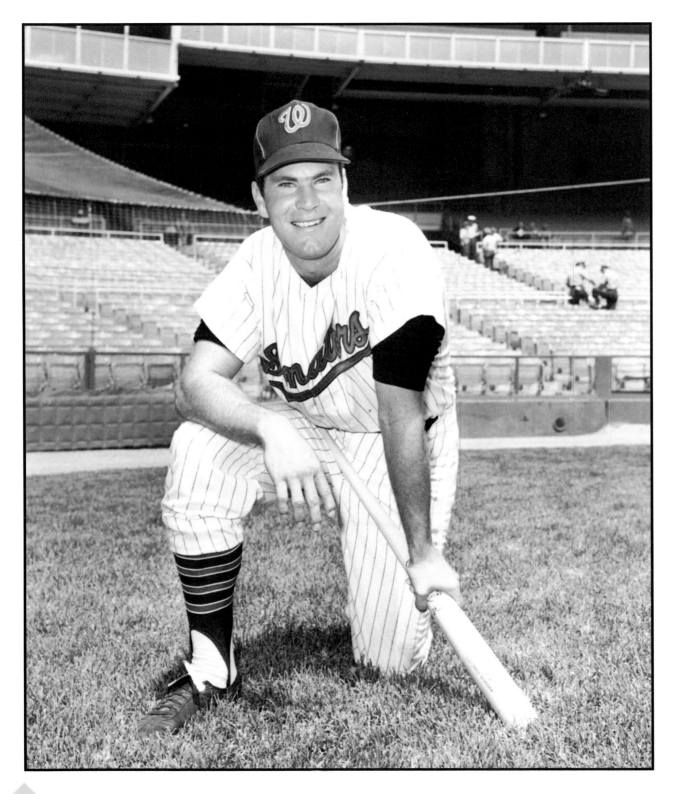

## Ken McMullen
### Third baseman, 1965 - 1970

Ken McMullen was yet another piece of the package that came to Washington in the Claude Osteen deal. A part-timer with the Dodgers, Ken became the everyday third baseman for the Senators, displaying decent power and a solid glove. McMullen hit 86 home runs in a Washington uniform, and was as good as it gets handling barehanded pickups of bunts and slow rollers down the line.

If there had been a captain of the Senators, it would likely have been McMullen. Team chemistry clearly faltered when he was swapped to the Angels in April 1970 for Aurelio Rodriguez and Rick Reichardt.

McMullen returned to the Dodgers in 1973, and finished up with the 1977 Brewers.

**Frank Howard**
**1968**

At times during the 1968 season, the baseball must have seemed frozen in place when Frank Howard came to bat. From May 12-18, Hondo connected for 10 home runs in 20 at-bats. Two came off of Cleveland's Sam McDowell and three off of Detroit's Mickey Lolich, including a roof shot at Tiger Stadium on May 18.

Howard batted .600 over the streak, which included a single and a double, and drove in 17 runs. He set major league records at the time with most home runs in five consecutive games (8), most home runs in six consecutive games (10) and most home runs in a week (10). Howard ended up leading the majors in home runs with 44, 18 at home, 26 on the road.

**Paul Casanova**
**Catcher, 1965 - 1971**

Paul Casanova played for the barnstorming Indianapolis Clowns in 1961, and made it to the Washington farm system in 1963. He hit .254 with 13 homers in 1966, and was the Senators' All-Star representative in 1967, but thereafter never hit above .229. The Cuban-born receiver was a fan favorite, due largely to his ever-present smile, and penchant for throwing the ball behind the runner at first base on pickoff attempts.

Stadium P.A. Announcer Phil Hochberg's introduction of Cazzie - "Now batting for Washington, number eight, Paul Cass-a-NOOOO-va" was unforgettable as well. He was traded to the Braves in 1972, and retired in 1974.

**Bernie Allen**
**Second baseman, 1967 - 1971**

Former Purdue quarterback Bernie Allen was traded to Washington by Minnesota along with Camilo Pascual for Ron Kline in the winter of 1966-67. A lefty swinger, Allen platooned with Tim Cullen at second base his entire time with the Senators, with 1969 his best year: nine home runs and 45 RBI in 365 at-bats.

Never a big fan of Ted Williams' managerial style, Bernie was traded to the Yankees at the end of the '71 season, and finished his career with the Expos in 1973.

### Darold Knowles
### Pitcher, 1967 - 1971

The Senators acquired Darold Knowles from the Phillies for Don Lock in November 1966, and he paid immediate dividends, winning six and saving 14 in 61 appearances in 1967. He spent much of 1968 in the service, and returned during the summer of '69 to win nine and save 13.

Knowles' 1970 season was one for the books: 27 saves, a 2.04 ERA, and a 2-14 record. At one point during the season, his record was 1-6 despite an ERA of 1.38. After 12 appearances in 1971 he was dealt to Oakland, where he teamed with Rollie Fingers to form the American League's best righty-lefty relief tandem. Knowles appeared in all seven games of the 1973 World Series, allowing no earned runs.

He later pitched for the Cubs, Rangers, Expos and Cardinals before retiring in 1980.

## Robert Short
### Owner, 1969 - 1971

Businessman Robert E. Short may be the most reviled man in Washington sports history for moving the Senators to Texas not long after buying the team.

Short had a history of doing cities wrong, having already bought his hometown Minneapolis Lakers and moving them to Los Angeles.

The Senators had three seasons left on their stadium lease when Short outbid comedian Bob Hope for the team at the 1968 winter meetings in San Francisco. The D.C. investment banking firm of Johnston, Lemon and Co., team owners for five years, sold the franchise for a reported $9.4 million. The deal allowed Short to put down very little cash, but leverage his other businesses - a trucking company and a Minneapolis hotel.

Short made a huge splash by luring Ted Williams out of retirement to serve as Senators manager. Almost immediately, Short began dropping hints that he wasn't happy in Washington. In 1970, he began talks with Arlington, Texas. At one point, he planned to move the club at the 1971 All-Star break but decided to wait until September to steal away.

On his deathbed in 1982, Short reportedly told the visiting Ted Williams that, in retrospect, he was sorry he'd moved the club.

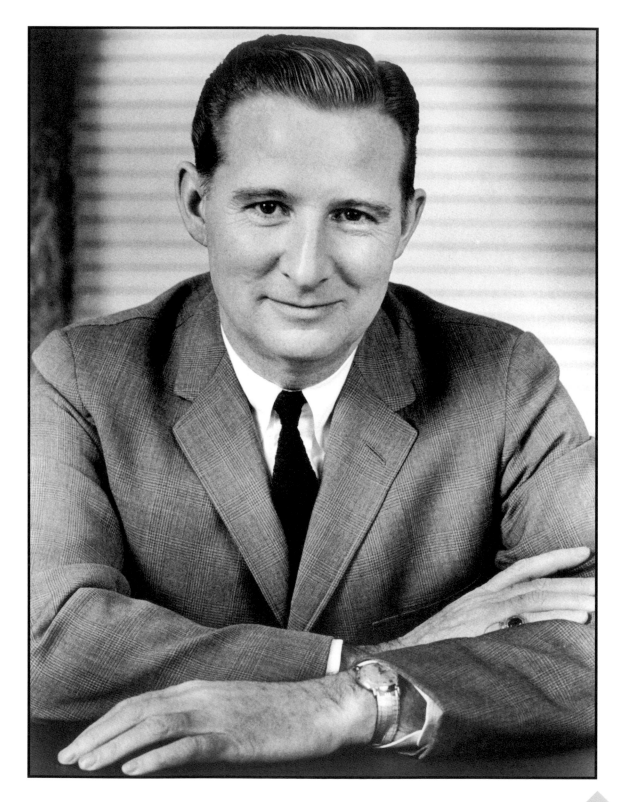

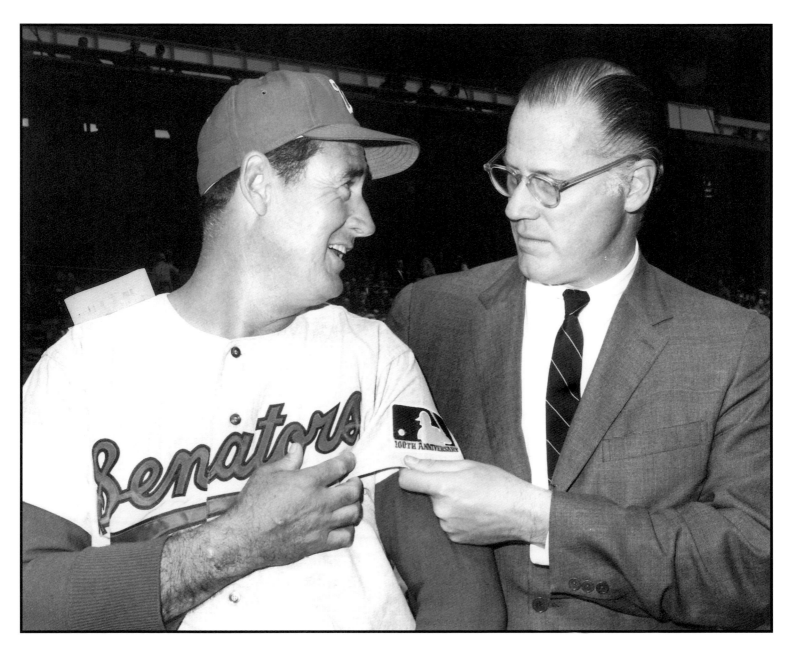

**Ted Williams and Bowie Kuhn**
**Opening Day, 1969**

Ted Williams came out of retirement to manage the Senators in 1969. He was also club vice-president, though it's safe to say he never showed up to the office in a coat and tie. His presence brought an excitement to Washington baseball not seen in decades.

Bowie Kuhn grew up in Washington, and worked at Griffith Stadium as a scoreboard operator during his youth. He was a surprise pick for commissioner of baseball following General William "Spike" Eckert, whose contribution to the game was pretty much non-existent.

Here Kuhn and Williams display for photographers baseball's 100th anniversary patch, worn on every team's - save Pittsburgh - uniform in 1969.

### Toby Harrah
### Shortstop, 1969, 1971

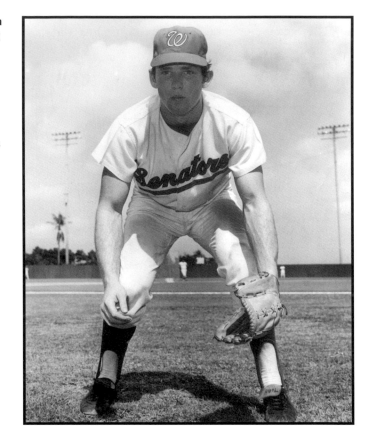

Toby Harrah - one of baseball's rare palindromes - was originally signed by the Phillies, and drafted by the Senators in 1967. He got a look-see in 1969, and was handed the shortstop position in 1971 following the trade of Ed Brinkman to Detroit. Harrah was not terribly impressive his rookie year: a .230 average, two home runs, 10 stolen bases and 22 RBI.

Harrah more than made up for it in Texas, where he consistently hit in the .260 range and hit a career-high 27 home runs in 1977. Harrah also played for the Indians and Yankees over his 17 big league seasons, swatting 195 homers and being named to three All-Star teams.

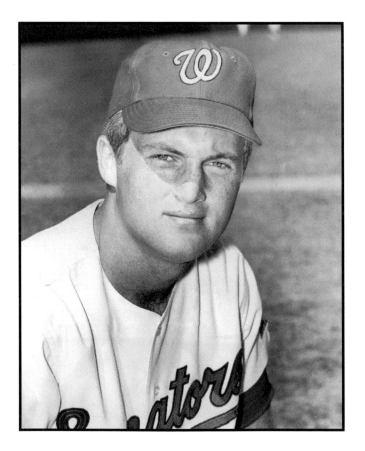

### Jeff Burroughs
### Outfielder, 1970 - 1971

Jeff Burroughs was the number one ranked high school player in the country when the Senators drafted him in 1969. He got a taste of the majors in 1970, and a longer look in 1971, when he hit .232 in 59 games with five home runs and 25 RBI.

By 1973 in Texas, however, he showed why he was so coveted as a prep star, belting 30 home runs with 85 RBI. He was the American League MVP the following year, batting .301 with 25 homers and 118 RBI. Traded to Atlanta in 1977, Burroughs added another All-Star caliber season in 1978, drawing a league-leading 117 walks. A journeyman at the end, Jeff returned to the AL with Seattle, Oakland and Toronto, and retired in 1985 with 240 career home runs. His son, Sean, played with the San Diego Padres.

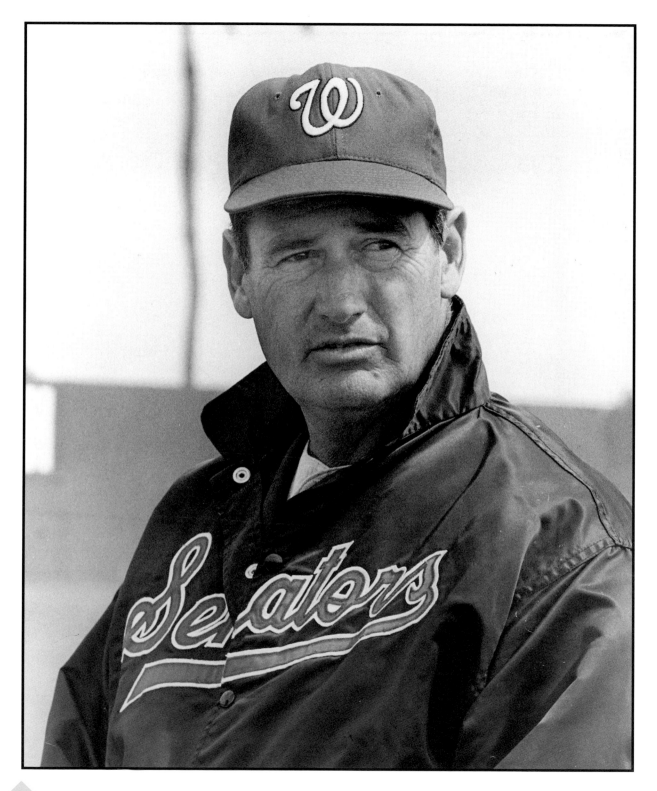

**Ted Williams**
**Manager, 1969 - 1971**

It may seem surprising to see Red Sox icon Ted Williams in a Washington Senators uniform, but for three seasons, the great left-handed hitter managed the team and drew big crowds wherever the club played.

Williams could be moody and intense, but in 1969, he did something no Washington skipper had done since Bucky Harris in 1952: he won more games than he lost. At 86-76, the Senators were not contenders, but for long-suffering Senators' fans, it was like hitting the lottery.

Teddy Ballgame occasionally grabbed a bat and got into the cage before a game, and in his 50's, could still reach the fences.

**Del Unser**
**Outfielder, 1968 - 1971**

Del Unser was another son of a big league dad: Al Unser had caught for the Tigers and Reds during World War II. Del had a so-so year at York in 1967, batting .231, but made the big league club in 1968, where he hit .230, a decent number for a rookie during the year of the pitcher.

For his efforts, he was voted *The Sporting News* American League Rookie-of-the-Year. He followed that up with a solid .286 in 1969, but after a hernia operation and assorted injuries, dropped to .258 and .255 in 1970-71.

Traded to Cleveland in 1972, Unser spent the final decade of his career in the National League with the Phillies, Mets, and Expos. He was a reliable pinch hitter, and later a hitting coach. Unser got into the administrative side of things with the Phillies, and is currently a scout.

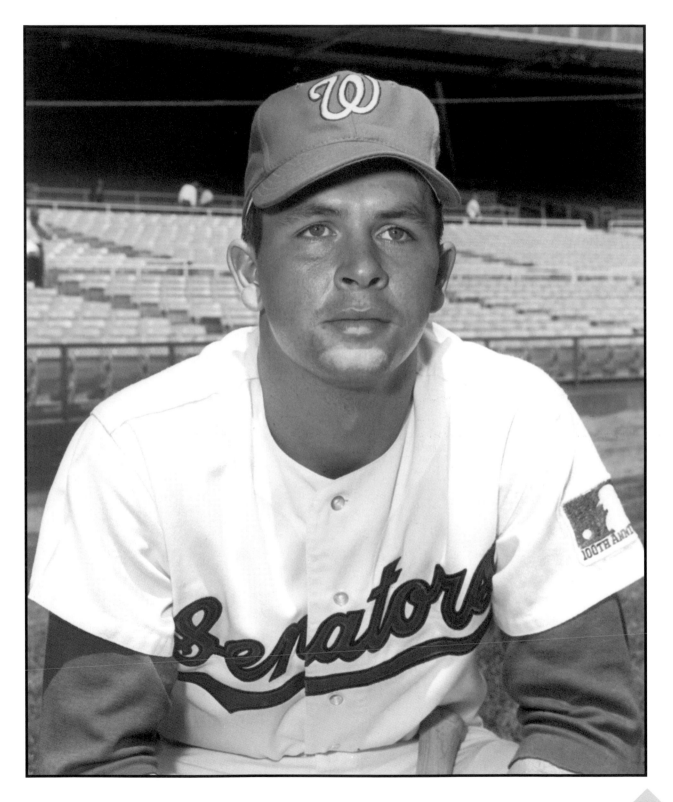

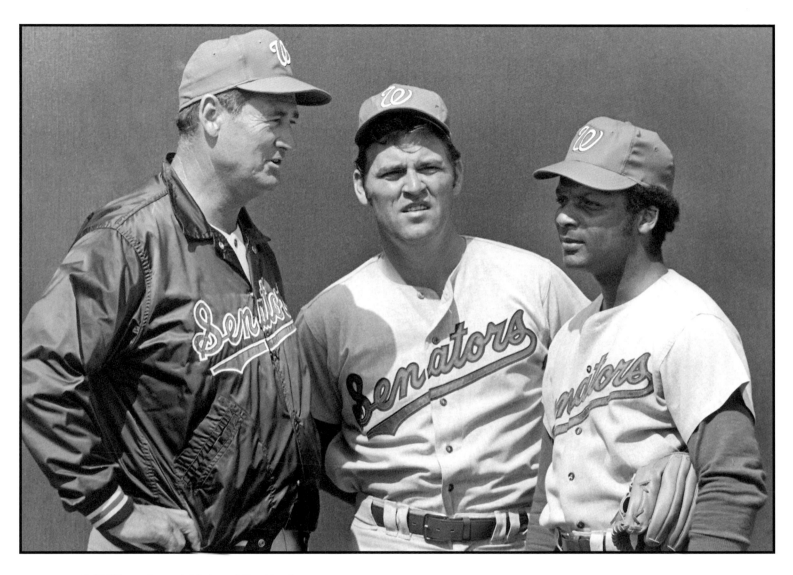

**Ted Williams, Denny McLain and Curt Flood**
**Spring Training, 1971**

During the 1970 World Series, owner Bob Short ignored the advice of manager Ted Williams and made a bad trade with Detroit. Along with two pitchers, he gave up the left side of his infield for two-time Cy Young Award winner Denny McLain, veteran third baseman Don Wert, outfielder Elliot Maddox, and minor league pitcher Norm McRae. The next year, McLain went 10-22, Wert retired mid-season, Maddox hit .217 and McRae labored in the minors.

Worse, Short also acquired former Cardinal All-Star Curt Flood, who had sat out the season in Philadelphia fighting baseball's reserve clause in court. Flood had almost nothing left. He hit .200 in 13 games, seven singles in 35 at-bats. He was slow in the field and knew it was time to leave. Without warning, he left the club and flew to Denmark.

Flood lost his case against baseball, but a few years later an arbitrator struck down baseball's reserve clause. The decision came too late for Flood, but he clearly lit the match that led to free agency.

Short's personnel moves doomed the Senators on the field. Washington lost 96 games. In their farewell on September 30, the team was leading, 7-5, when fans stormed the field with two outs in the 9th inning, resulting in a forfeit to the Yankees.

Washington baseball fans had no way of knowing that it would be 34 years before the national pastime would again be played in D.C.

# Photograph Credits

**Chicago Historical Society:**
(*Chicago Daily News* **negatives collection**)
8 (sdn-1320)
9 (sdn-1412)
10(sdn-3077)
11(sdn-2367)

**Feddeman, Kent:**
12, 13, 22, 25, 38, 41, 44, 51, 53(bottom), 68, 71, 72, 76, 85, 89, 90, 91(bottom), 107, 109, 121(bottom), 152(bottom), 155(top), 163(top), 164(bottom), 179(bottom), 191

**Feinberg, Alan:**
36, 37, 50, 54, 60, 65, 66, 73, 74, 94, 97, 108(bottom), 113, 115(top), 122, 123, 128, 148(top), 159, 174(bottom)

**Goldstein, Dennis:**
15, 18, 19, 23, 26, 27, 28, 29, 31, 34, 43, 46, 61(top), 79, 100, 105, 131, 157, 158

**Loughman, Bill:**
57, 64, 70, 87, 88, 95, 106, 124, 134, 180(bottom)

**Martin Luther King, Jr. Memorial Library, Washington, DC:**
(*Washington Star* **collection**)
62, 93, 99, 112(bottom), 114, 116, 118, 119, 126, 129, 198, 199, 210(bottom)

**Mumby, Mike:**
16(top), 17, 39, 61(bottom), 84, 111

**National Baseball Hall of Fame Library,
Cooperstown, NY**
16(bottom), 20, 24, 30, 33, 35, 45, 48, 53(top), 58, 59, 63, 67, 75, 77, 78, 80, 81(bottom), 91(top), 92, 96, 98, 102, 104, 108(top), 112(top), 115(bottom), 127, 130(bottom), 132, 133(top), 137, 138, 140, 141, 145, 146, 147(bottom), 148(bottom), 150, 151, 152(top), 154, 155(bottom), 156, 162, 163(bottom), 164(top), 170(bottom), 171, 172, 174(top), 175, 176, 177, 178, 179(top), 180(top), 181, 184, 185, 186, 187, 188, 189, 190, 192, 194, 196, 203

**Stang, Mark:**
40, 42, 47, 52, 69, 82, 83, 86, 120, 121(top), 130(top), 142, 144, 153, 168, 169(bottom),197, 201(top)

*The Sporting News:*
frontispiece, 14, 21, 32, 55, 56, 101, 110, 117, 125, 135, 136, 139, 143, 161, 165, 166, 182, 193, 195, 200, 202, 204

**Thomas, Hank:**
49

**Wood, Phil:**
81(top), 103, 133(bottom), 147(top), 149, 160, 167, 169(top), 170(top), 173, 183

# Photograph Index

## About The Authors

**Phil Wood** is a D.C. native, a 30+ year veteran of the Baltimore-Washington sports radio market, and occasional musician. He's currently a host on XM Satellite Radio's MLB Home Plate (channel 175), and is the baseball columnist for *The Washington Examiner*. He resides in Reisterstown, Maryland with his wife Diane Gunther and daughters Cari and Becky.

This is **Mark Stang's** sixth book on major league baseball. His previous team photo histories have included the Cincinnati Reds, Cleveland Indians, Chicago Cubs and St. Louis Cardinals. His first book, *Baseball By The Numbers*, which was awarded the 1991 SABR-McMillian baseball research award, is the definitive guide to major league uniform numbers. Stang currently resides in Tampa, Florida with his wife Rosemary.

To order additional copies of *Nationals On Parade*, or for information about other titles currently available from Orange Frazer Press, please call **1–800–852–9332**, or visit our website at **orangefrazer.com**. Address inquiries to:

Orange Frazer Press
P.O. Box 214
37½ West Main Street
Wilmington, OH 45177.